JULIUS · S · HELD
RUBENS DRAWINGS
PHAIDON

MCMLIX

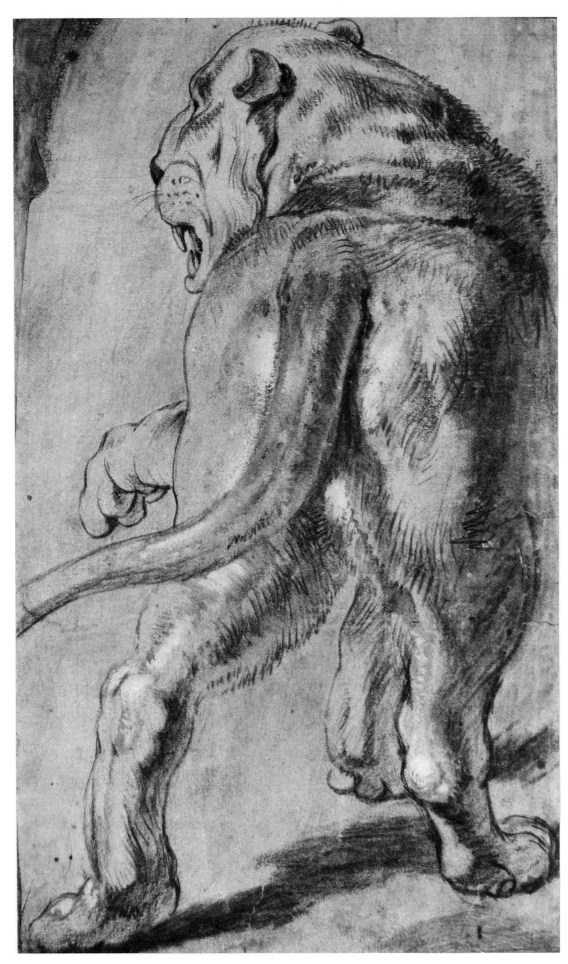

A LIONESS. London, British Museum

RUBENS

SELECTED DRAWINGS

WITH AN INTRODUCTION
AND A CRITICAL CATALOGUE
BY JULIUS · S · HELD

VOL · II

THE PLATES

PHAIDON PRESS · LONDON

CONTENTS

THE PLATES

I : SKETCHES FOR COMPOSITIONS
(PLATES 1–79)

II : STUDIES FROM MODELS AND PORTRAITS
(PLATES 80–139)

III : LANDSCAPES
(PLATES 140–147)

IV : DESIGNS FOR SCULPTURES, ENGRAVINGS AND WOODCUTS
(PLATES 148–164)

V : COPIES BY RUBENS AFTER OTHER MASTERS AND DRAWINGS RETOUCHED BY RUBENS
(PLATES 165–179)

LIST OF PLATES

LIST OF COLLECTIONS

THE PLATES

I
SKETCHES FOR COMPOSITIONS

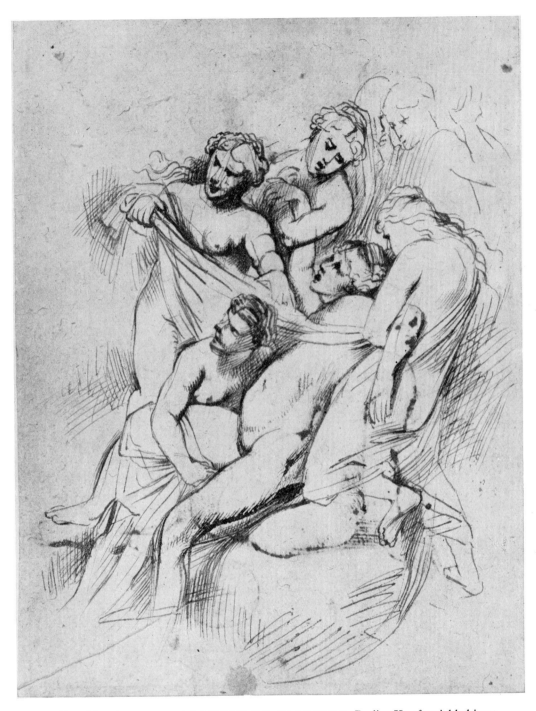

1 (Cat. No. 1) THE DISCOVERY OF CALLISTO. Berlin, Kupferstichkabinett

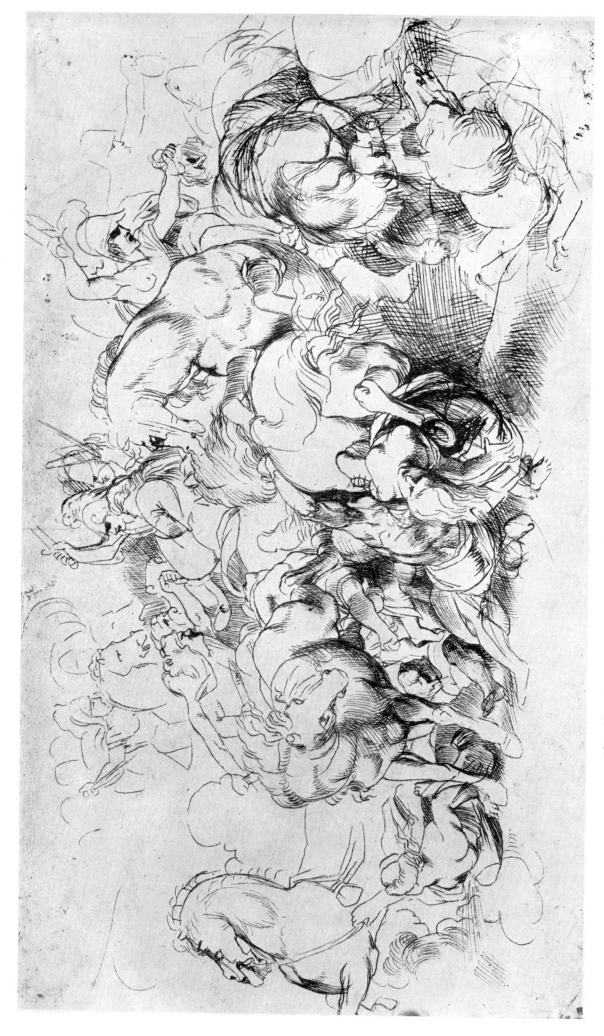

2 (Cat. No. 2) A BATTLE OF GREEKS AND AMAZONS. London, British Museum

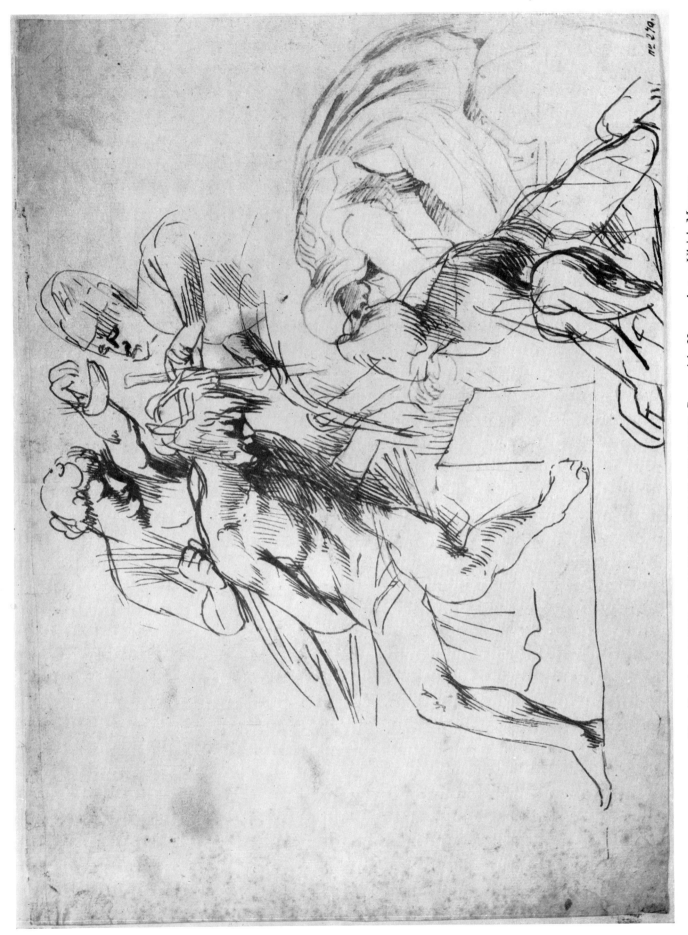

3 (Cat. No. 5) CHRIST CROWNED WITH THORNS. Brunswick, Herzog Anton Ulrich-Museum

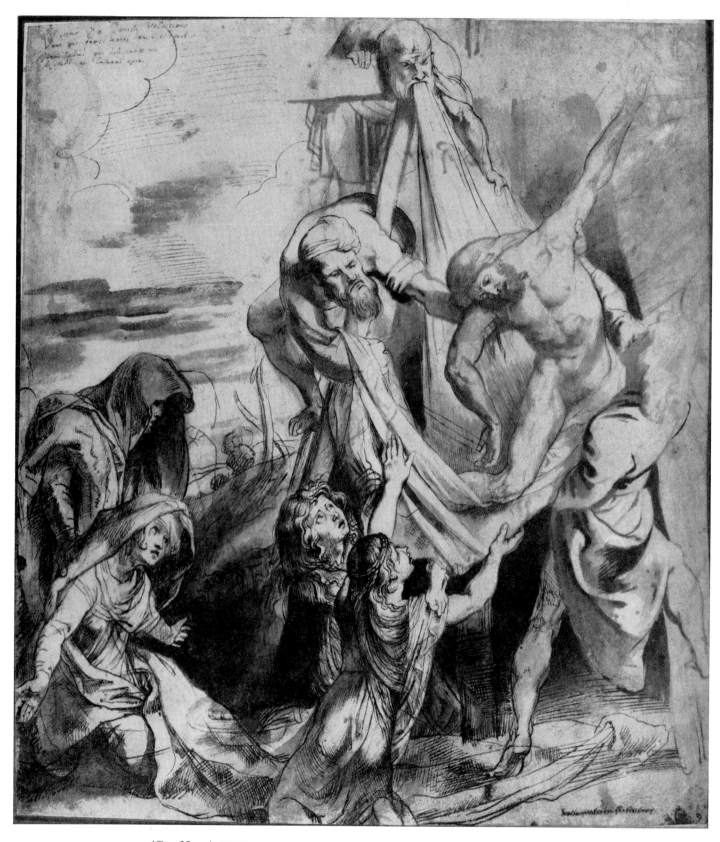

4 (Cat. No. 3) THE DESCENT FROM THE CROSS. Leningrad, Hermitage

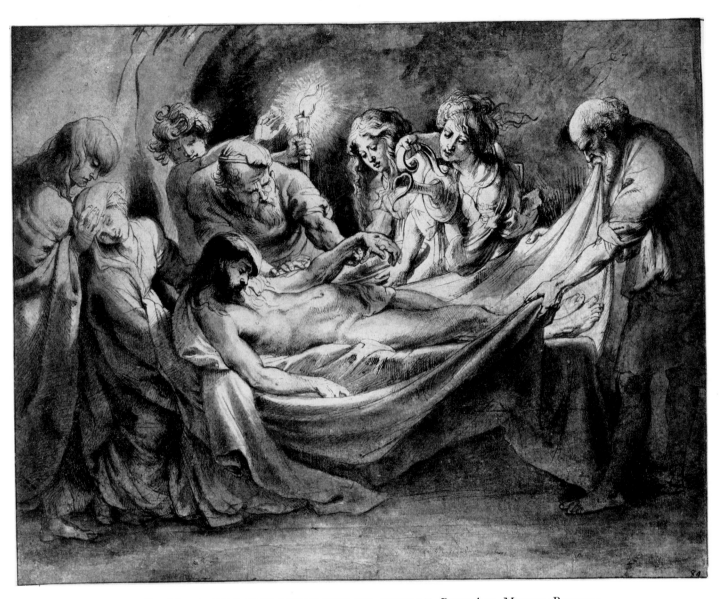

5 (Cat. No. 4) THE ENTOMBMENT OF CHRIST. Rotterdam, Museum Boymans

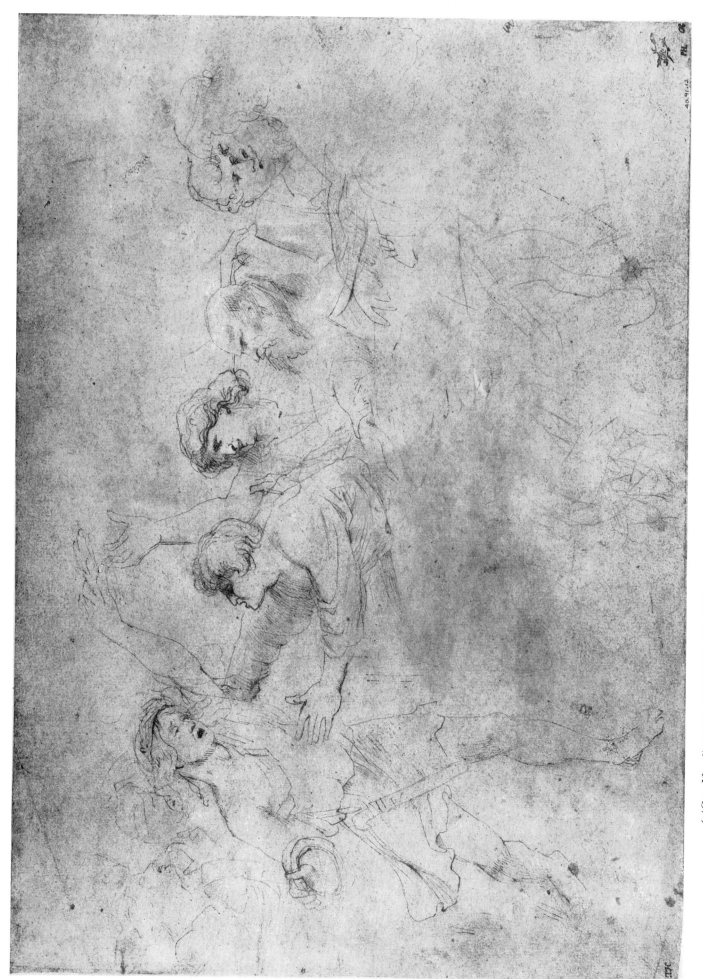

6 (Cat. No. 6) THE RETURN OF THE VICTORIOUS HORATIUS. New York, Metropolitan Museum of Art

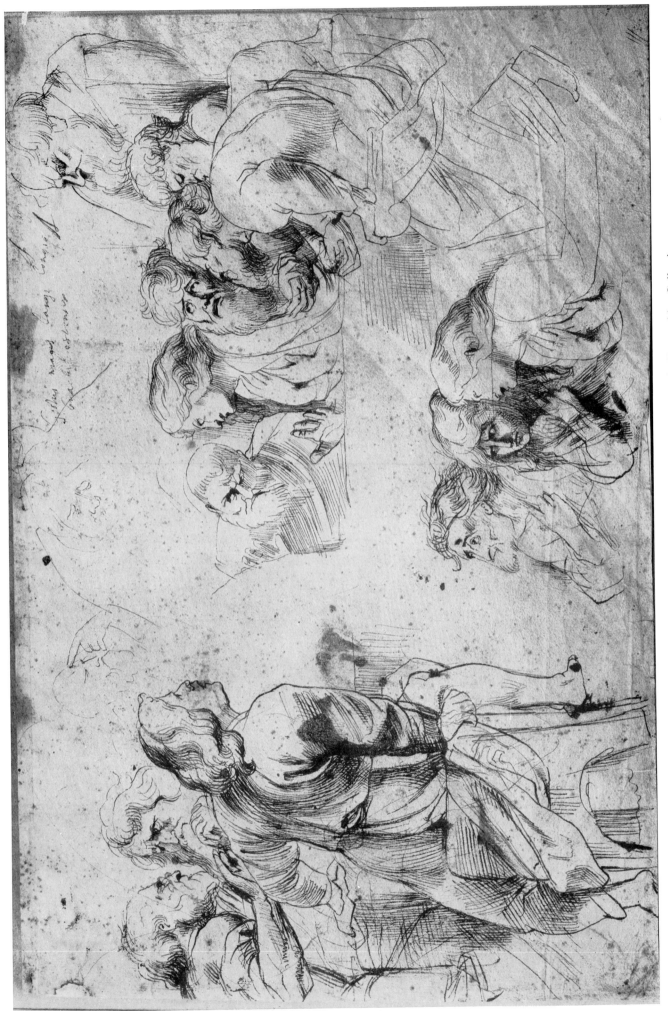

7 (Cat. No. 7) SKETCHES FOR THE LAST SUPPER. Chatsworth, Devonshire Collection

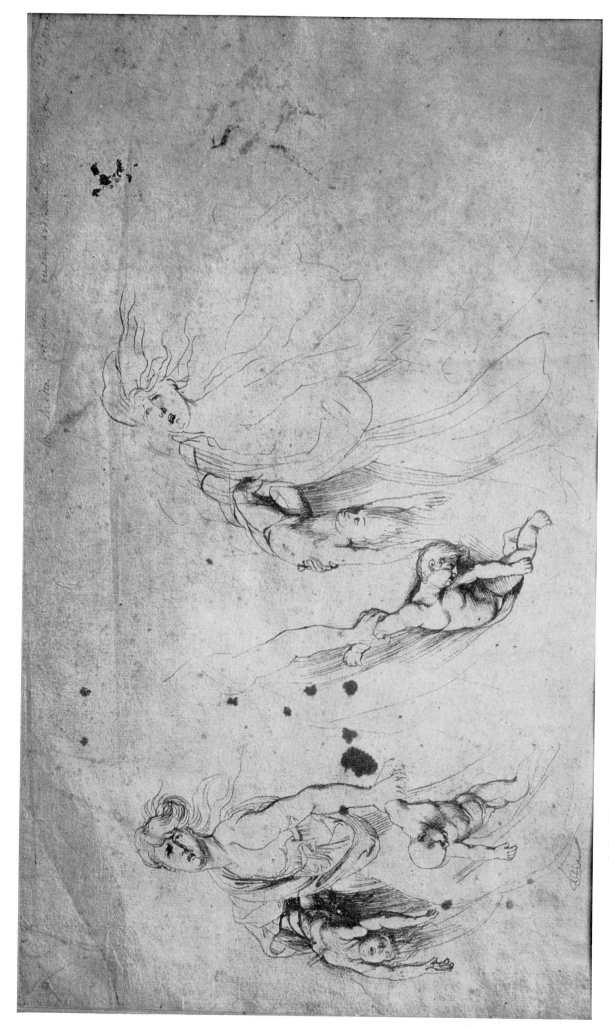

8 (Cat. No. 7 verso) MEDEA AND HER SLAIN CHILDREN. Reverse of Plate 7. Chatsworth, Devonshire Collection

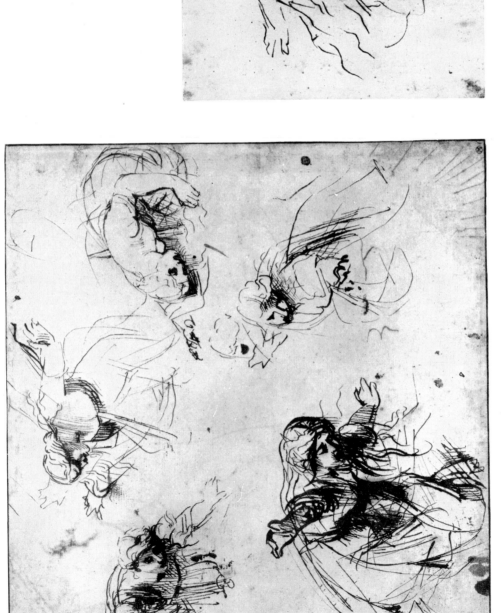

10 (Cat. No. 9) THISBE COMMITTING SUICIDE.
Brunswick (Maine), Collection of Mrs. Stanley P. Chase

9 (Cat. No. 8) STUDIES FOR THE SUICIDE OF THISBE.
Paris, Louvre

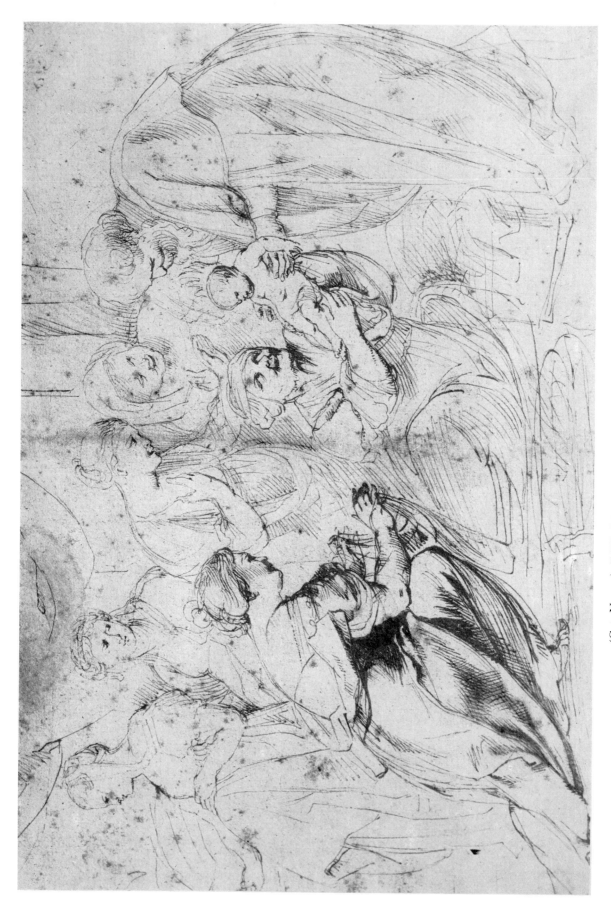

11 (Cat. No. 12) THE BIRTH OF THE VIRGIN. Paris, Petit Palais

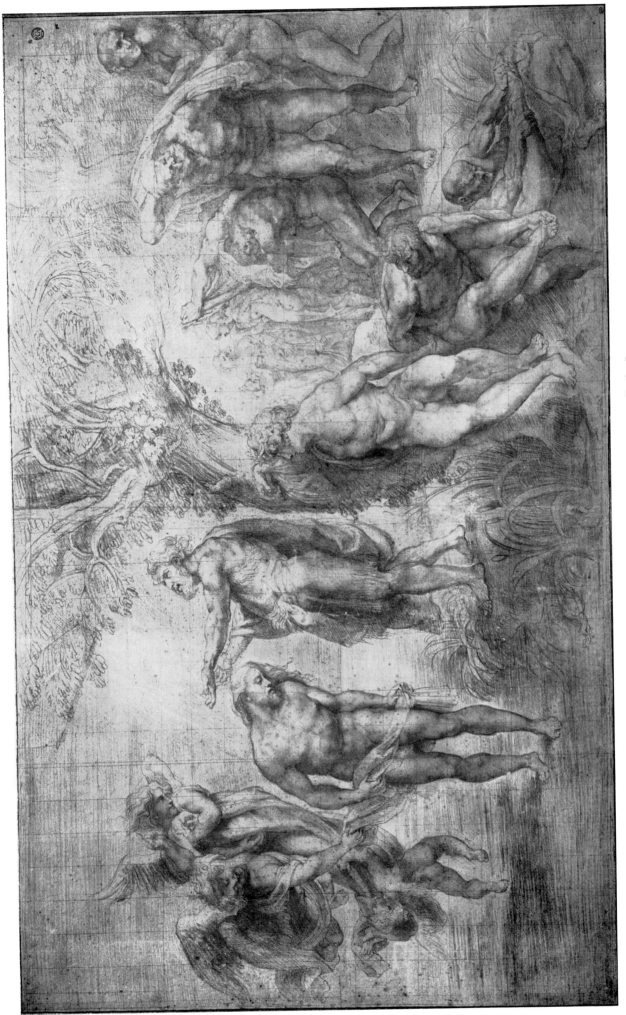

12 (Cat. No. 11) THE BAPTISM OF CHRIST. Paris, Louvre

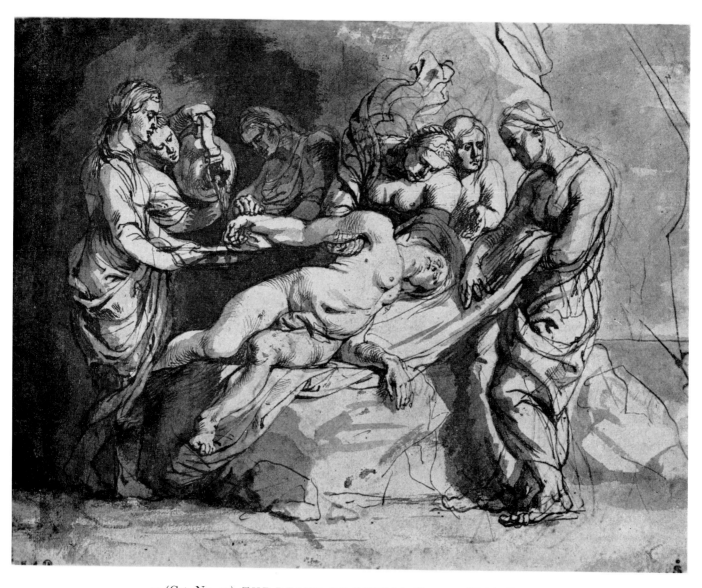

13 (Cat. No. 13) THE DEATH OF CREUSA. Bayonne, Musée Bonnat

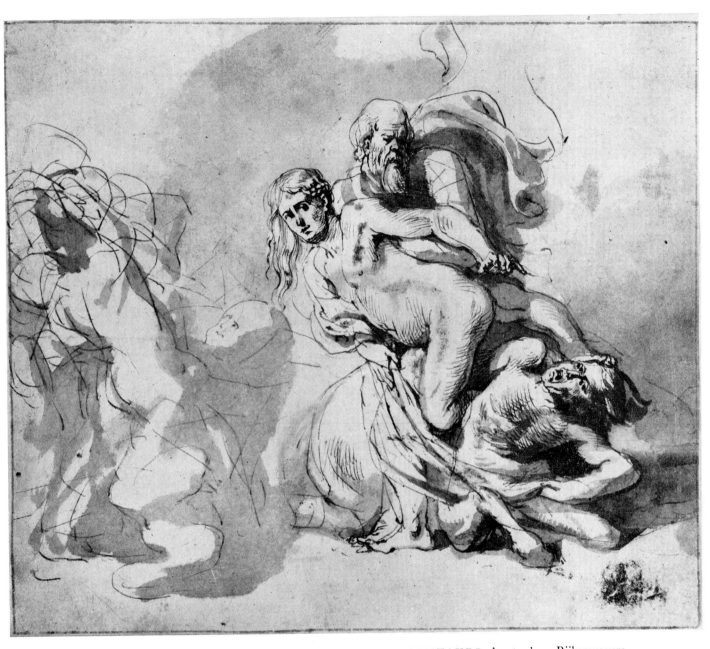

14 (Cat. No. 14) THE BATTLE OF LAPITHS AND CENTAURS. Amsterdam, Rijksmuseum

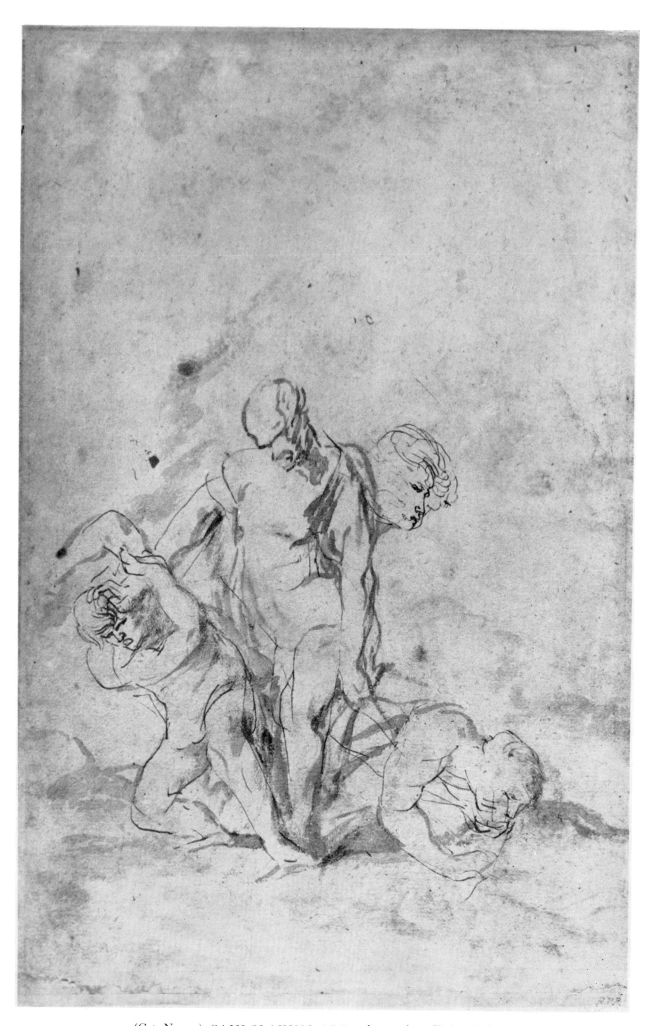

15 (Cat. No. 10) CAIN SLAYING ABEL. Amsterdam, Fodor Collection

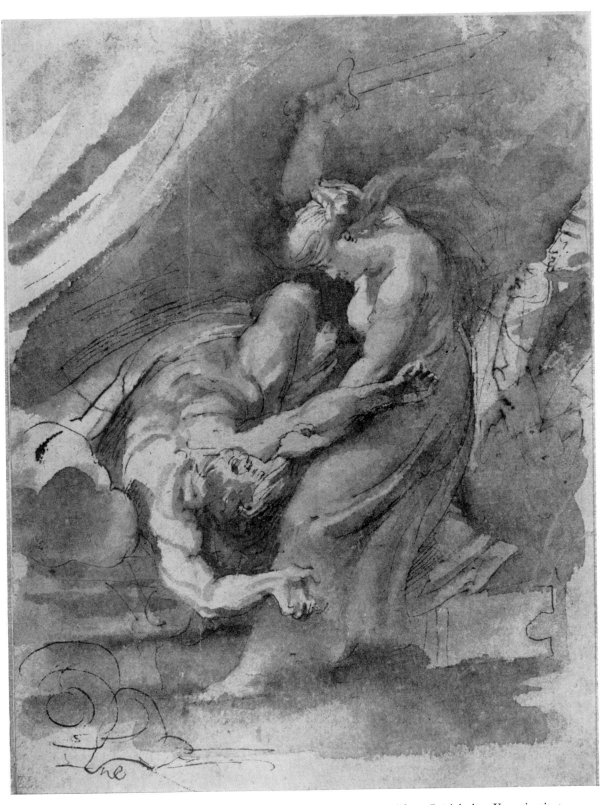

16 (Cat. No. 15) JUDITH KILLING HOLOFERNES. Frankfurt, Städelsches Kunstinstitut

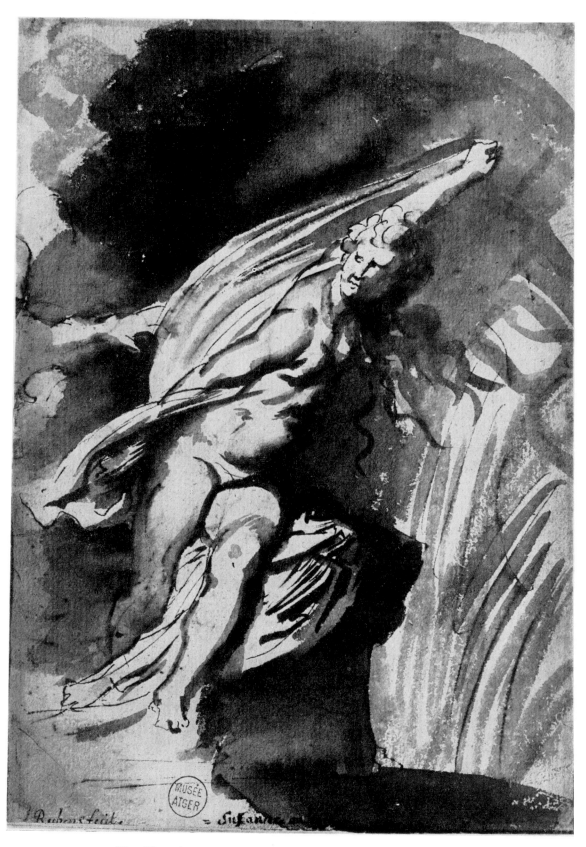

17 (Cat. No. 20) SUSANNA. Montpellier, Bibliothèque Universitaire

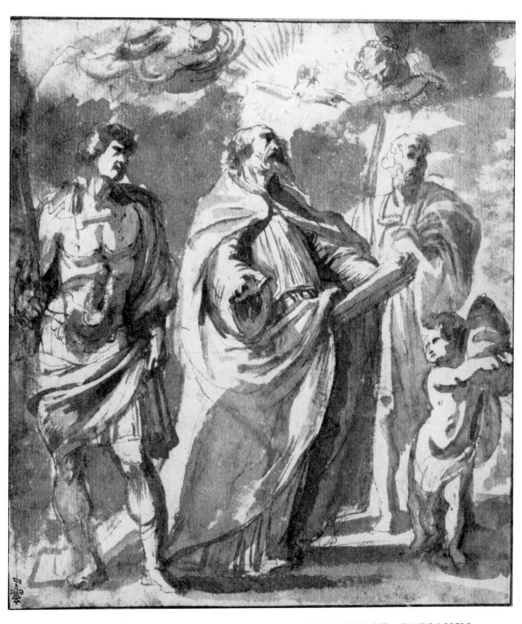

18 (Cat. No. 16) ST. GREGORY, ST. MAURUS AND ST. PAPIANUS.
Chantilly, Musée Condé

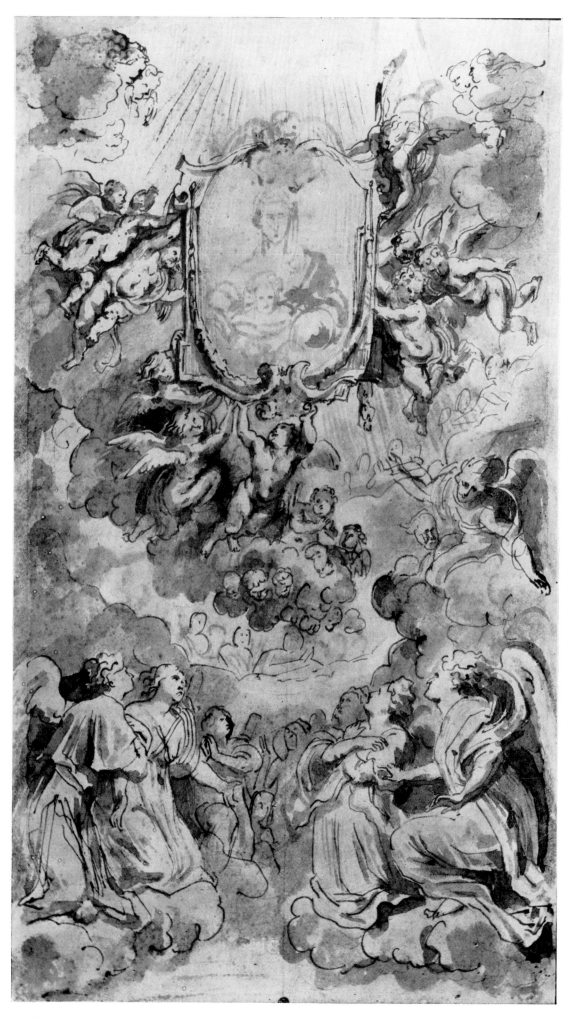

19 (Cat. No. 17) THE IMAGE OF THE VIRGIN ADORED BY ANGELS. Vienna, Albertina

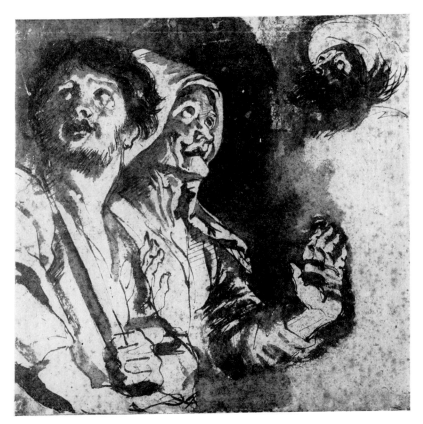

20 (Cat. No. 18) TWO SHEPHERDS AND MAN WITH TURBAN.
Amsterdam, Fodor Collection

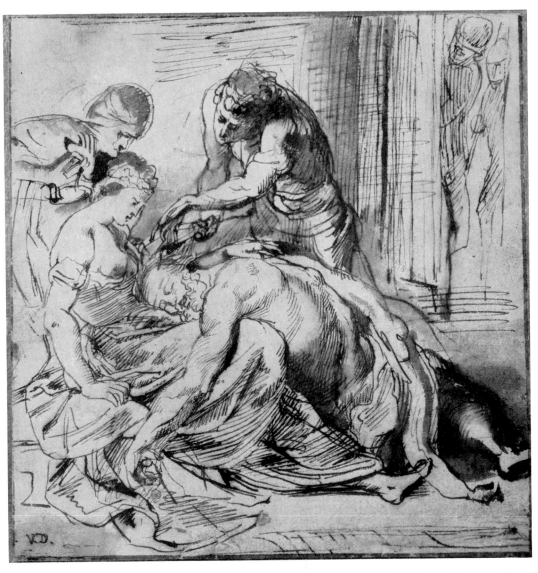

21 (Cat. No. 24) SAMSON AND DELILA. Amsterdam, Collection of J.Q. van Regteren Altena

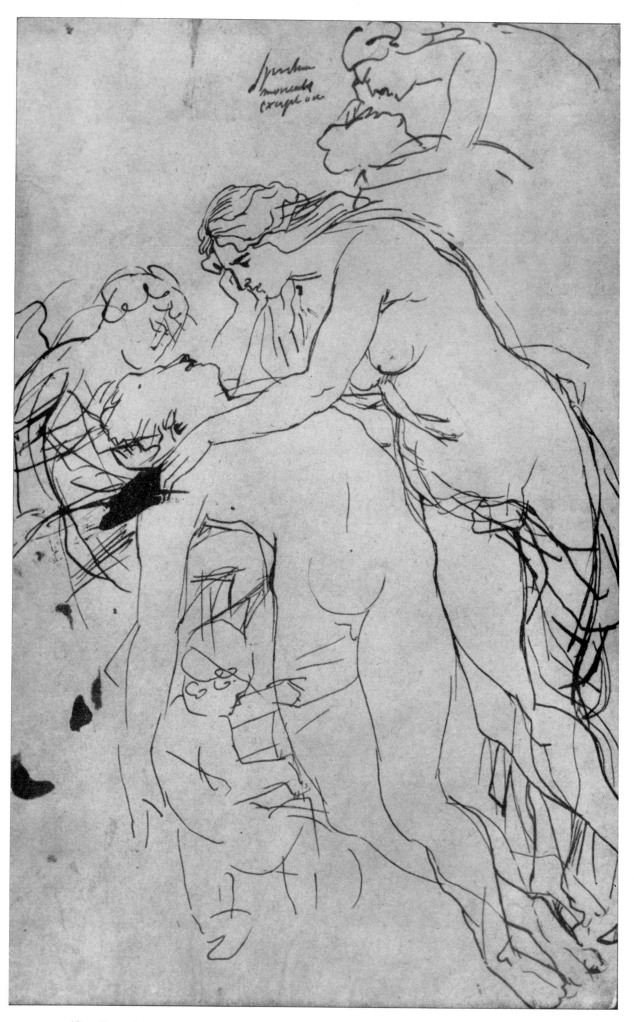

22 (Cat. No. 23) VENUS LAMENTING ADONIS. London, Collection of Ludwig Burchard

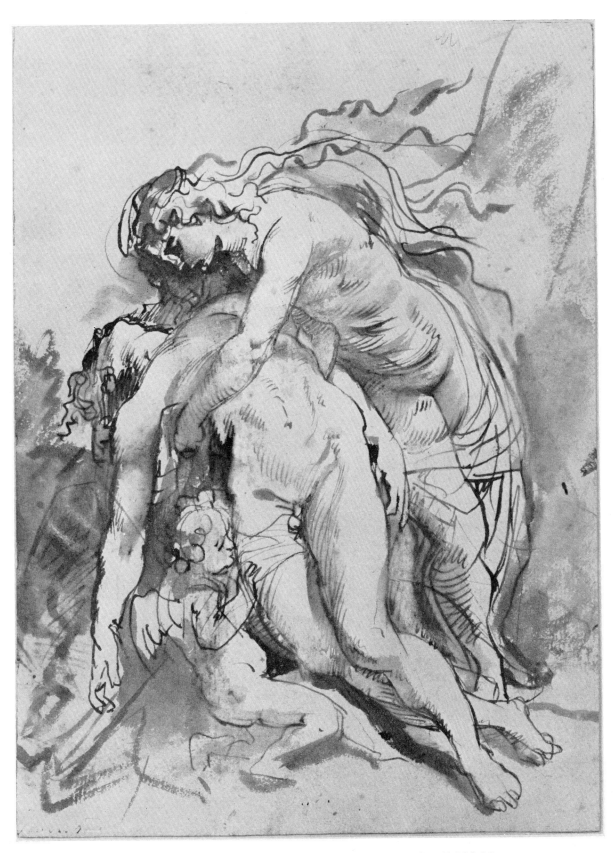

23 (Cat. No. 22) VENUS LAMENTING ADONIS. London, British Museum

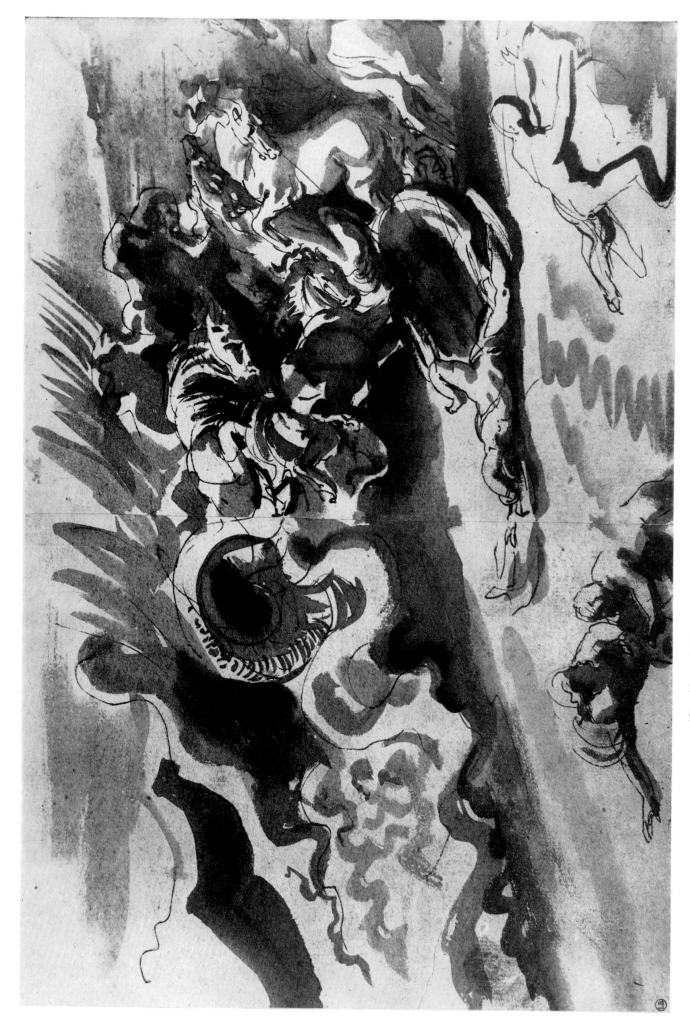

24 (Cat. No. 21) THE DEATH OF HIPPOLYTUS. Bayonne, Musée Bonnat

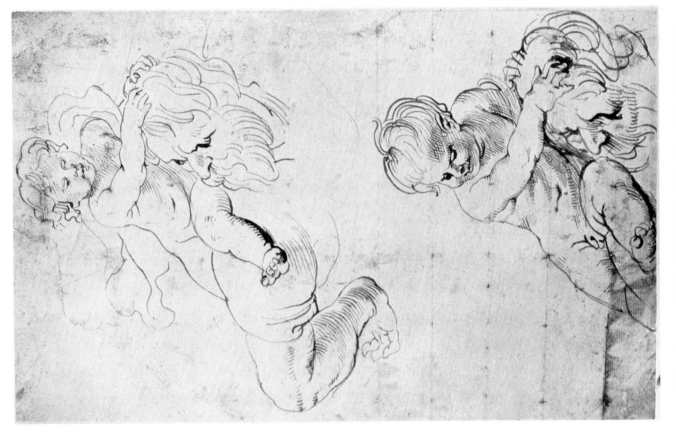

26 (Cat. No. 30) TWO STUDIES FOR ST. CHRISTOPHER.
London, British Museum

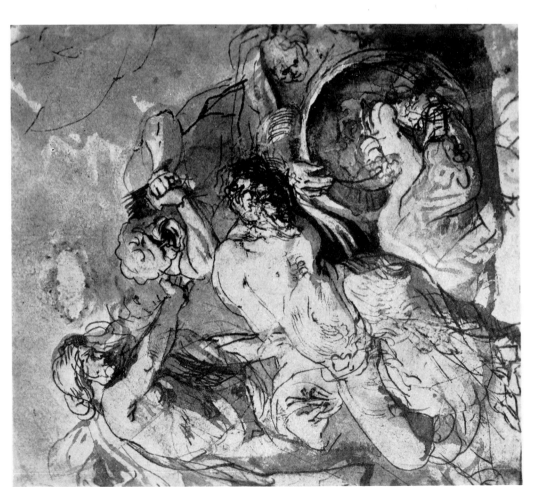

25 (Cat. No. 19) A BACCHANAL.
Antwerp, Cabinet des Estampes

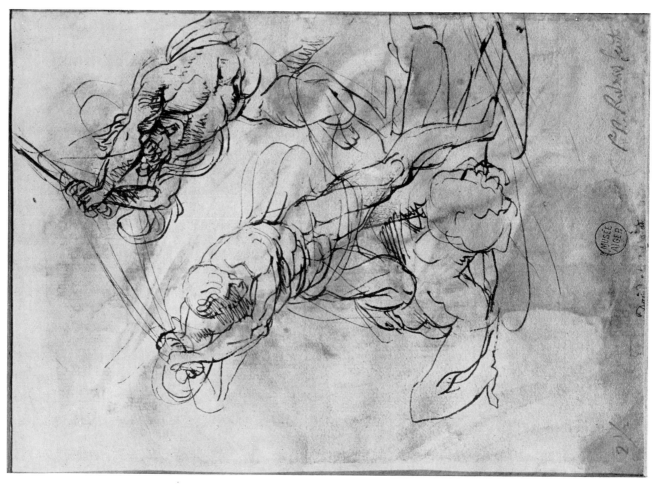

28 (Cat. No. 26) DAVID AND GOLIATH. Montpellier, Bibliothèque Universitaire

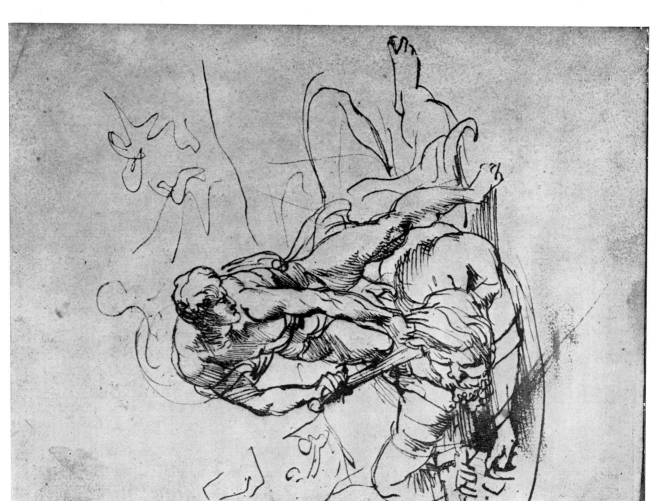

27 (Cat. No. 25) DAVID AND GOLIATH. Rotterdam, Museum Boymans

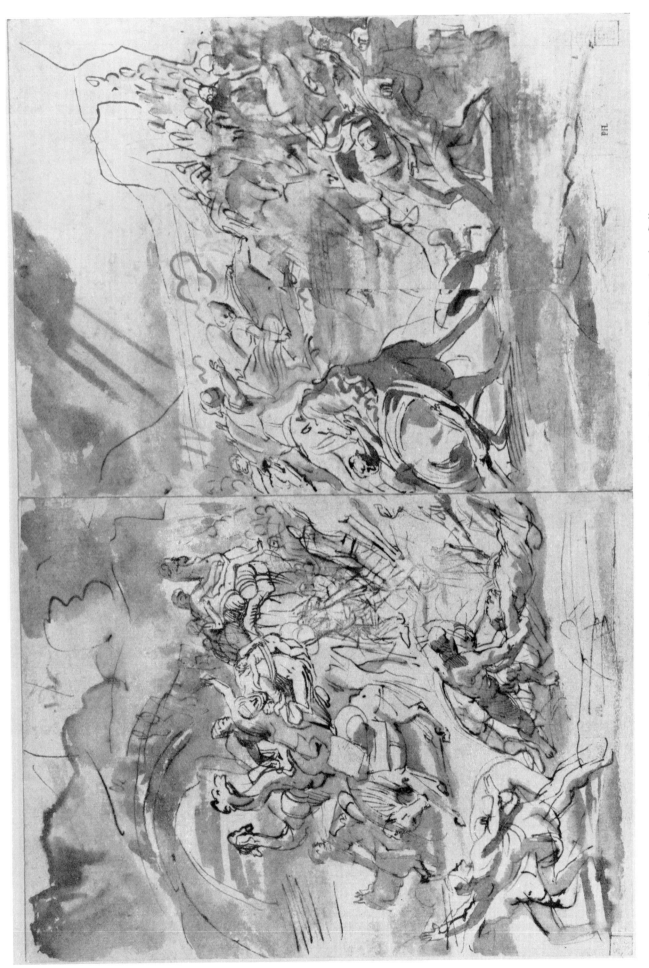

29 (Cat. No. 31) THE CONVERSION OF ST. PAUL. London, Collection of Count Antoine Seilern

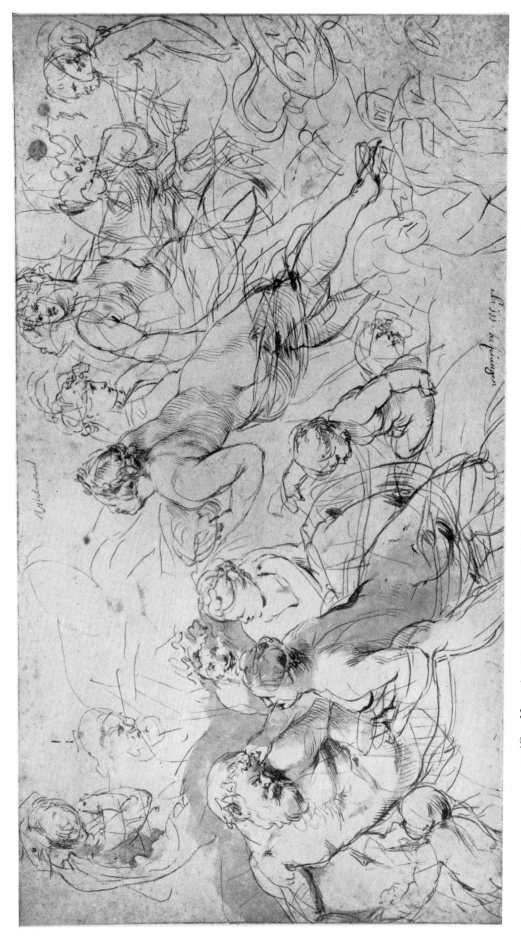

30 (Cat. No. 29) SILENUS AND AEGLE, AND OTHER FIGURES. Windsor Castle, Royal Library

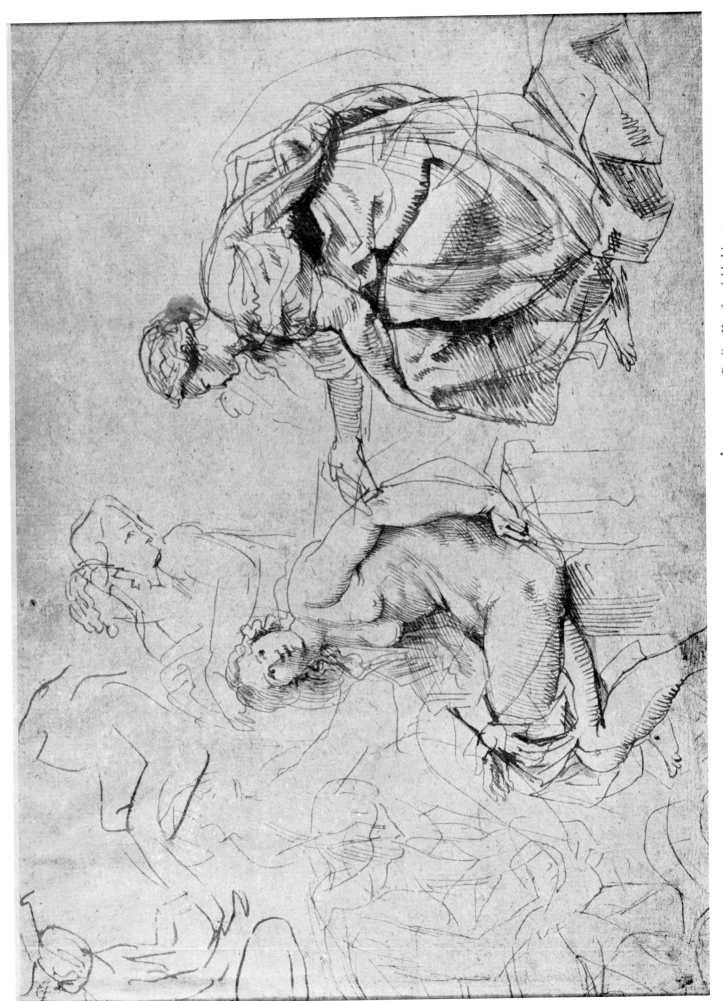

31 (Cat. No. 32) BATHSHEBA RECEIVING DAVID'S LETTER. Berlin, Kupferstichkabinett

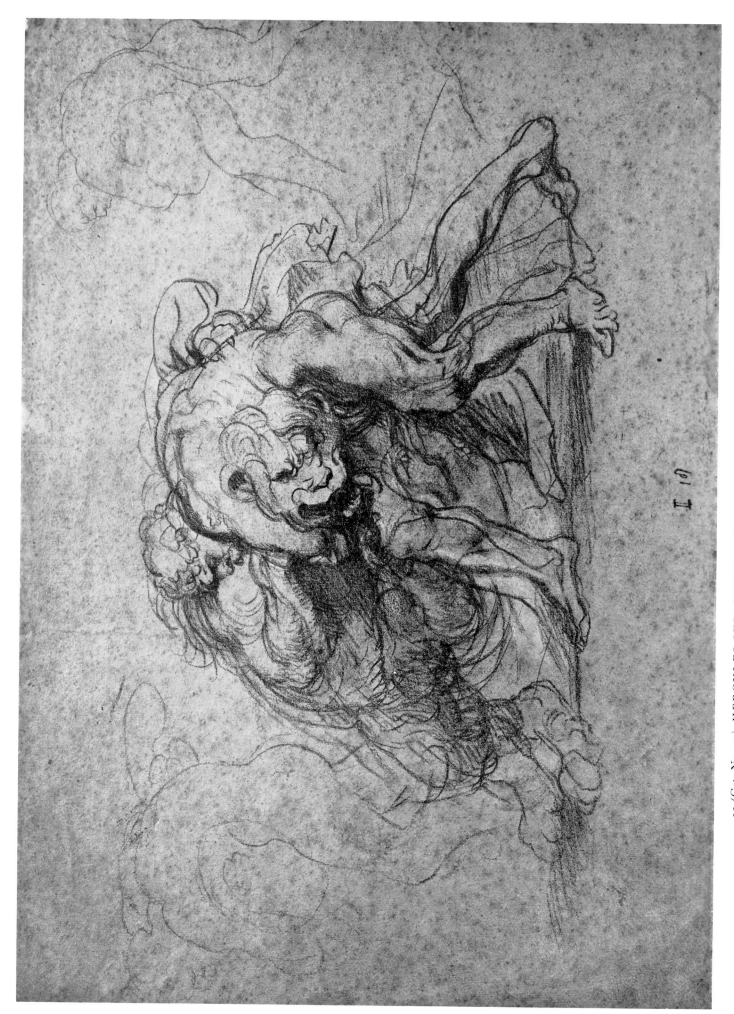

32 (Cat. No. 34) HERCULES STRANGLING THE NEMEAN LION. Antwerp, Cabinet des Estampes

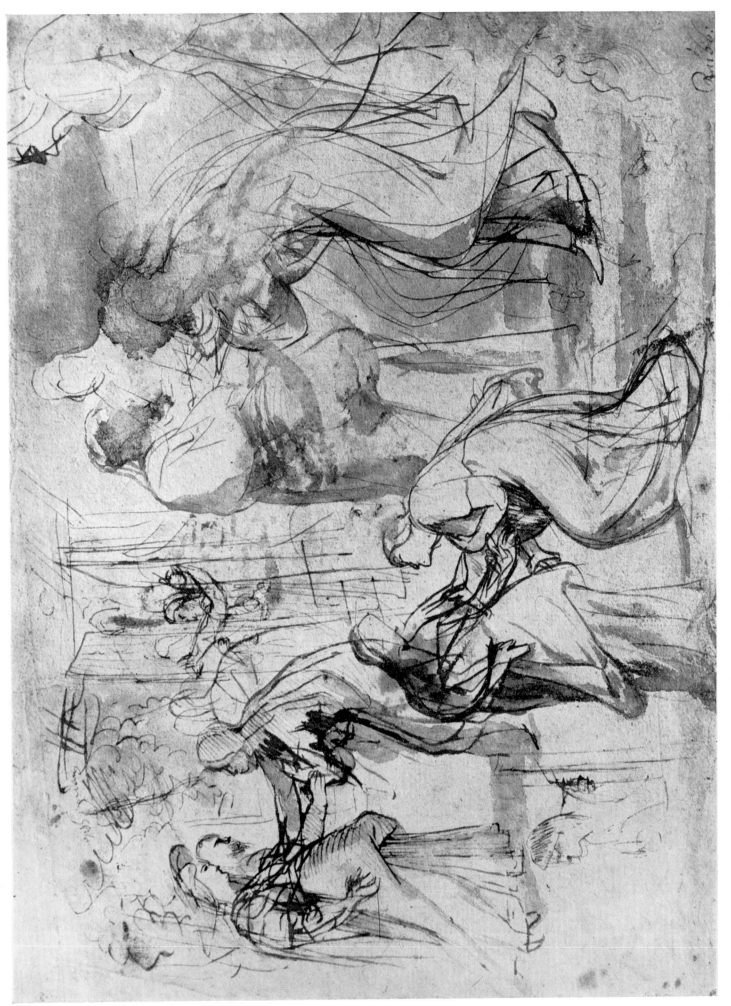

33 (Cat. No. 27) STUDIES FOR THE VISITATION. Bayonne, Musée Bonnat

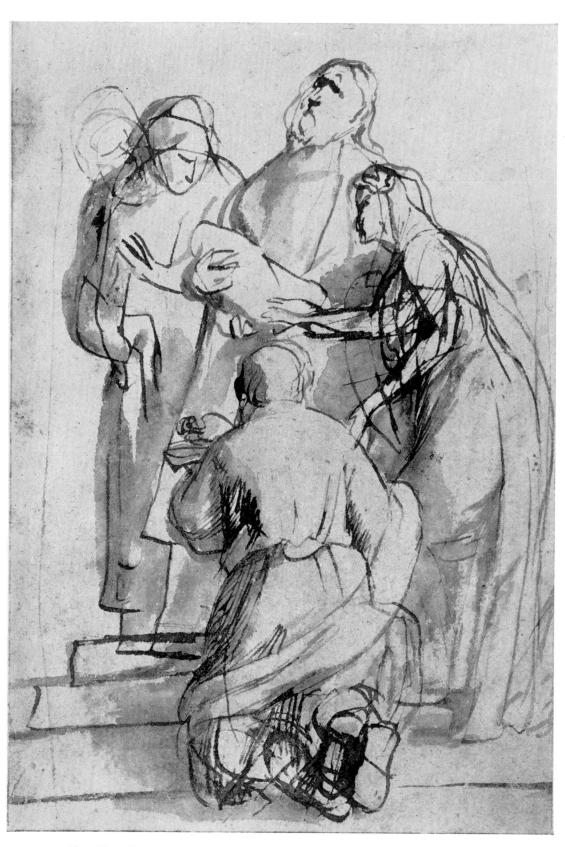

34 (Cat. No. 28) STUDIES FOR THE PRESENTATION IN THE TEMPLE.
New York, Metropolitan Museum of Art

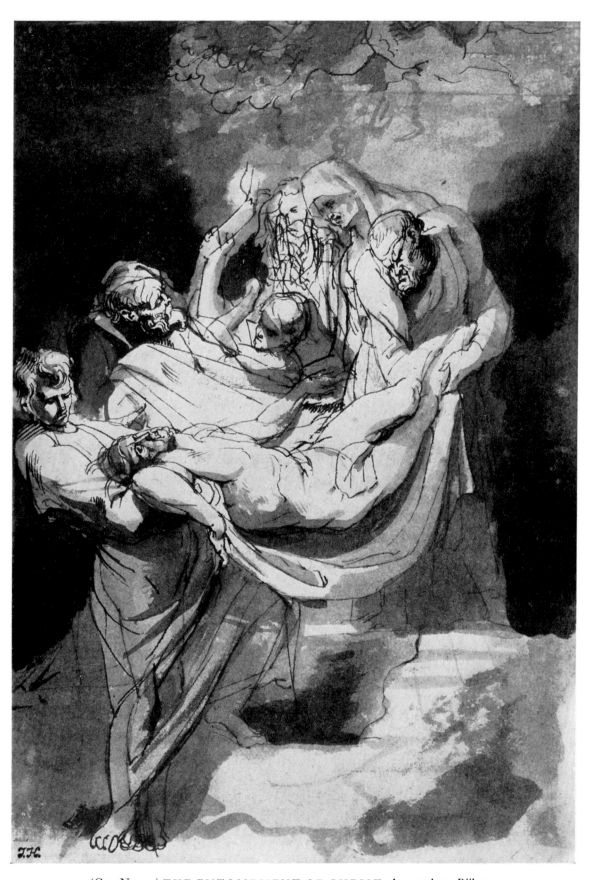

35 (Cat. No. 37) THE ENTOMBMENT OF CHRIST. Amsterdam, Rijksmuseum

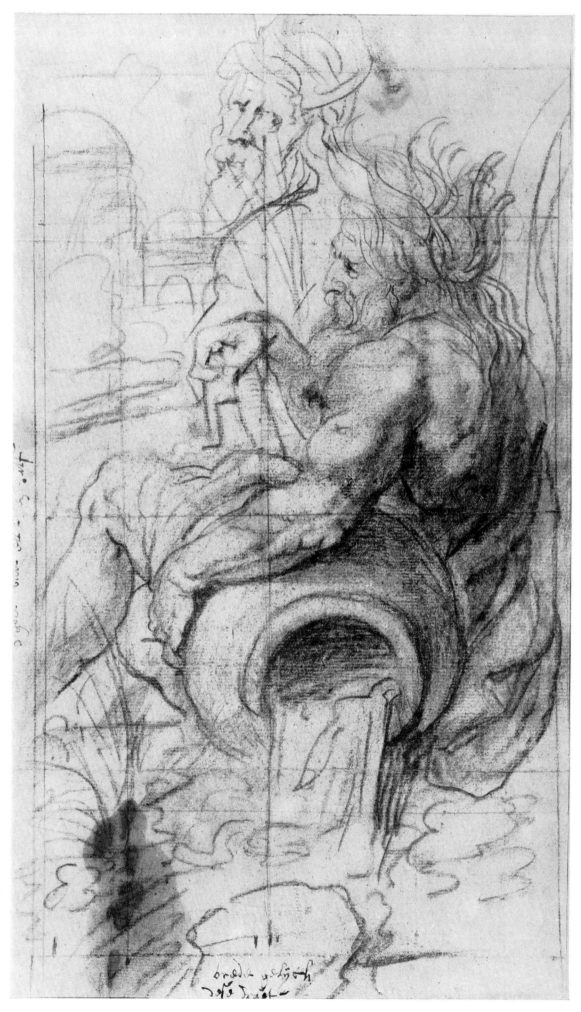

36 (Cat. No. 33) TWO STUDIES OF A RIVER-GOD. Boston, Museum of Fine Arts

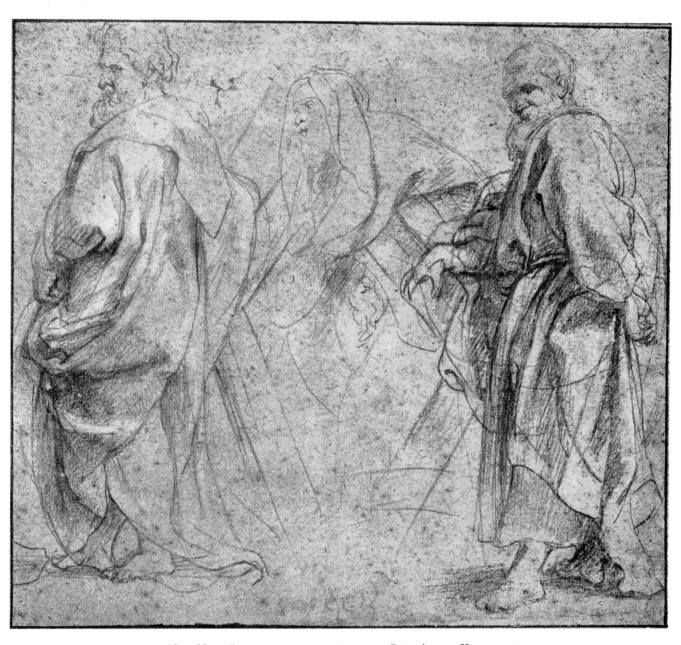

37 (Cat. No. 36) THREE ROBED MEN. Copenhagen, Kunstmuseet

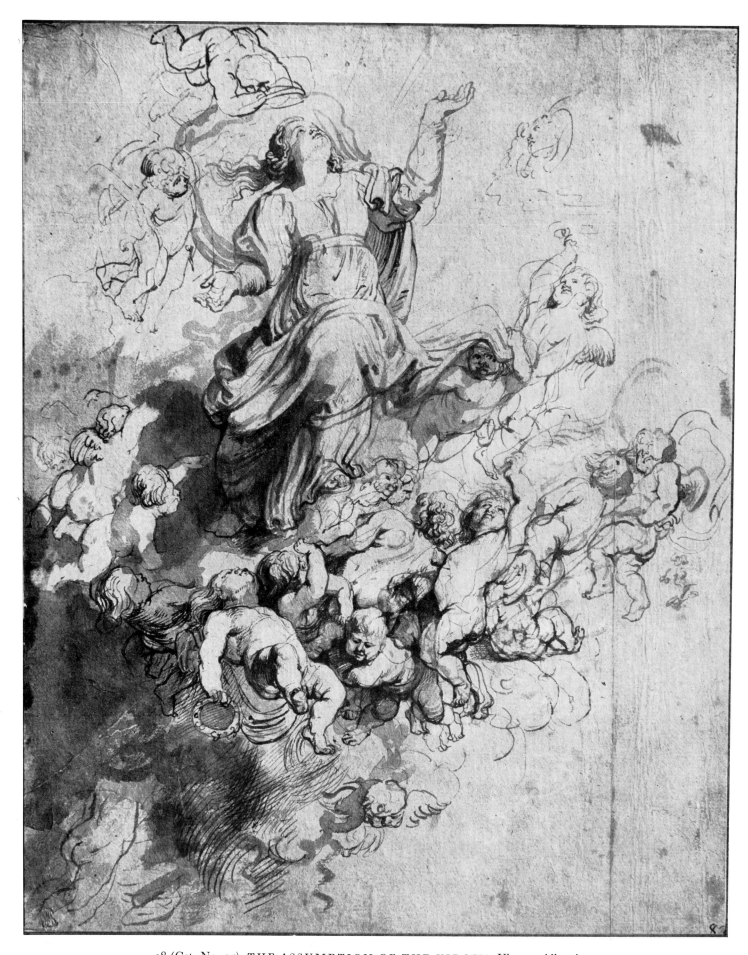

38 (Cat. No. 35) THE ASSUMPTION OF THE VIRGIN. Vienna, Albertina

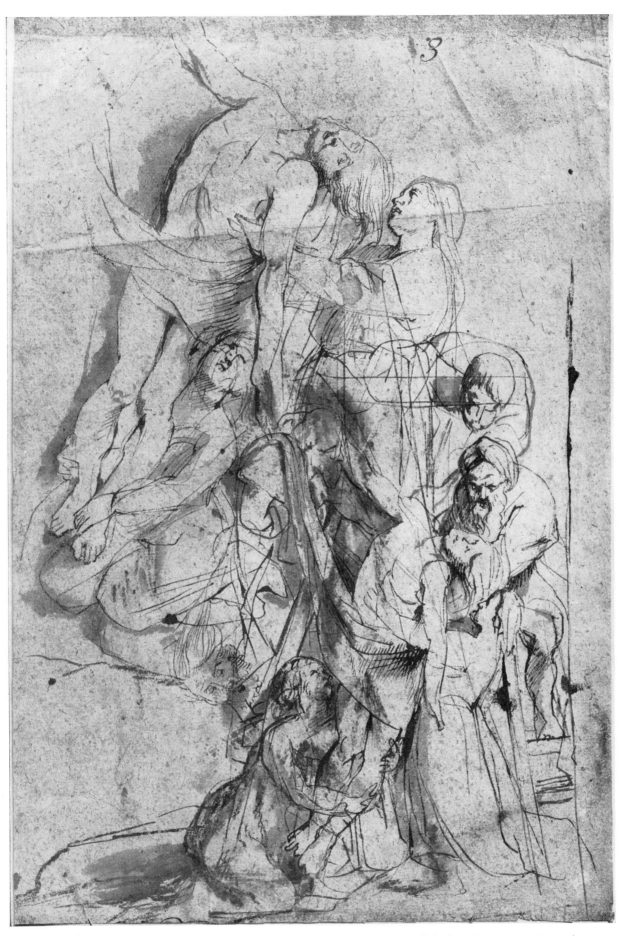

39 (Cat. No. 42) THE DESCENT FROM THE CROSS. Collection of the late Mrs. G. W. Wrangham

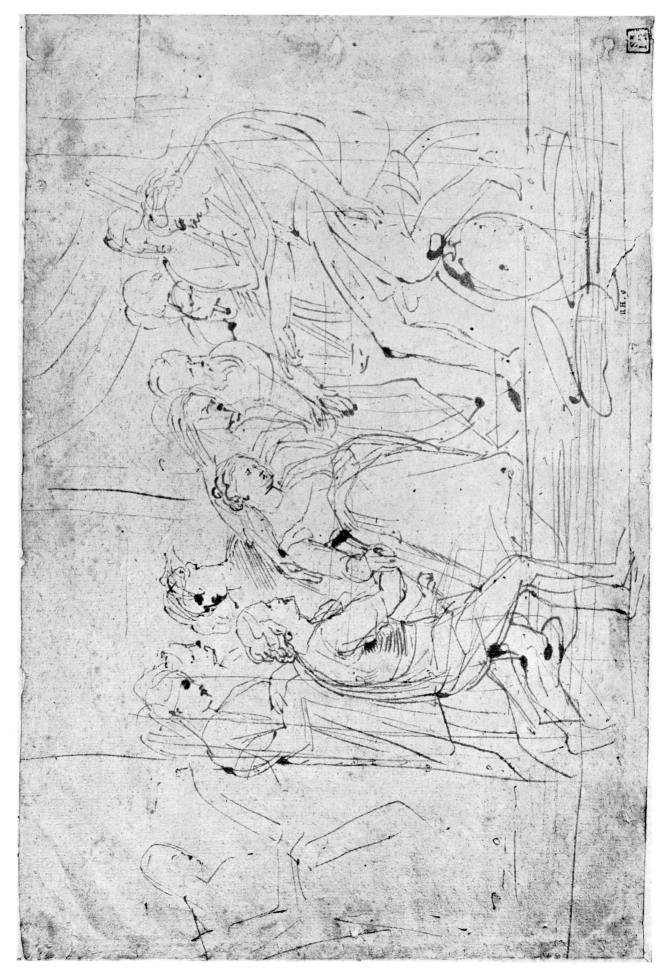

40 (Cat. No. 38) THE CONTINENCE OF SCIPIO. Berlin, Kupferstichkabinett

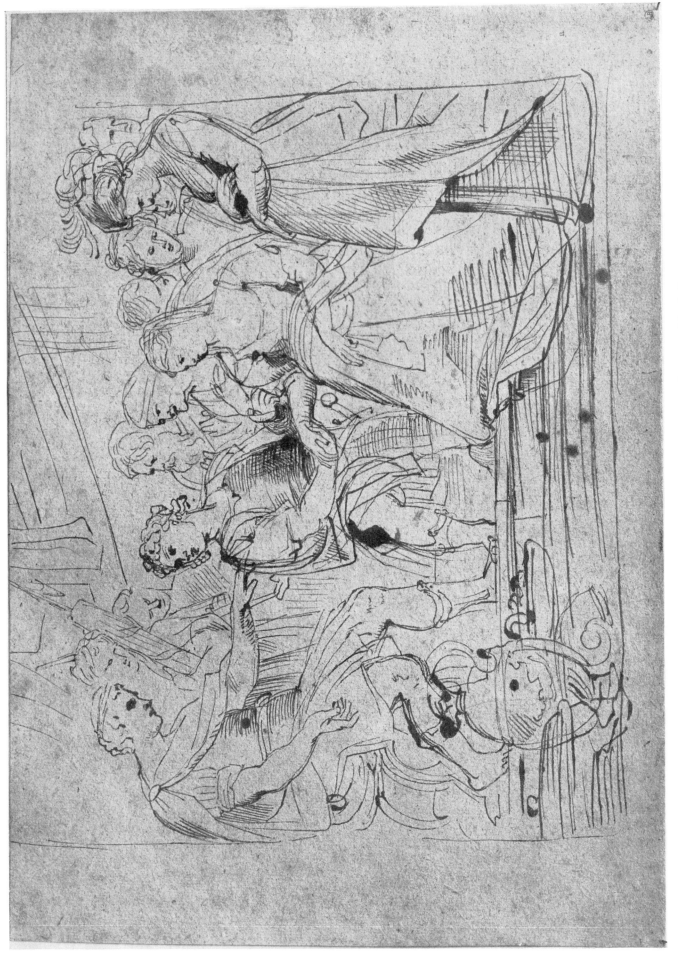

41 (Cat. No. 39) THE CONTINENCE OF SCIPIO. Bayonne, Musée Bonnat

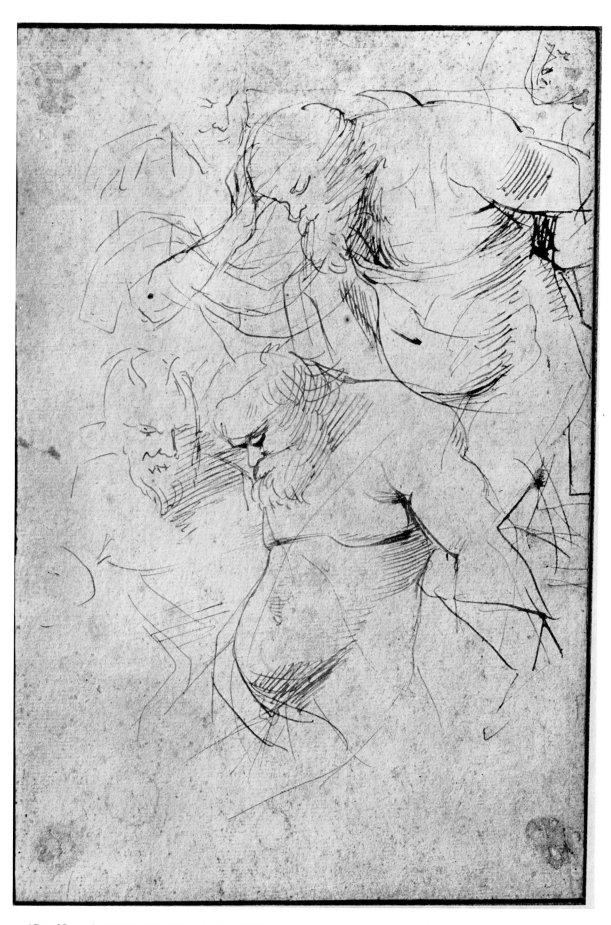

42 (Cat. No. 41) STUDIES FOR A DRUNKEN SILENUS. Collection of the late Mrs. G. W. Wrangham

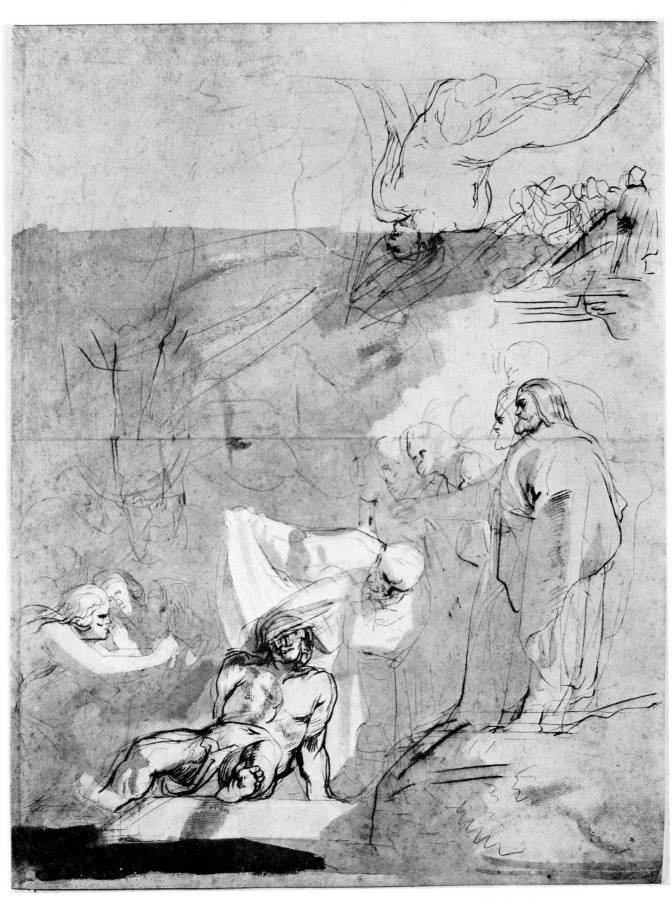

43 (Cat. No. 43) THE RAISING OF LAZARUS. Berlin, Kupferstichkabinett

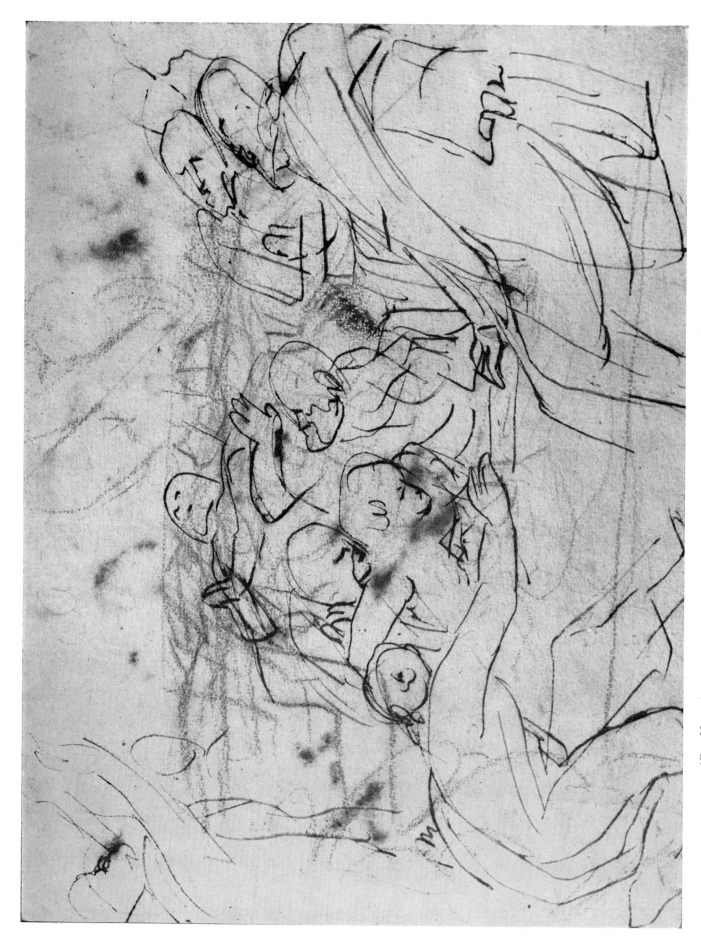

44 (Cat. No. 40) THE APOSTLES SURROUNDING THE VIRGIN'S TOMB. Oslo, Nasjonalgalleriet

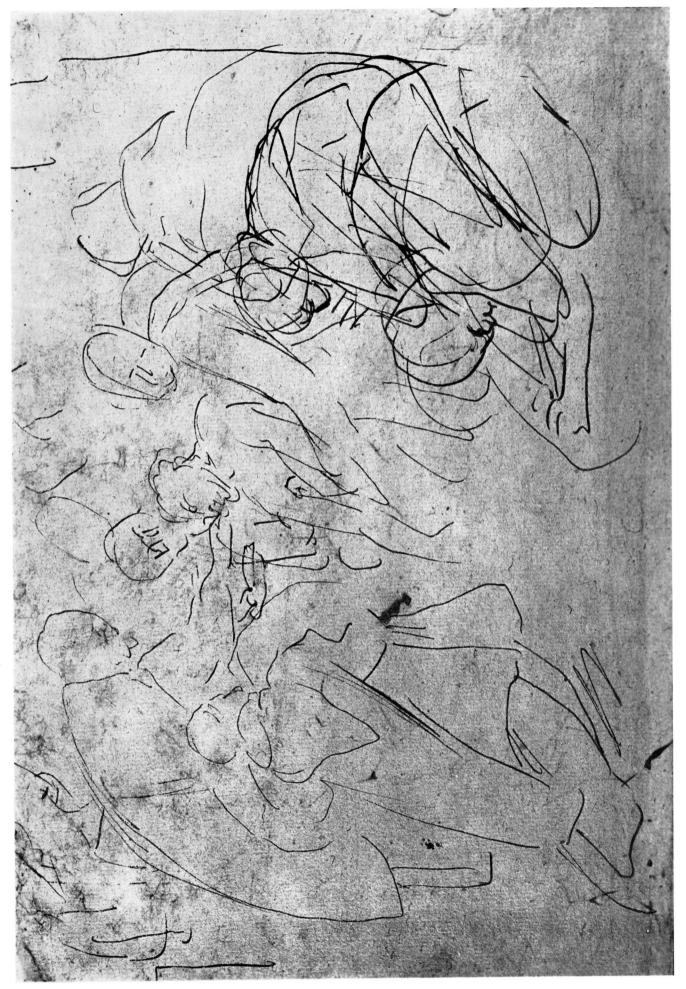

45 (Cat. No. 44) THE LAST COMMUNION OF ST. FRANCIS. Antwerp, Cabinet des Estampes

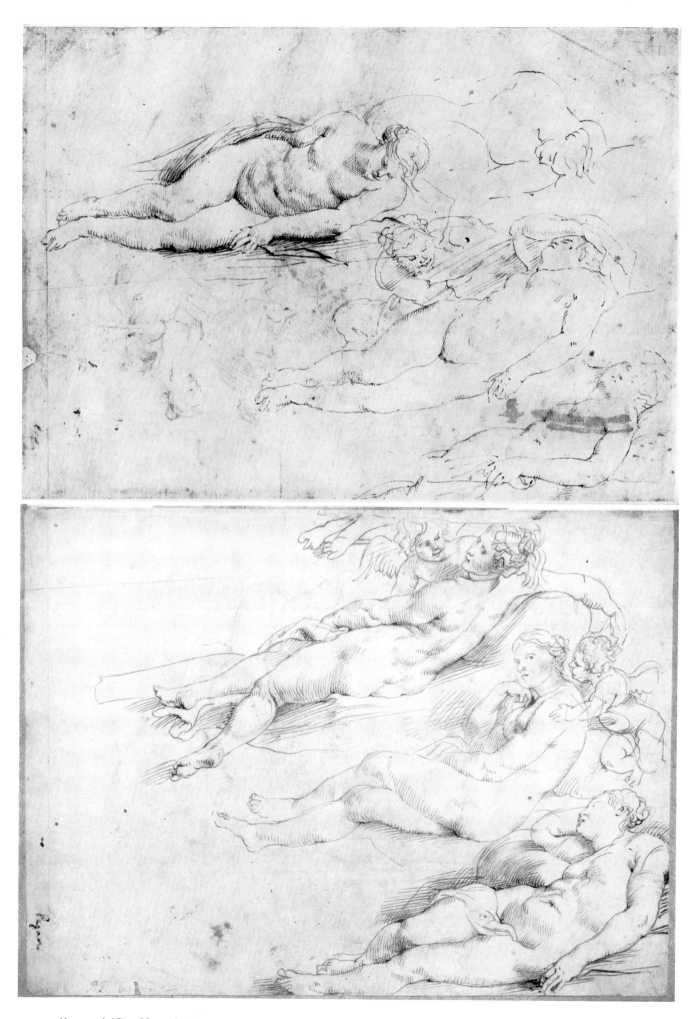

Above: 46 (Cat. No. 45) FEMALE NUDES RECLINING. London, Collection of Count Antoine Seilern
Below: 47 (Cat. No. 46) STUDIES FOR VENUS AND CUPID. New York, Frick Collection

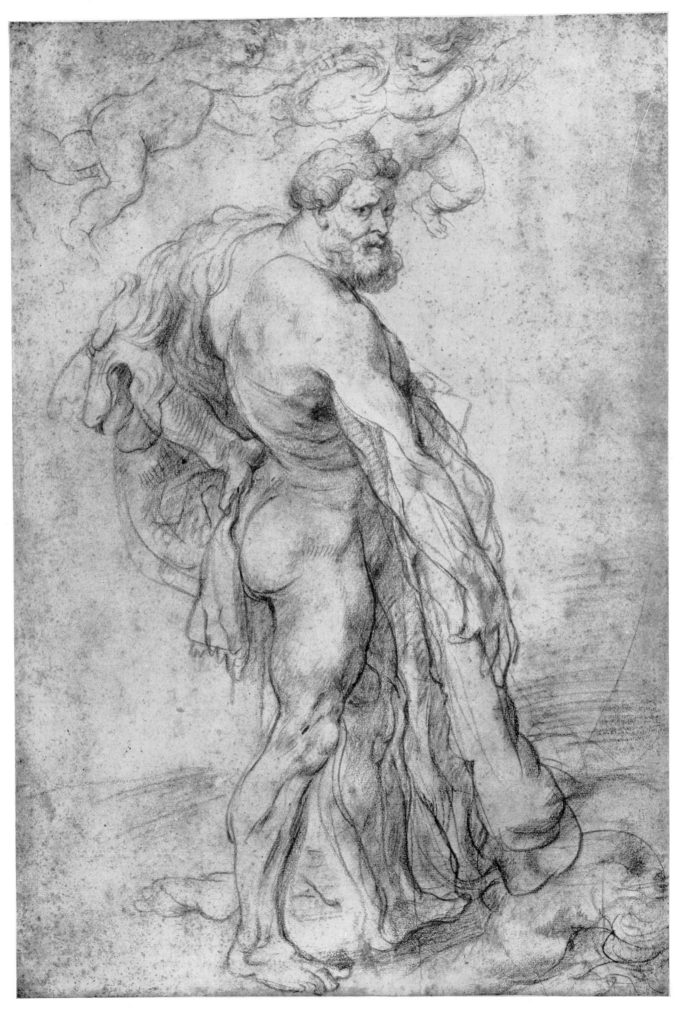

48 (Cat. No. 48) HERCULES STANDING ON DISCORD, CROWNED BY TWO GENII.
London, British Museum

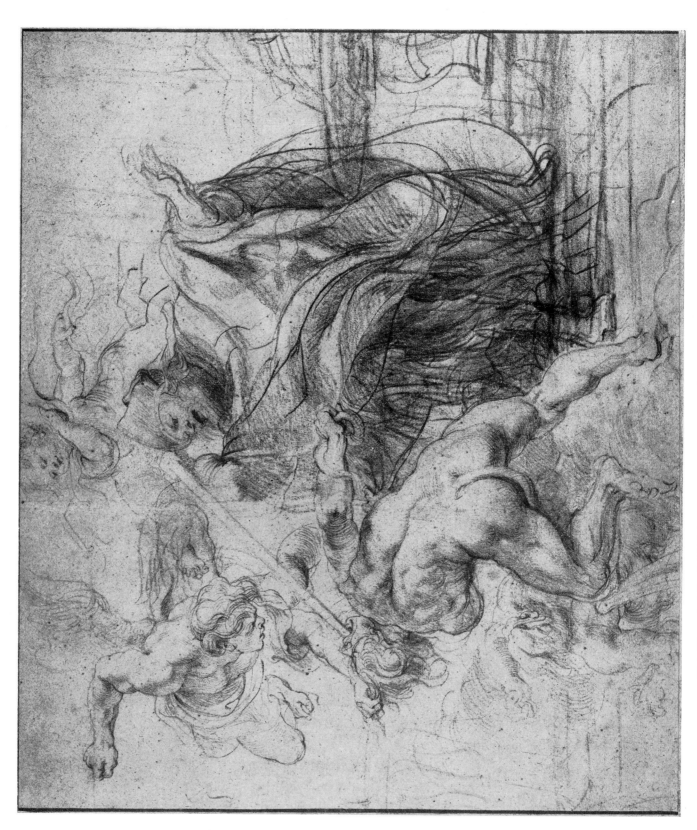

49 (Cat. No. 47) ST. GREGORY NAZIANZENUS. New York, Collection of Clarence L. Hay

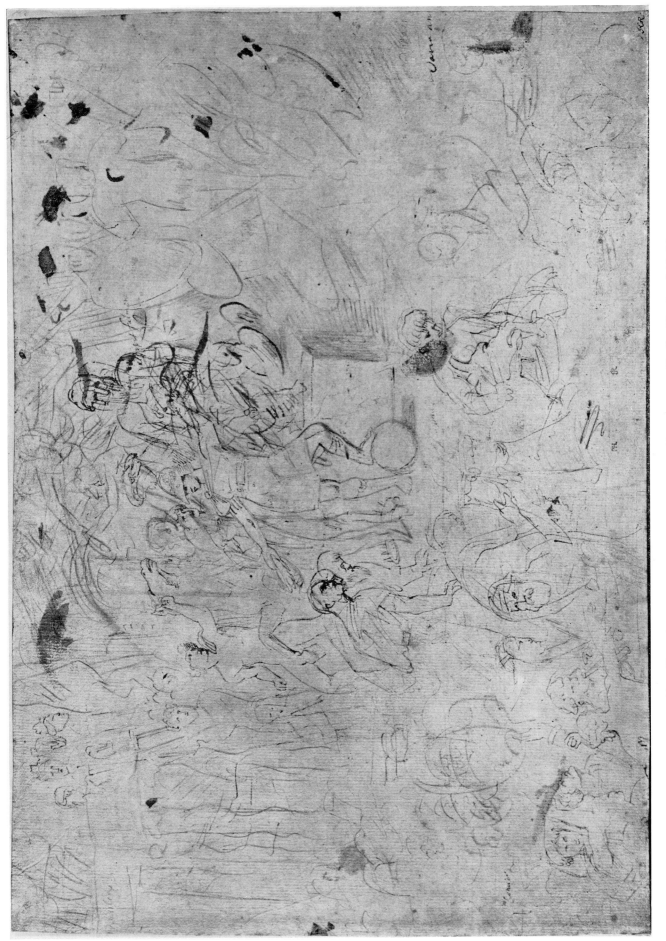

50 (Cat. No. 52) STUDIES FOR A ROMAN TRIUMPH. Berlin, Kupferstichkabinett

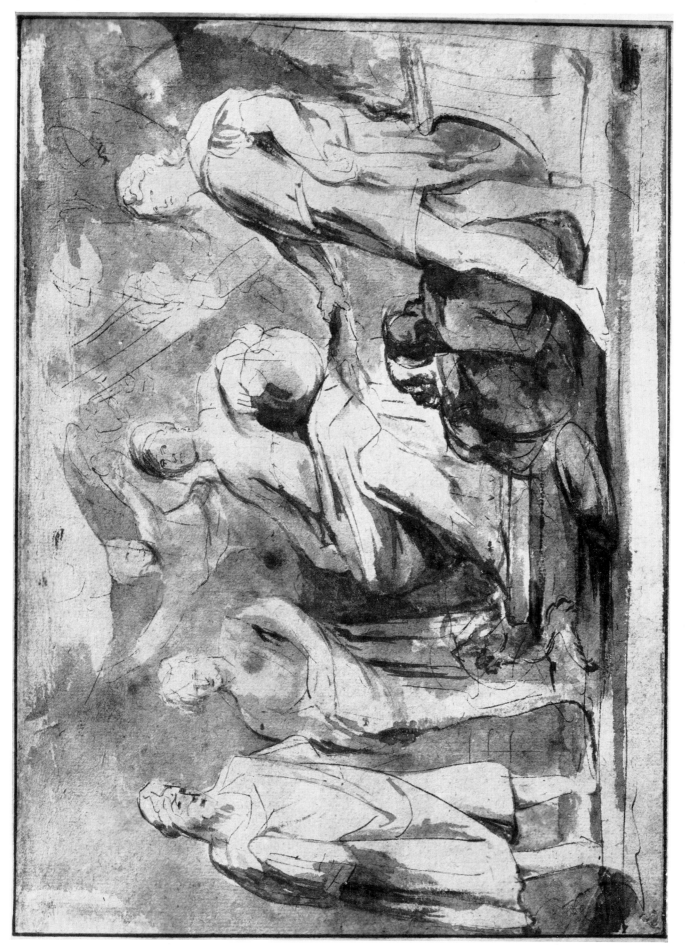

51 (Cat. No. 49) ROMA TRIUMPHANS. Vienna, Albertina

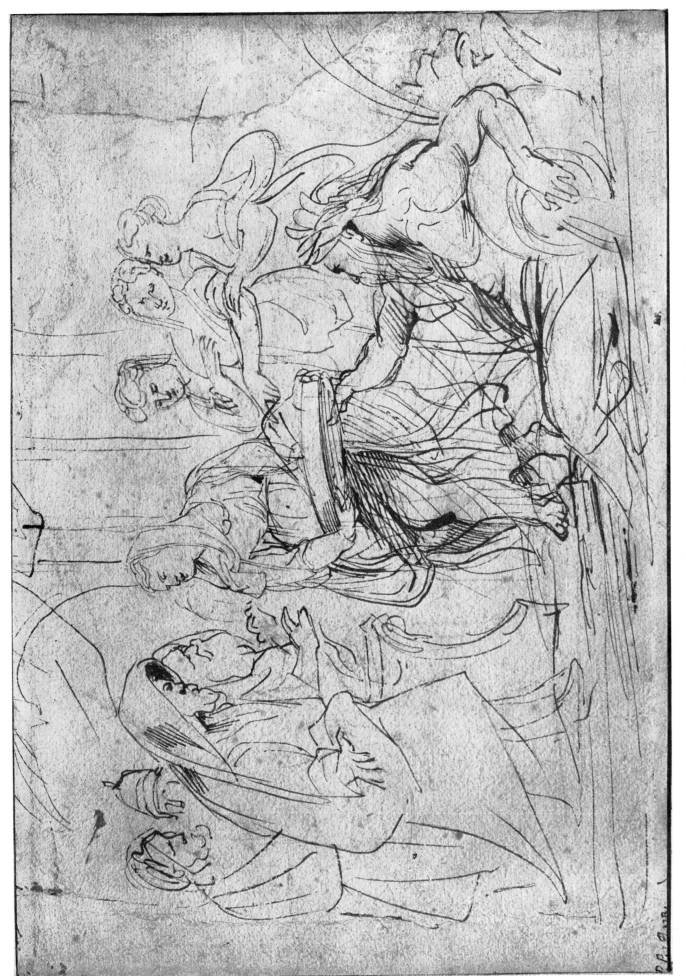

52 (Cat. No. 50 recto) THE VESTAL TUCCIA. Paris, Louvre

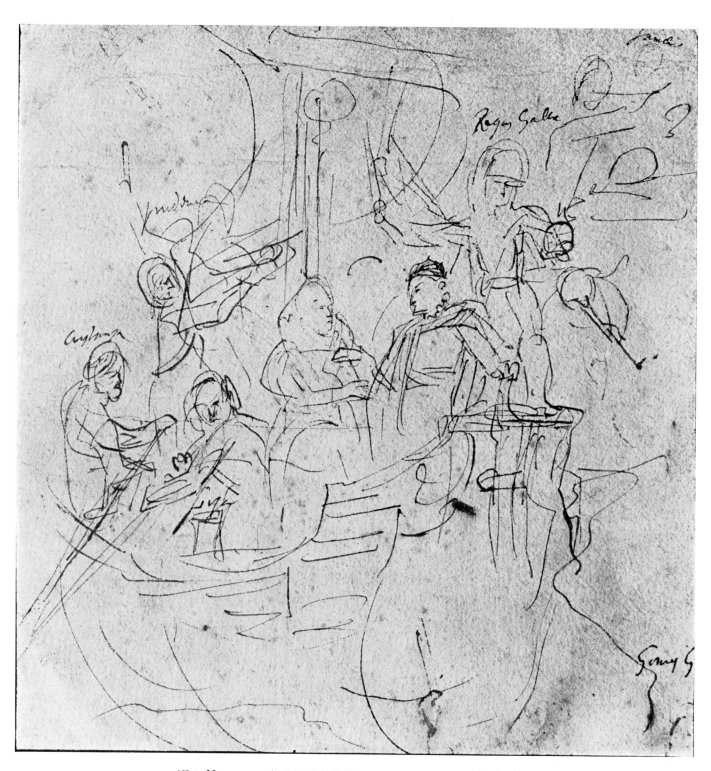

53 (Cat. No. 50 verso) LOUIS XIII COMES OF AGE. Paris, Louvre

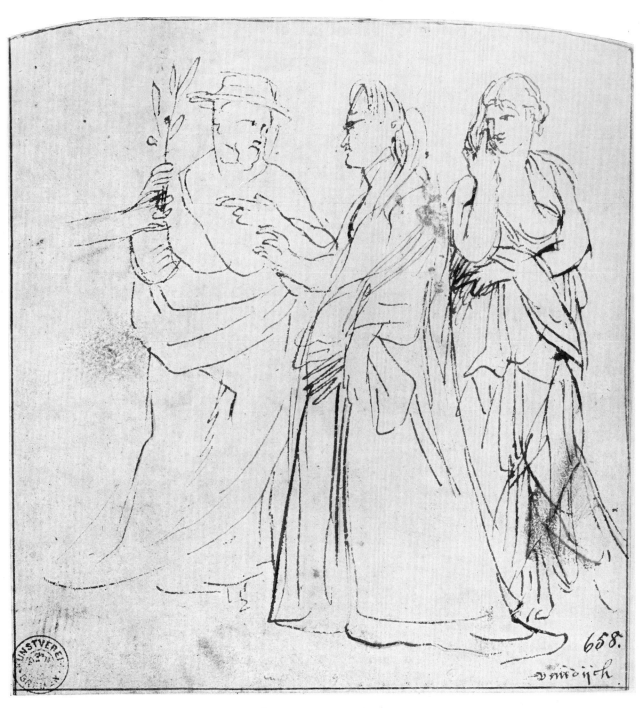

54 (Cat. No. 51 recto) MARIE DE MÉDICIS RECEIVES THE OLIVE BRANCH OF PEACE.
Formerly Bremen, Kunsthalle

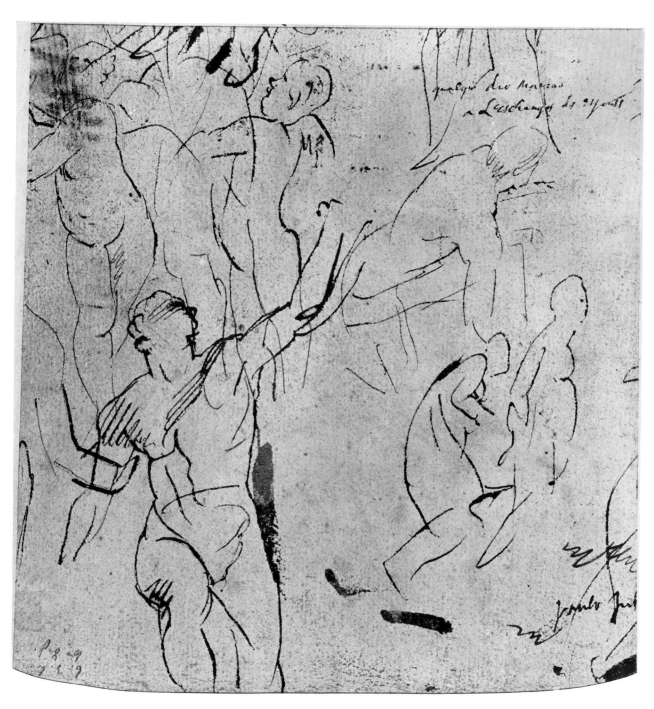

55 (Cat. No. 51 verso) HENRY IV CARRIED TO HEAVEN AND OTHER FIGURES. Reverse of Plate 54.
Formerly Bremen, Kunsthalle

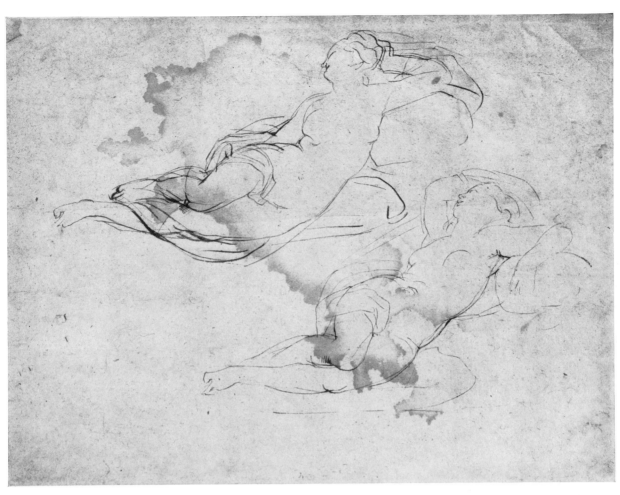

56 (Cat. No. 55 recto) FEMALE NUDES RECLINING. London, Collection of Count Antoine Seilern

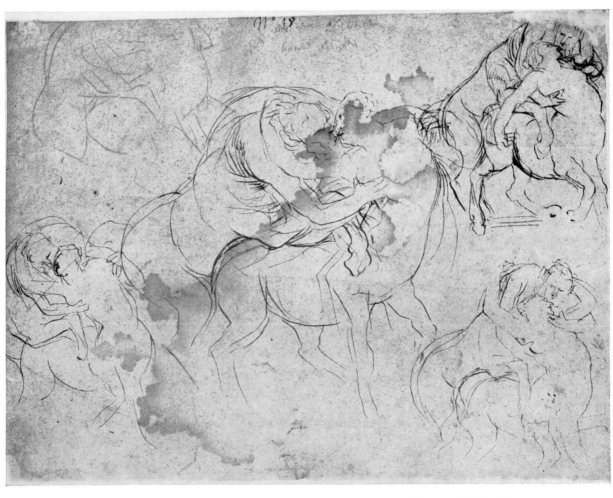

57 (Cat. No. 55 verso) CENTAURS EMBRACING. Reverse of Plate 56

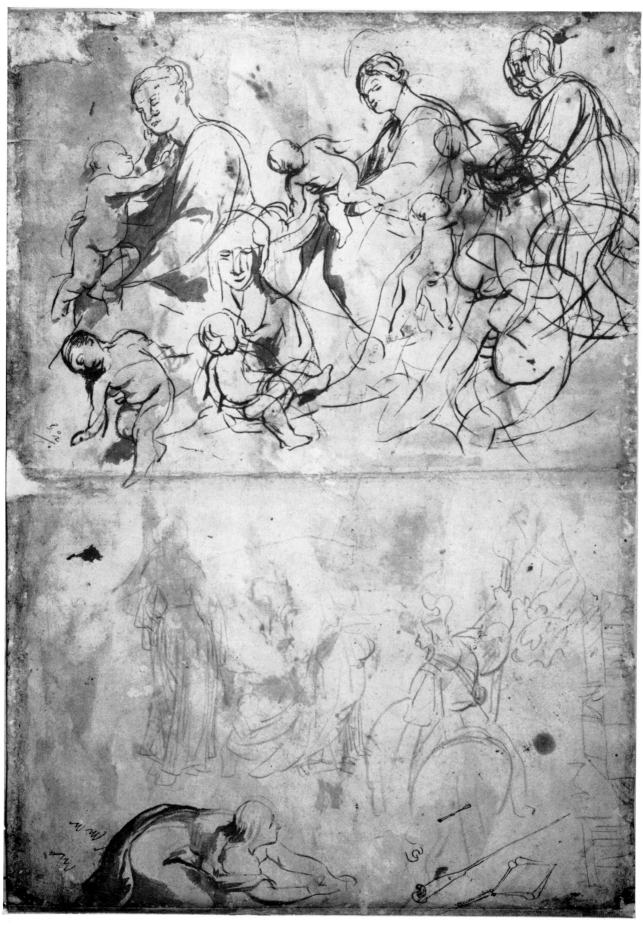

58 (Cat. No. 53 verso) STUDIES FOR THE VIRGIN AND CHILD; AND STUDIES FOR ST. GEORGE
AND THE DRAGON. Reverse of Plate 59

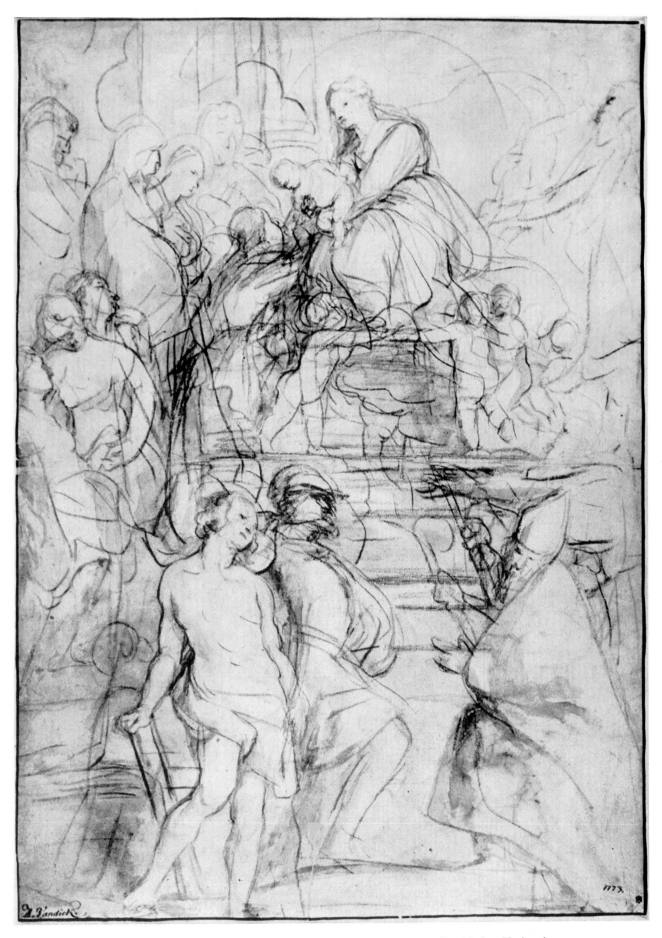

59 (Cat. No. 53 recto) THE VIRGIN ADORED BY SAINTS. Stockholm, Nationalmuseum

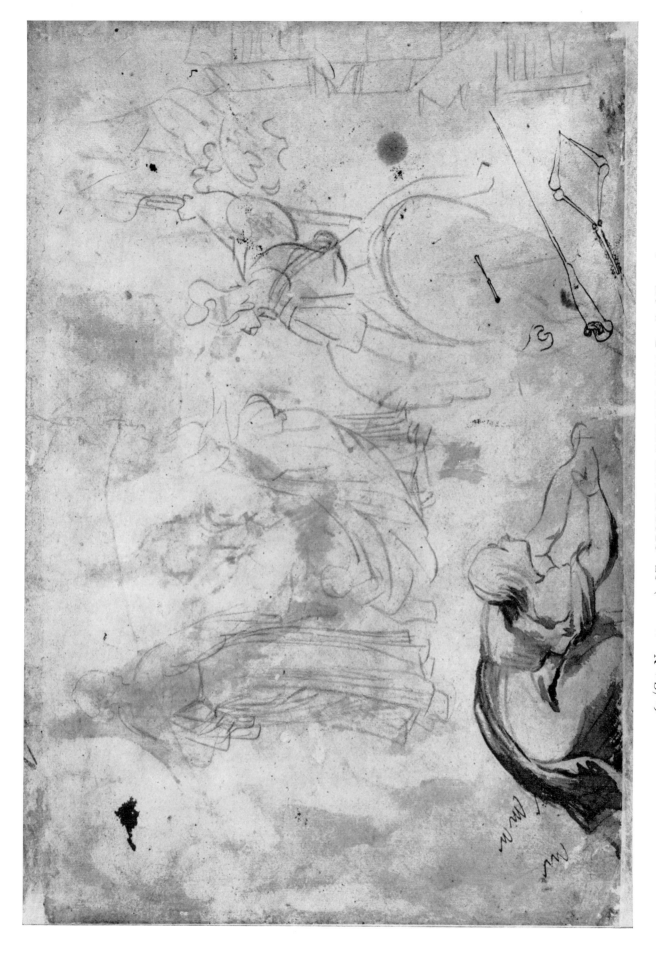

60 (Cat. No. 53 verso) ST. GEORGE AND THE DRAGON. Detail of Plate 58

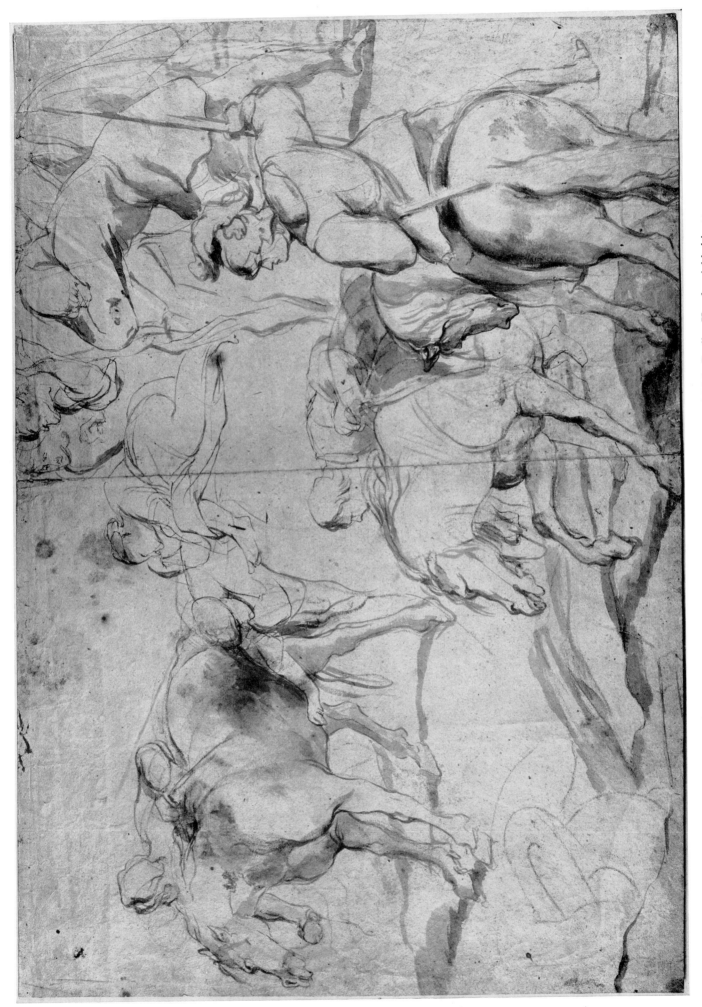

61 (Cat. No. 54) STUDIES FOR ST. GEORGE AND THE PRINCESS. Berlin, Kupferstichkabinett

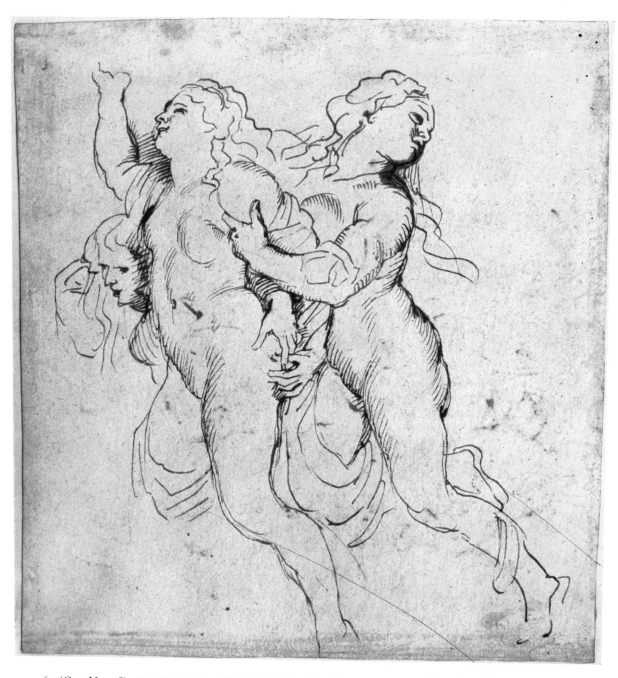

62 (Cat. No. 58) VENUS ANADYOMENE AND TWO NEREIDS. London, British Museum

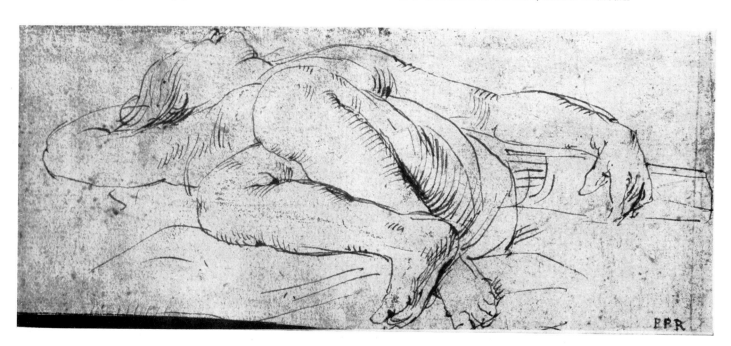

63 (Cat. No. 56) A NYMPH ASLEEP. Rotterdam, Museum Boymans

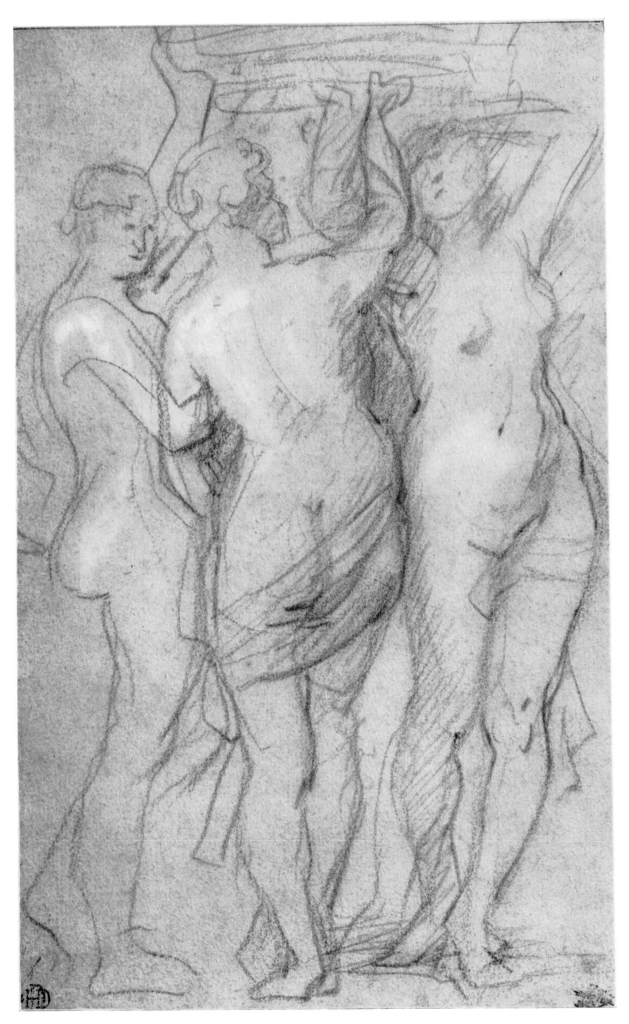

64 (Cat. No. 62) THE THREE GRACES. London, Collection of Count Antoine Seilern

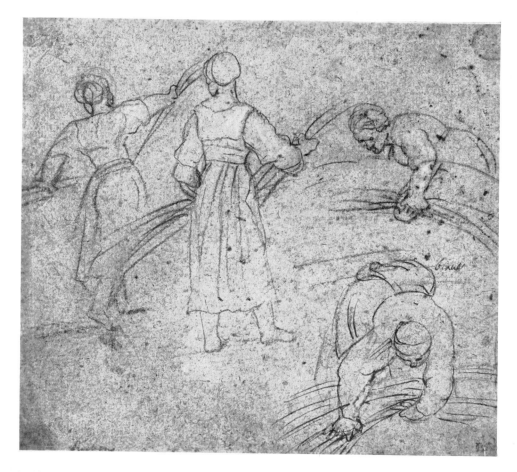

65 (Cat. No. 59, 60) WOMEN HARVESTING. Edinburgh, National Gallery of Scotland

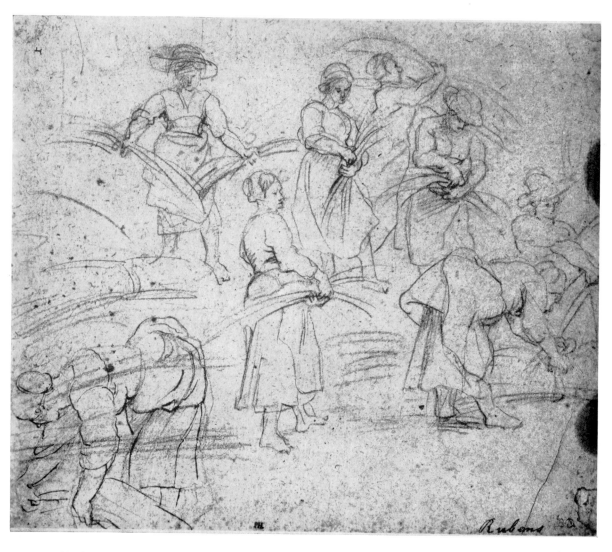

66 (Cat. No. 59, 60) WOMEN HARVESTING. Edinburgh, National Gallery of Scotland

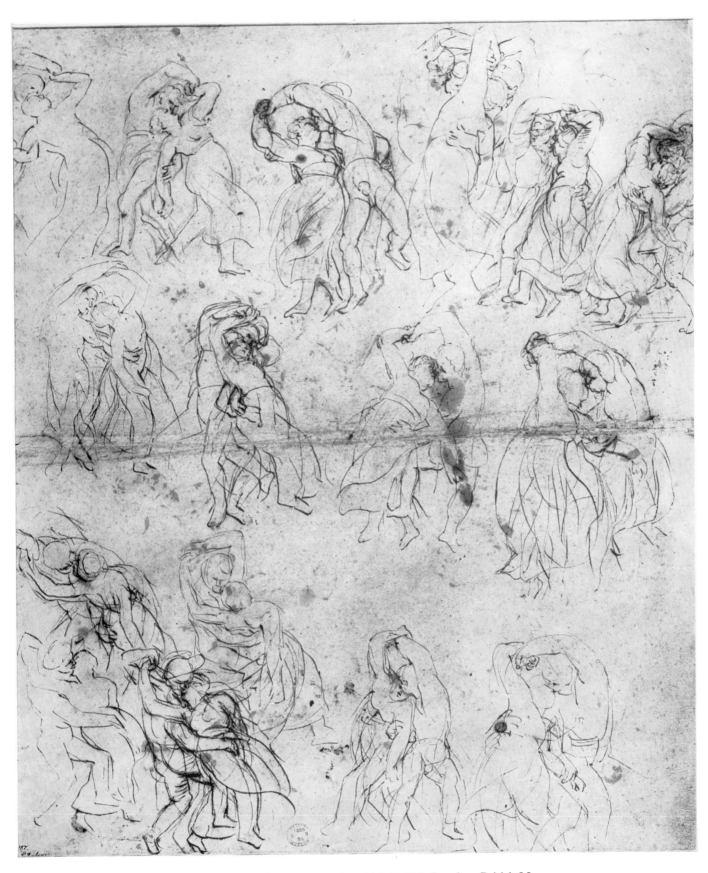

67 (Cat. No. 57 verso) DANCING PEASANTS. London, British Museum

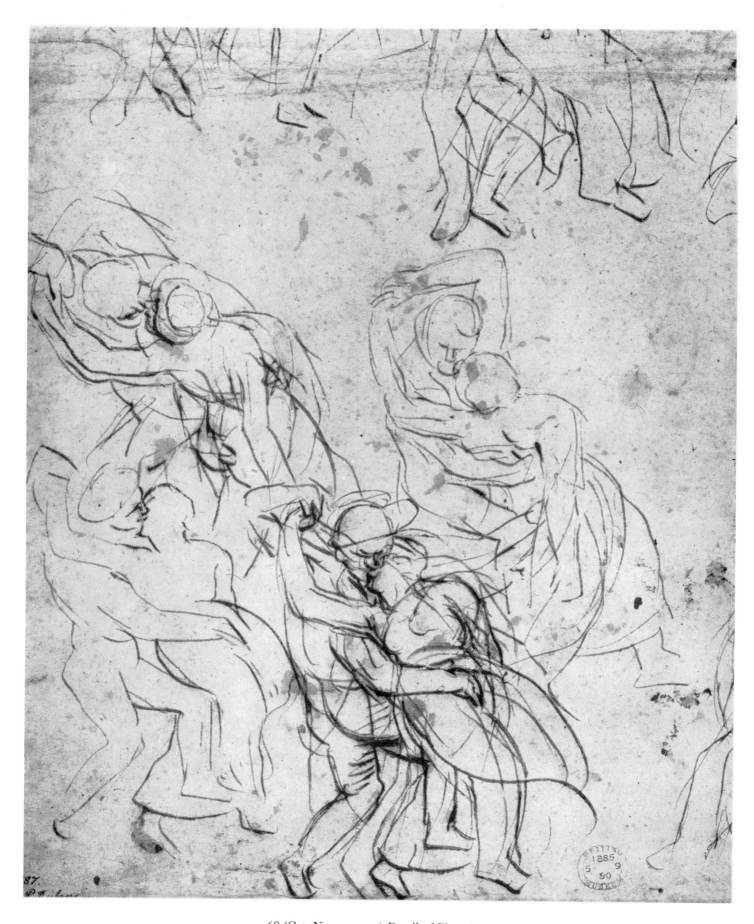

68 (Cat. No. 57 verso) Detail of Plate 67

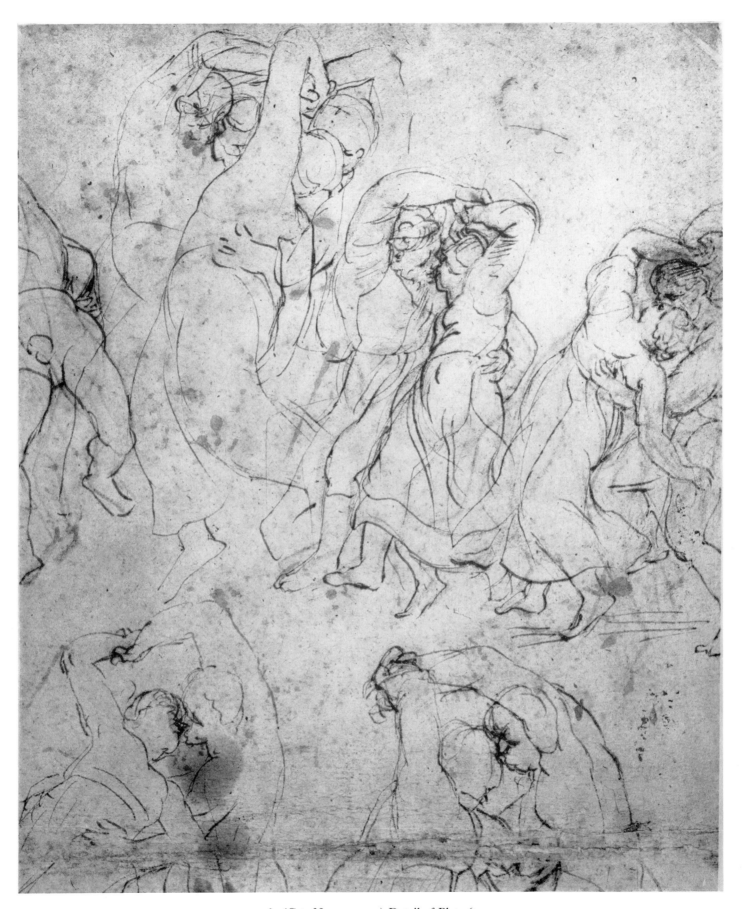

69 (Cat. No. 57 verso) Detail of Plate 67

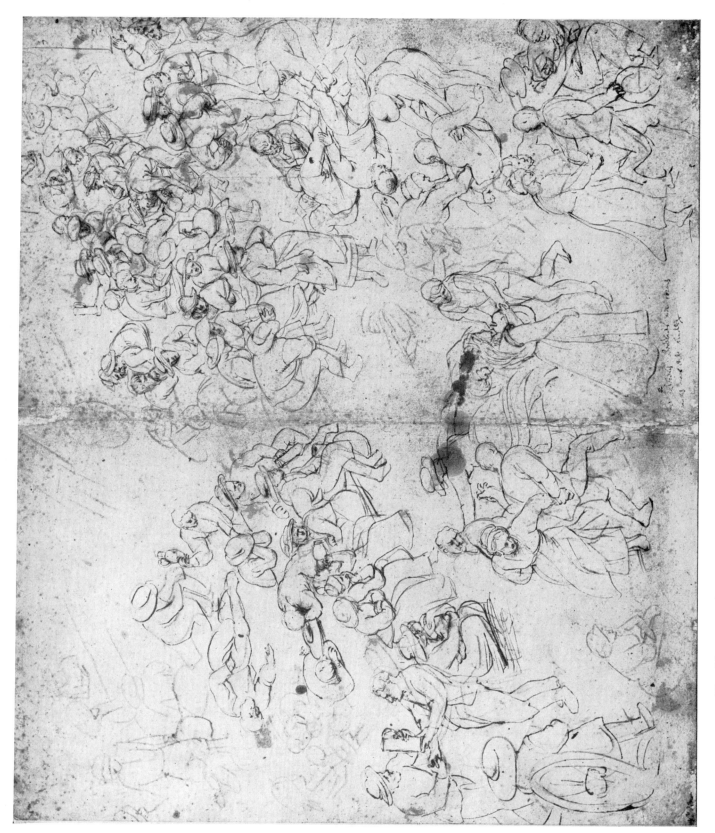

70 (Cat. No. 57 recto) STUDIES FOR A KERMESSE. Reverse of Plate 67. London, British Museum

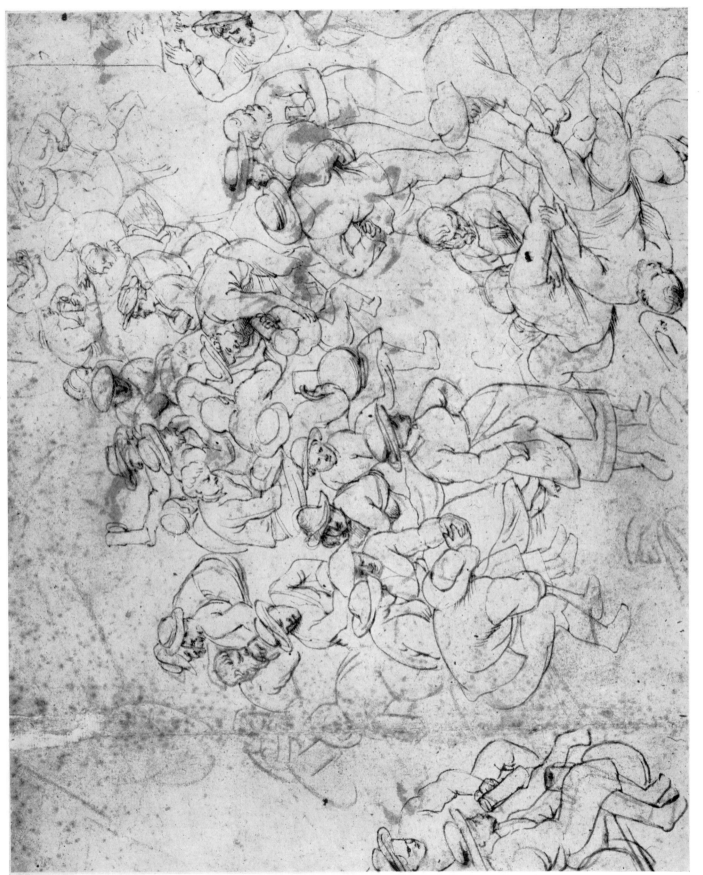

71 (Cat. No. 57 recto) Detail of Plate 70

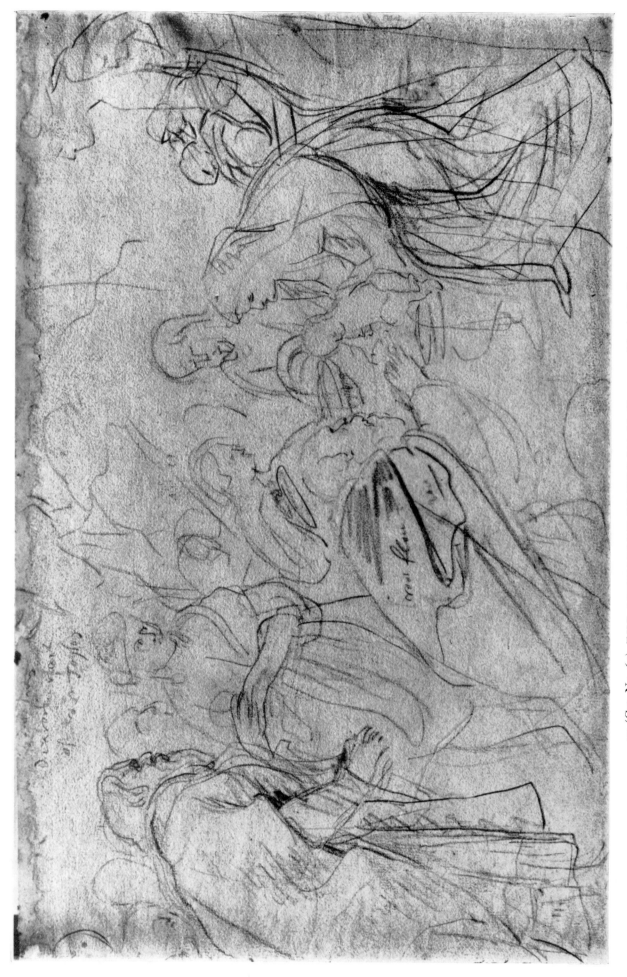

72 (Cat. No. 63) THE ADORATION OF THE MAGI. Besançon, Musée des Beaux-Arts

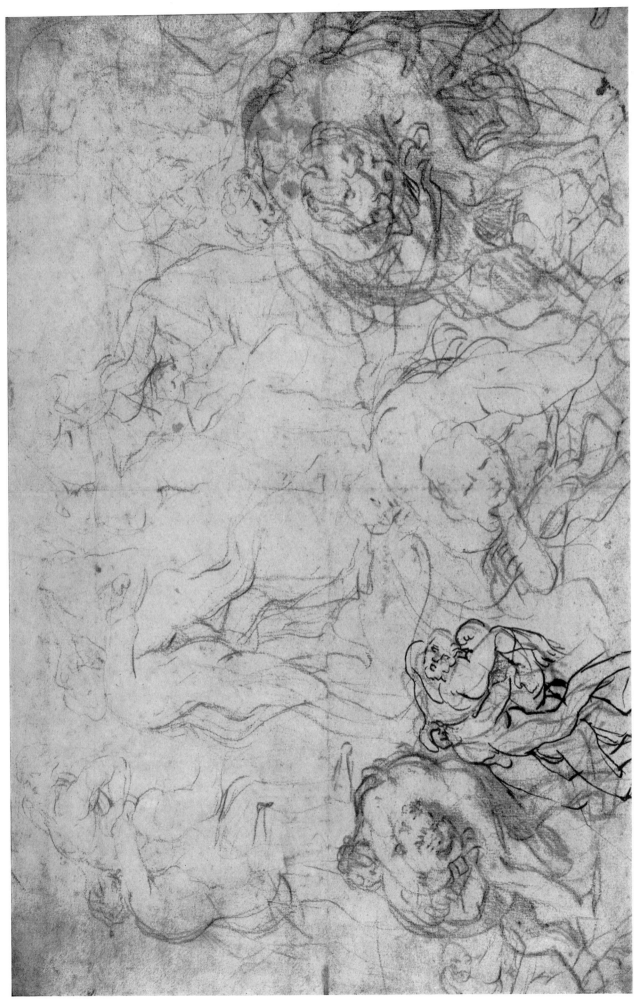

73 (Cat. No. 61) STUDIES FOR THE EXPLOITS OF HERCULES. London, British Museum

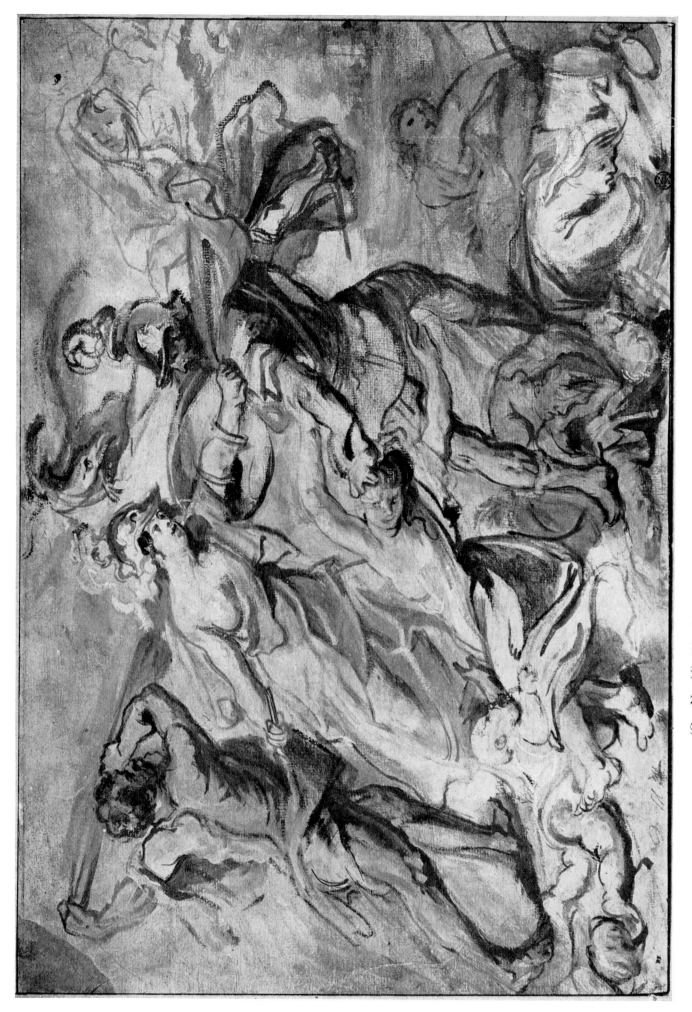

74 (Cat. No. 66) HERCULES AND MINERVA FIGHTING MARS. Paris, Louvre

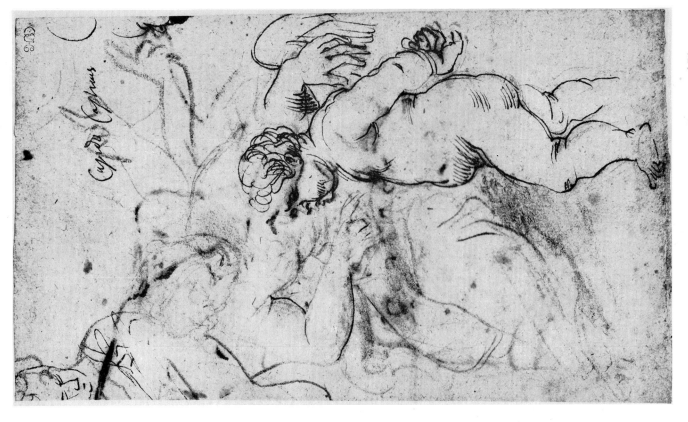

76 (Cat. No. 65 recto) CUPID CAPTURED. Reverse of Plate 75

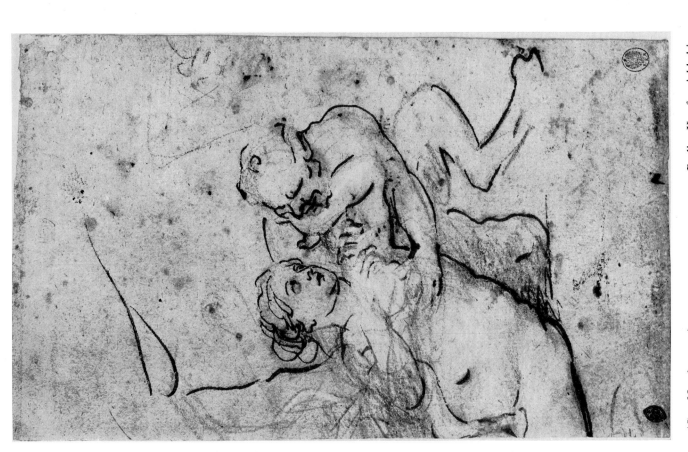

75 (Cat. No. 65 verso) NYMPH AND SATYR. Berlin, Kupferstichkabinett

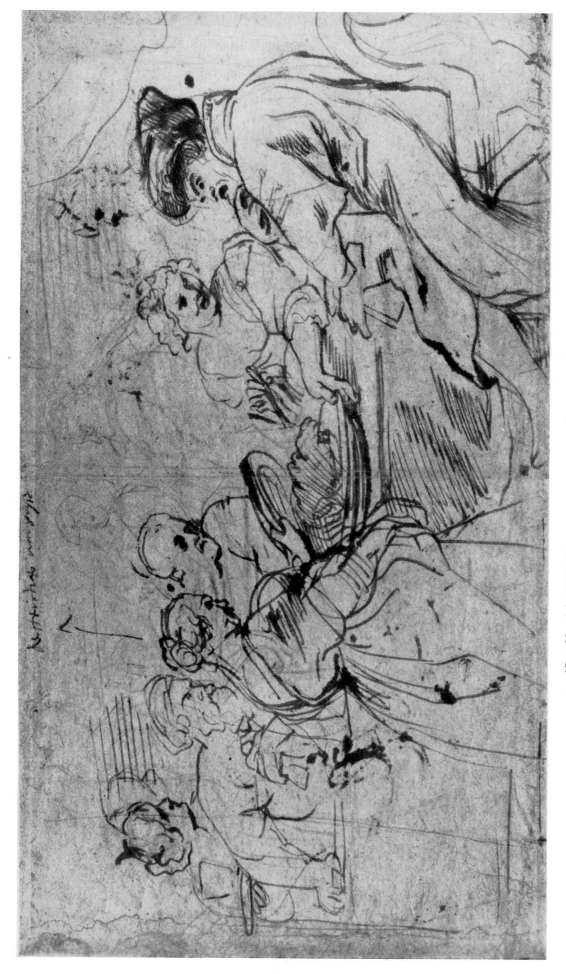

77 (Cat. No. 67) THE FEAST OF HEROD. Cleveland, Museum of Art

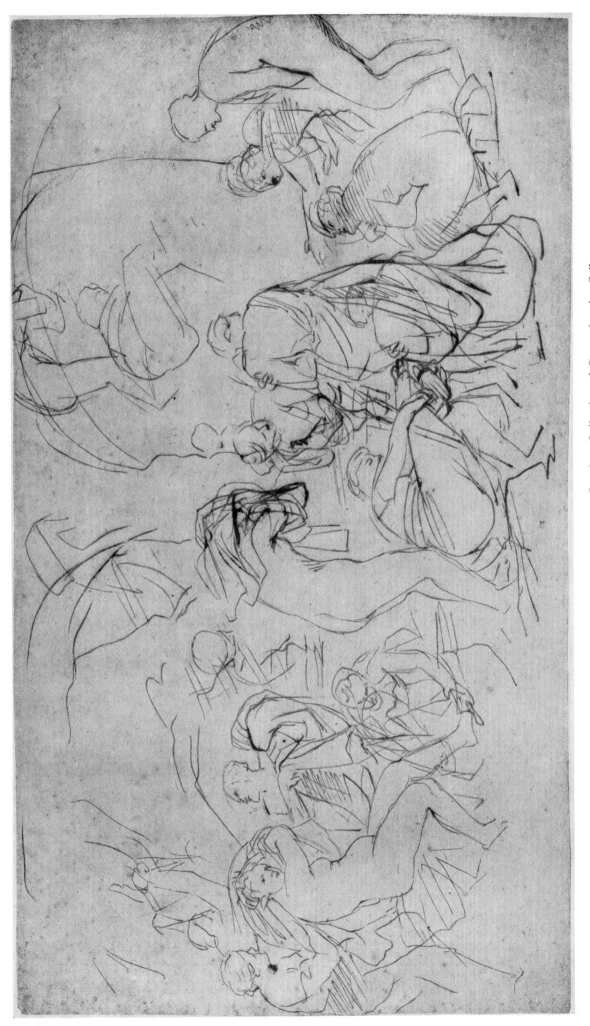

78 (Cat. No. 64) DIANA AND HER NYMPHS. London, Collection of Count Antoine Seilern

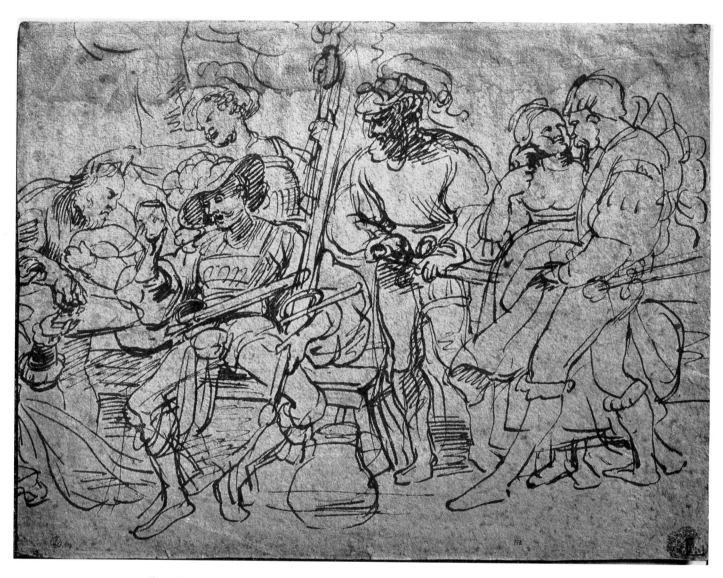

79 (Cat. No. 68) LANDSQUENETS CAROUSING. Paris, Collection of Frits Lugt

II
STUDIES FROM MODELS
AND PORTRAITS

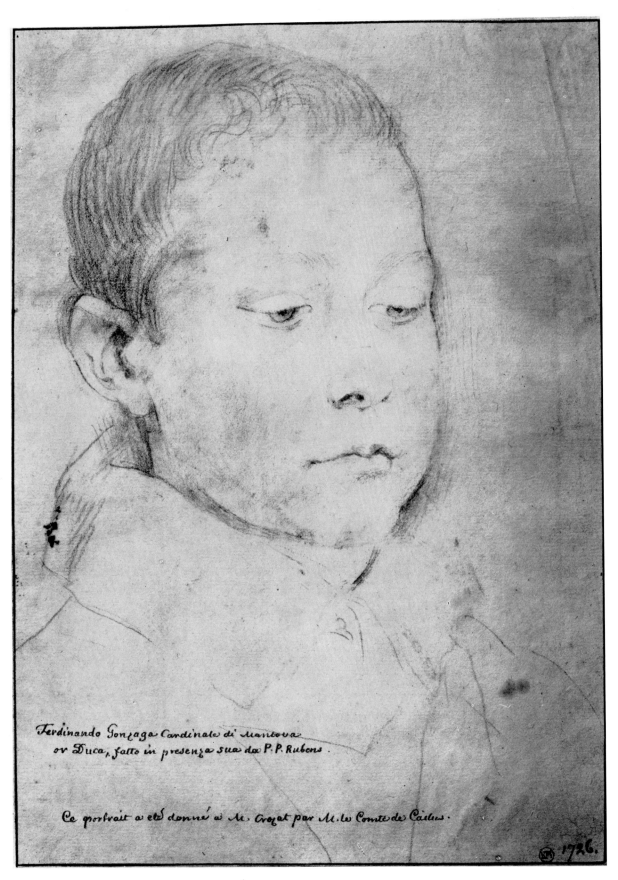

Ferdinando Gonzaga Cardinale di Mantova
ov Duca, fatto in presenza sua da P. P. Rubens.

Ce portrait a été donné a M. Crozat par M. le Comte de Caylus.

1726.

80 (Cat. No. 69) PORTRAIT OF FERDINANDO I GONZAGA, PRINCE OF MANTUA.
Stockholm, Nationalmuseum

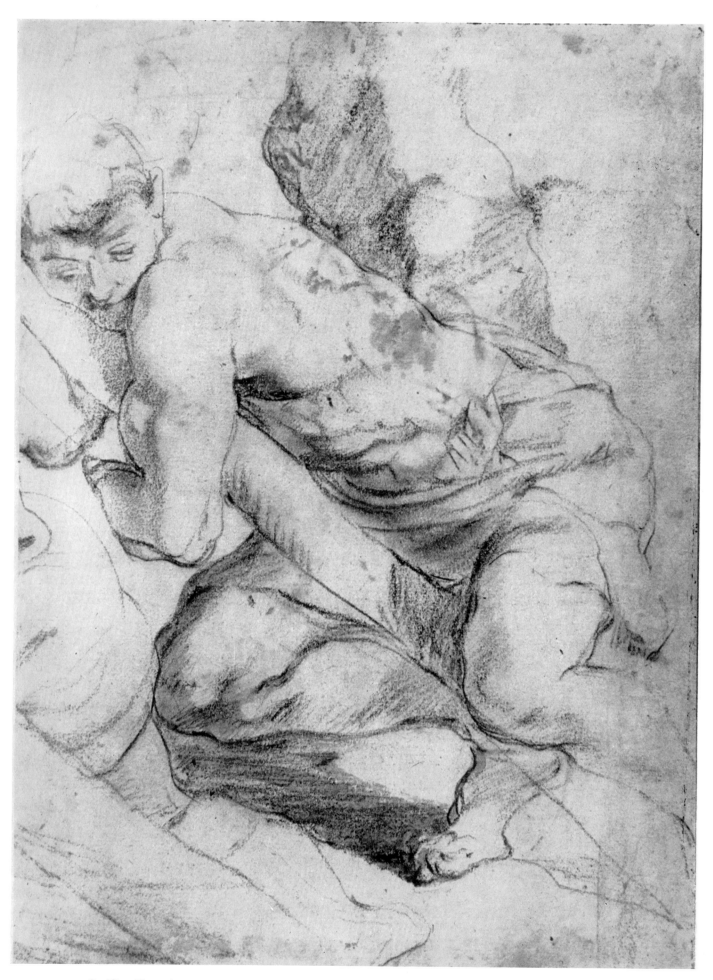

81 (Cat. No. 70) MAN HOLDING THE SHAFT OF THE CROSS. Bayonne, Musée Bonnat

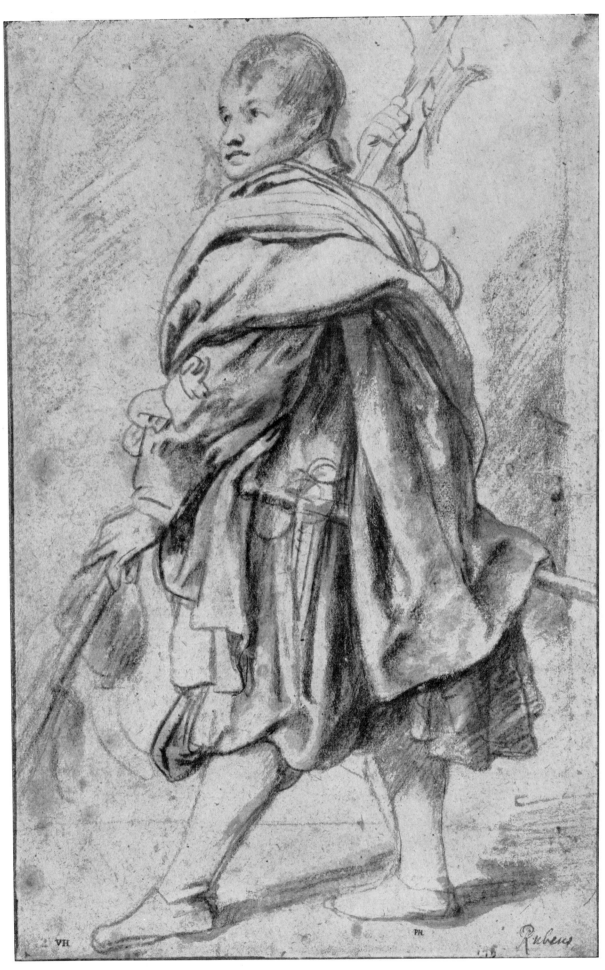

82 (Cat. No. 72) YOUNG SOLDIER WITH HALBERD. London, Collection of Michael Jaffé

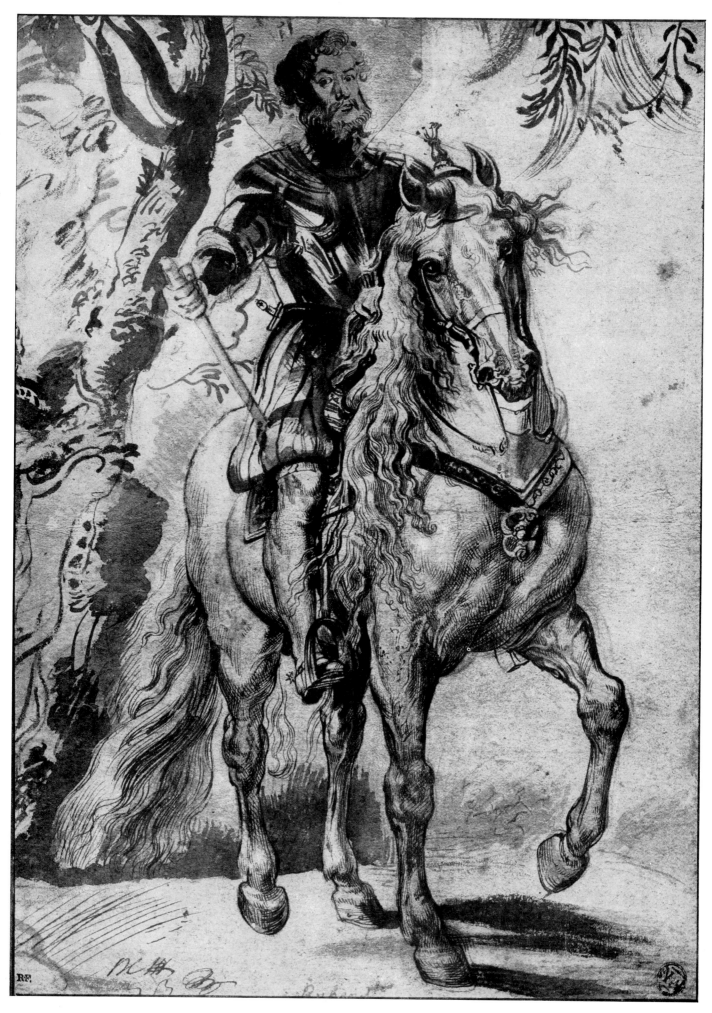

83 (Cat. No. 71) GENTLEMAN IN ARMOUR ON HORSEBACK. Paris, Louvre

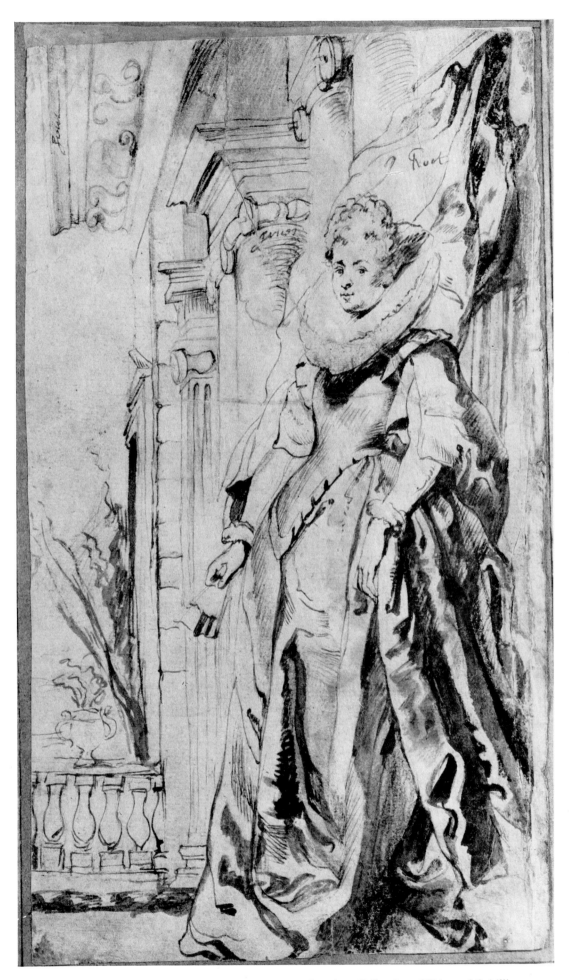

84 (Cat. No. 73) PORTRAIT OF A LADY. London, Collection of Edmund Schilling

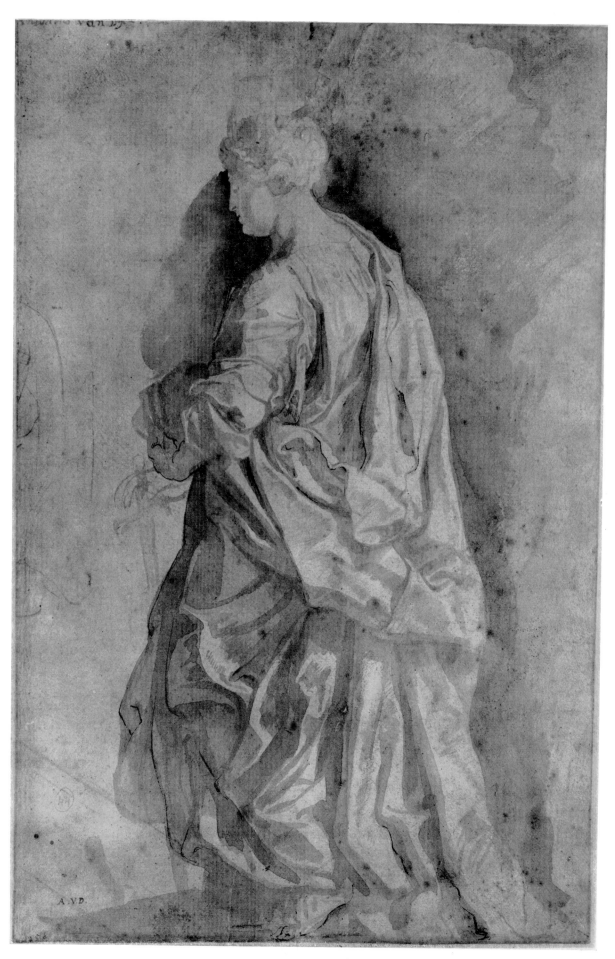

85 (Cat. No. 74) ST. CATHERINE. London, Collection of Ludwig Burchard

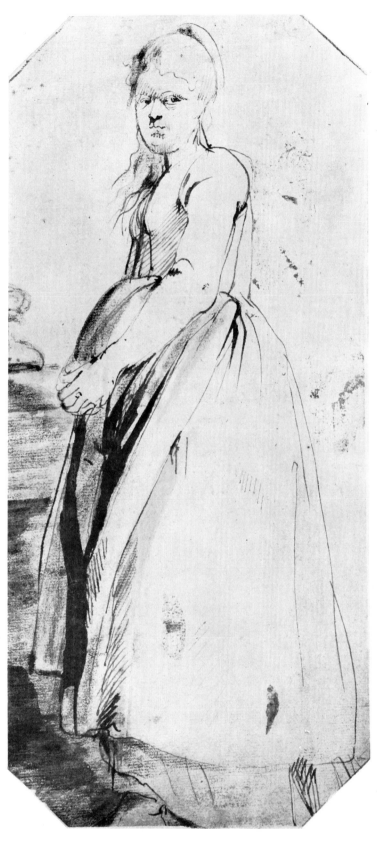

86 (Cat. No. 78) A FARM GIRL WITH FOLDED HANDS. Rotterdam, Museum Boymans

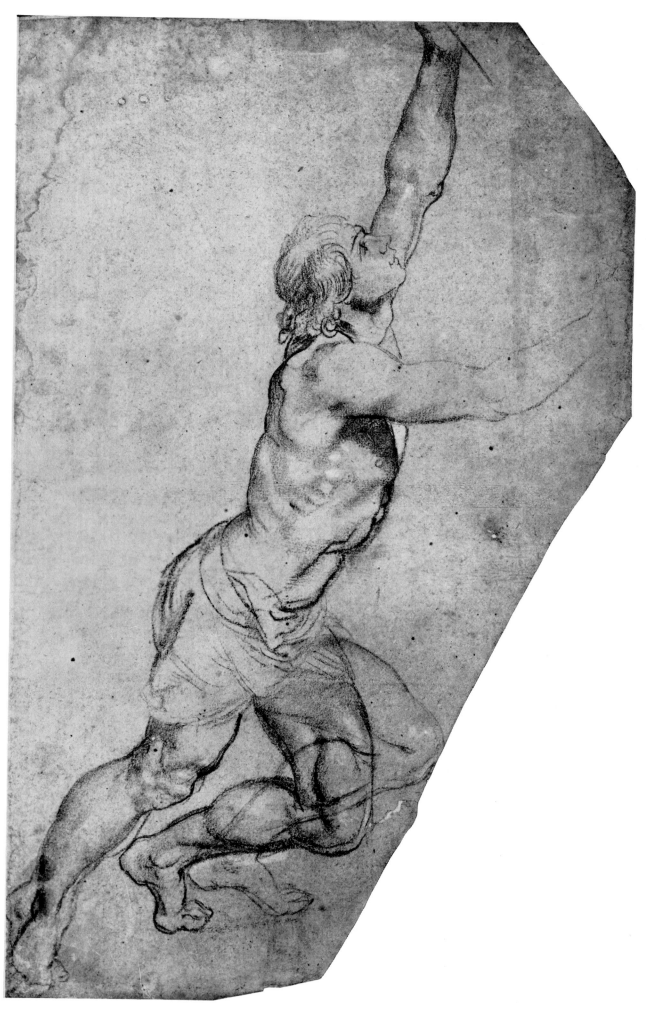

87 (Cat. No. 76) NUDE MAN WITH RAISED ARMS.
The Hague, Collection of H.R.H. Princess Wilhelmina of the Netherlands

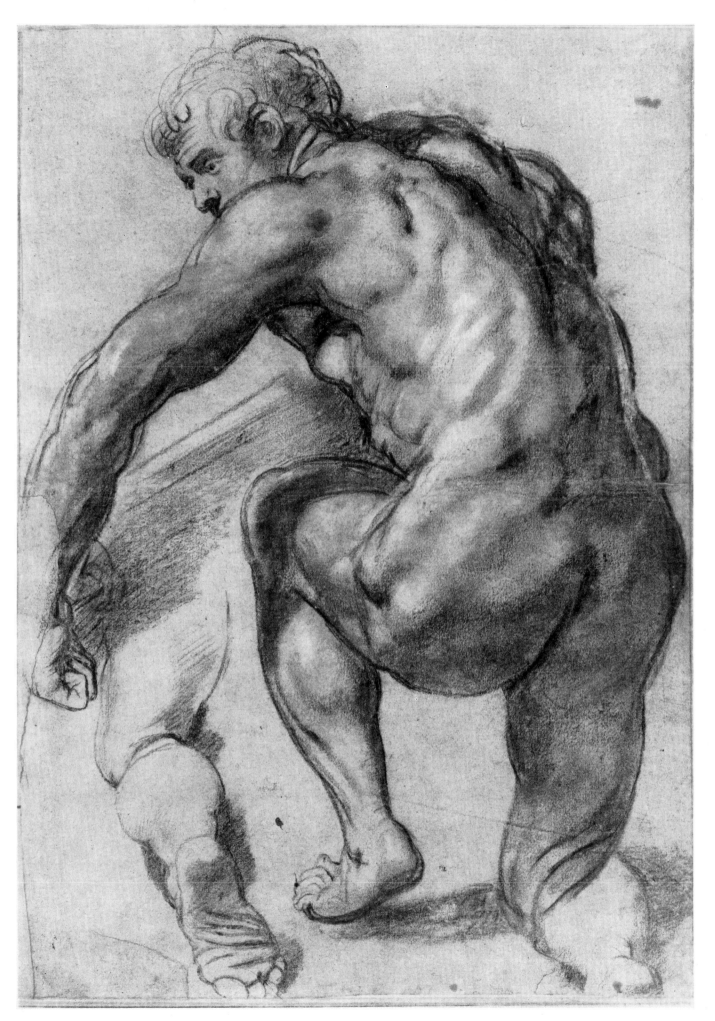

88 (Cat. No. 75) NUDE MAN, KNEELING. Rotterdam, Museum Boymans

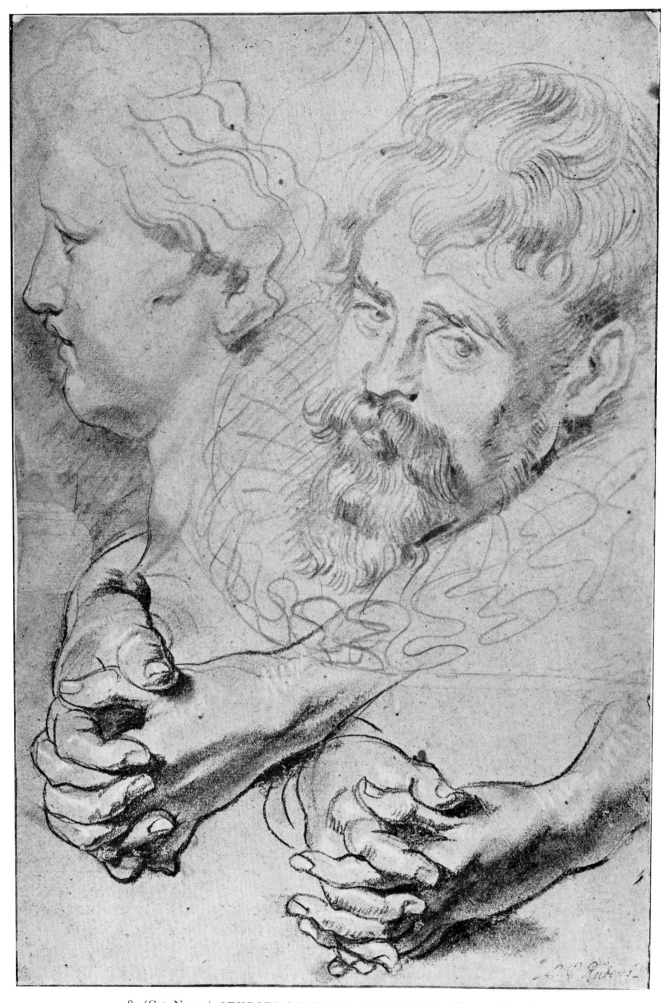

89 (Cat. No. 77) STUDIES OF HEADS AND HANDS. Vienna, Albertina

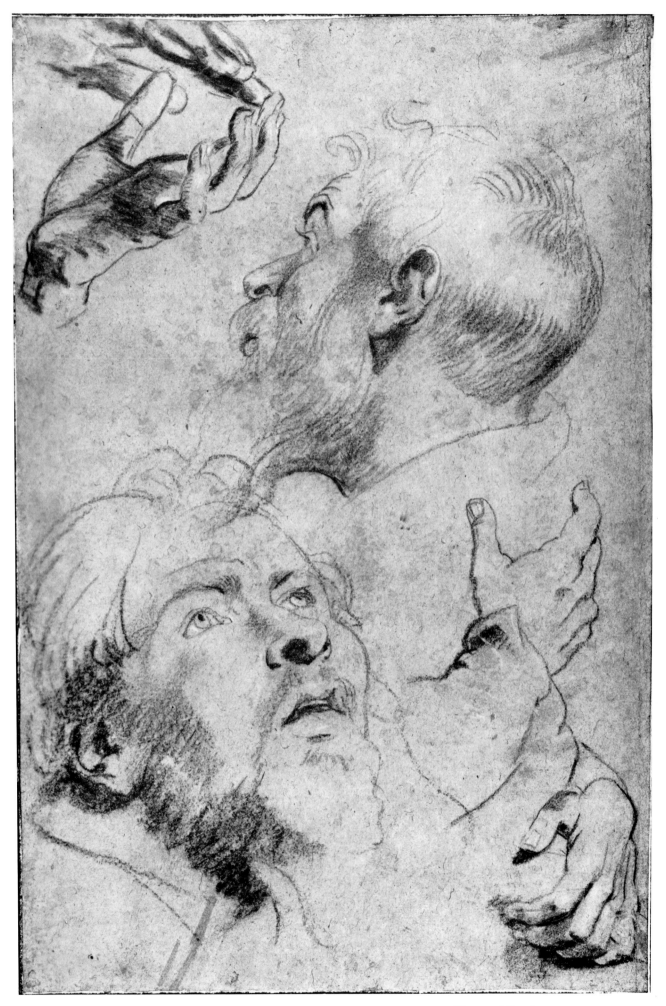

90 (Cat. No. 81) STUDIES OF HEADS AND HANDS. Vienna, Albertina

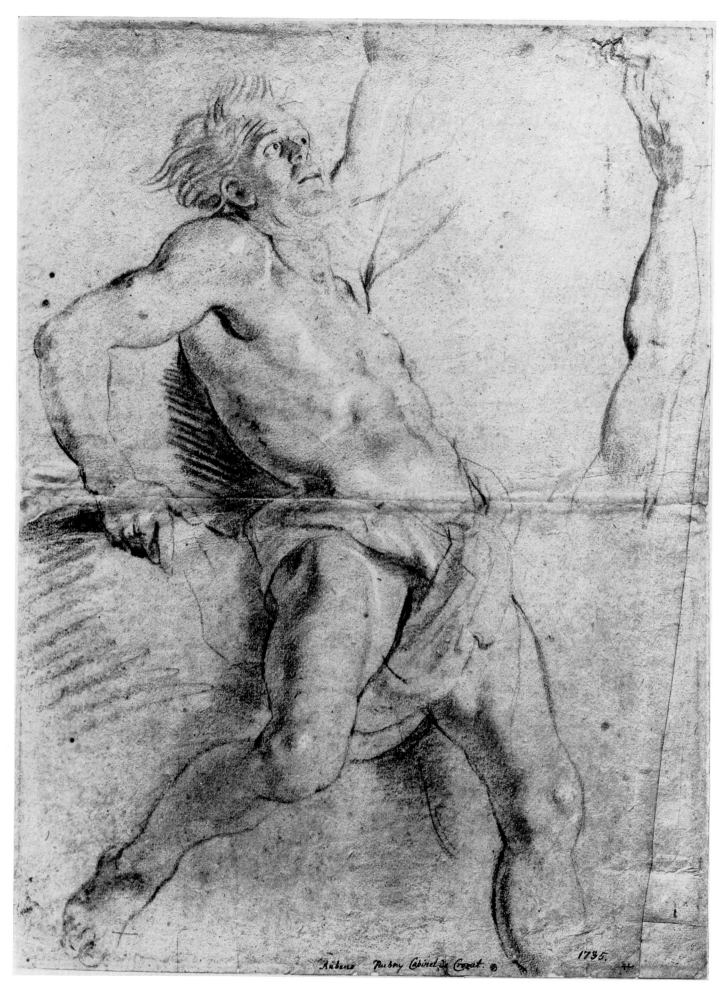

91 (Cat. No. 80) STUDY FOR JOB. Stockholm, Nationalmuseum

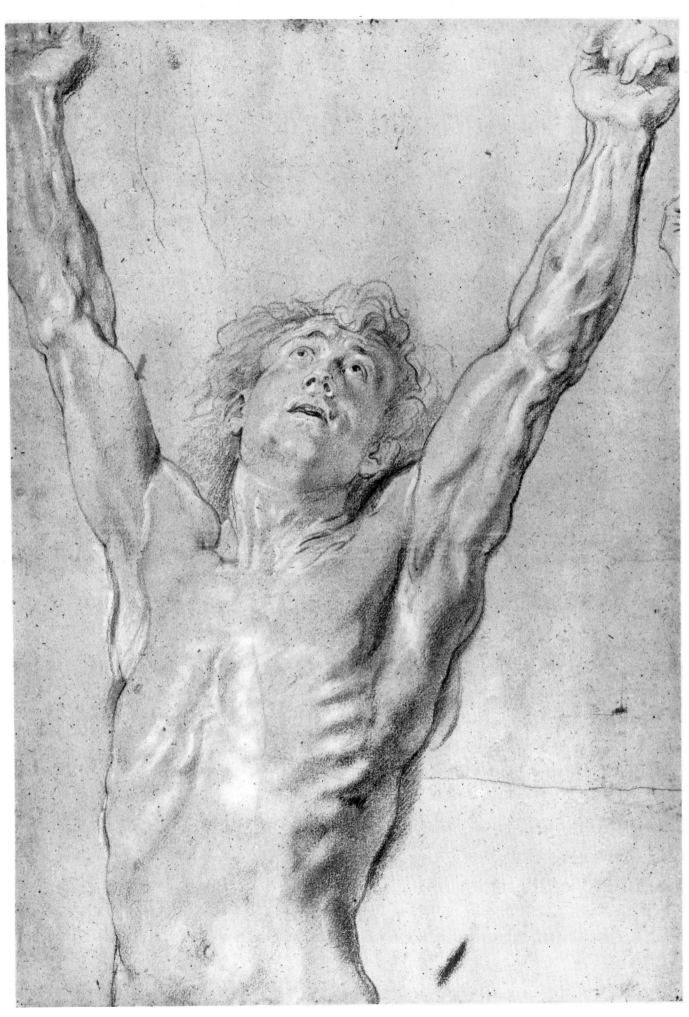

92 (Cat. No. 82) STUDY FOR THE FIGURE OF CHRIST ON THE CROSS. London, British Museum

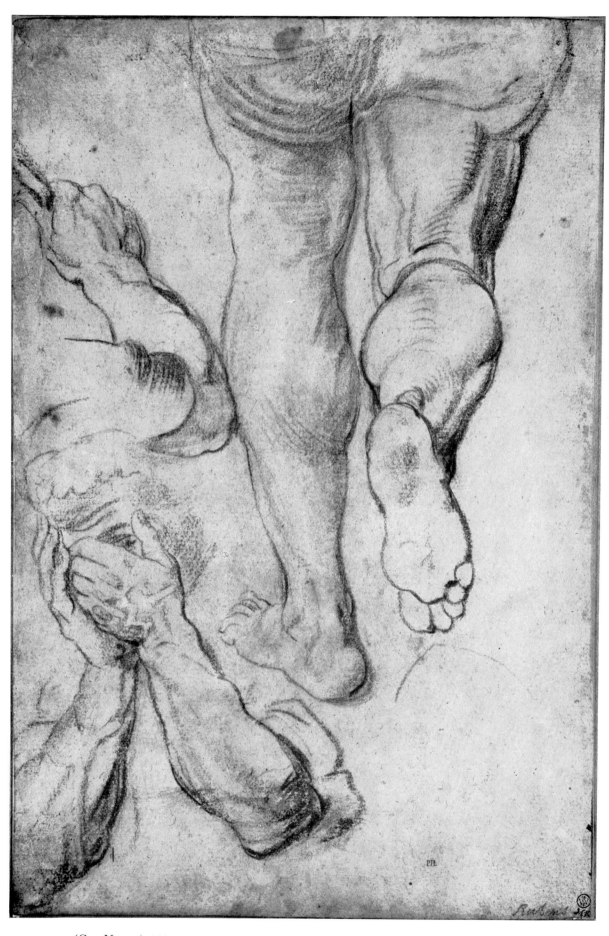

93 (Cat. No. 79) STUDIES OF ARMS AND LEGS. Rotterdam, Museum Boymans

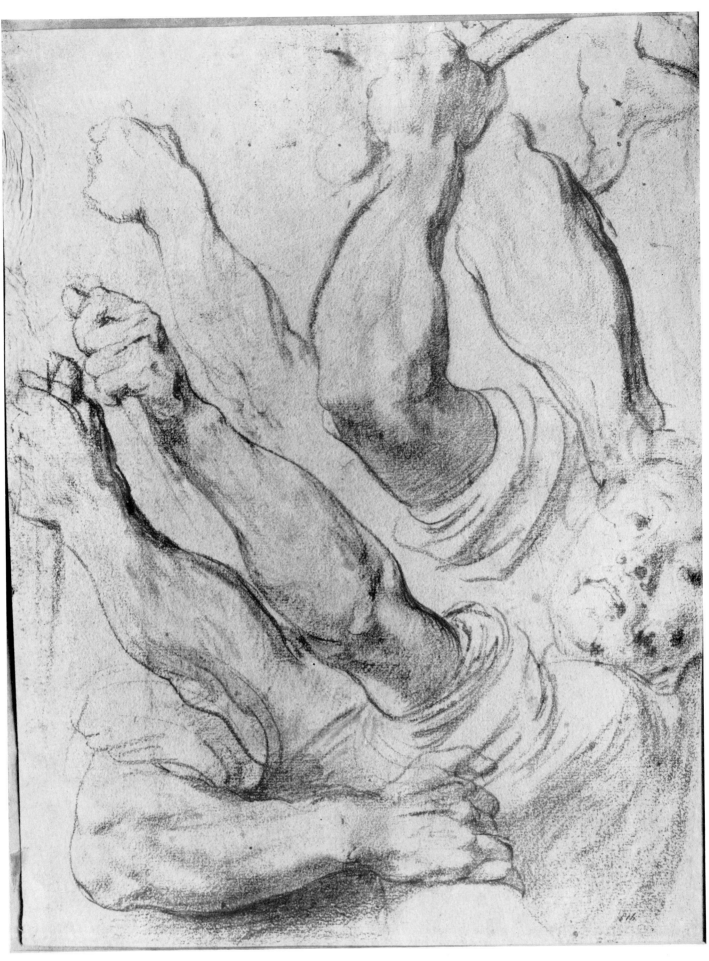

94 (Cat. No. 89) STUDIES OF ARMS AND A MAN'S FACE. London, Victoria and Albert Museum

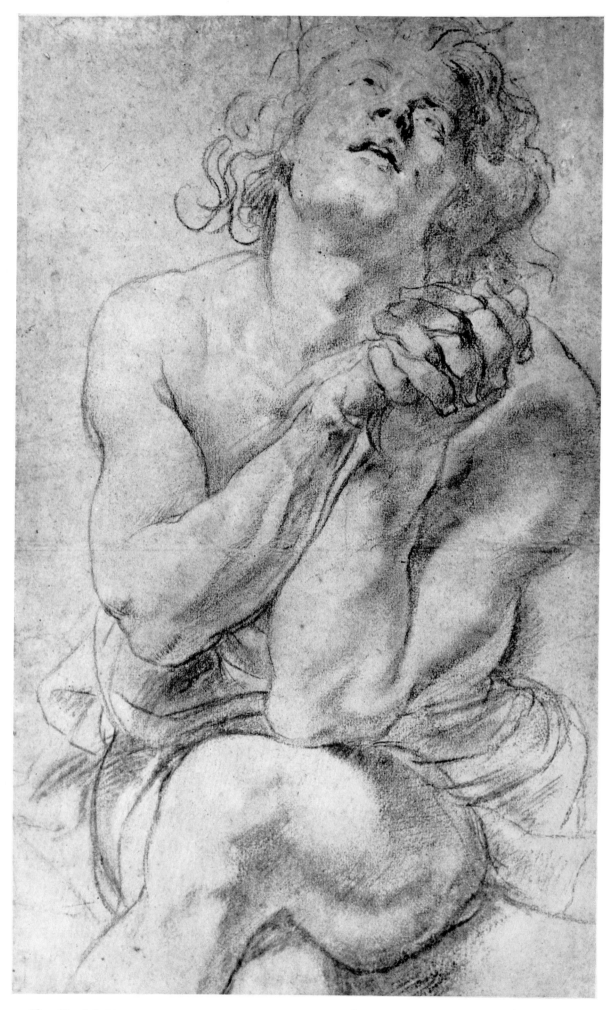

95 (Cat. No. 85) STUDY FOR DANIEL IN THE LIONS' DEN. New York, Pierpont Morgan Library

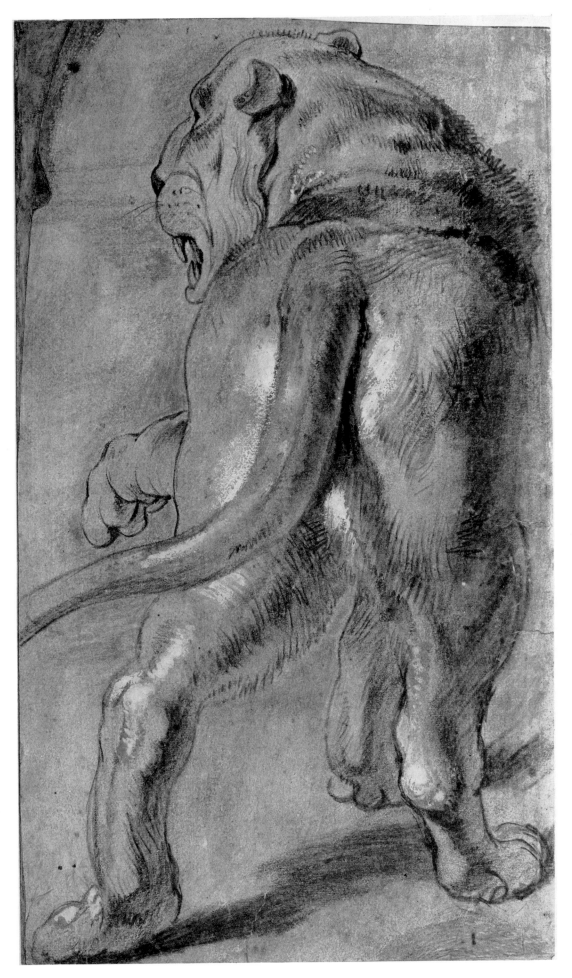

96 (Cat. No. 83) A LIONESS. London, British Museum

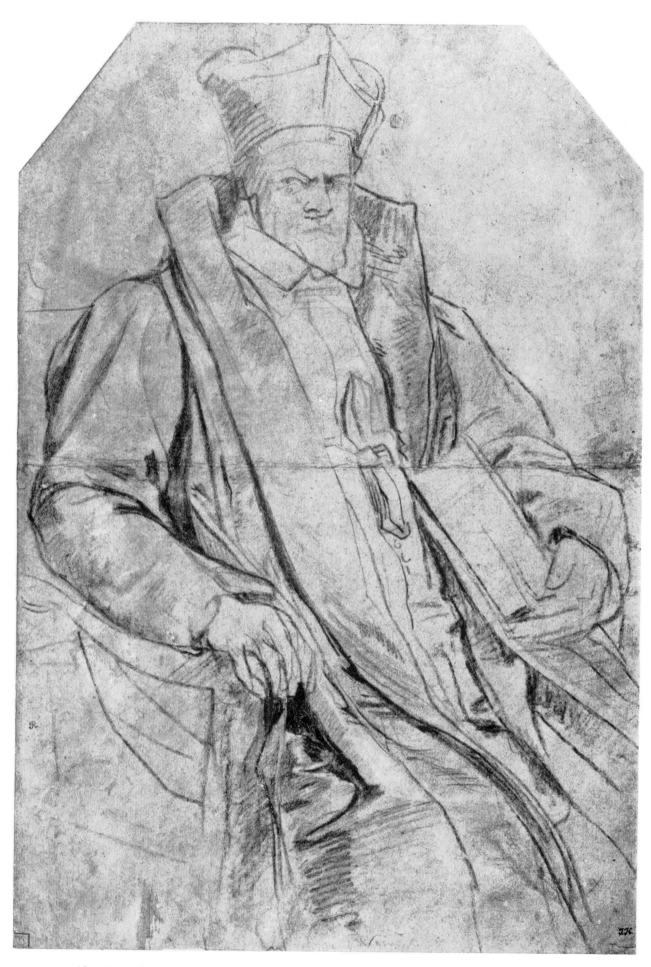

97 (Cat. No. 86) THE REVEREND HENDRIK VAN THULDEN. London, British Museum

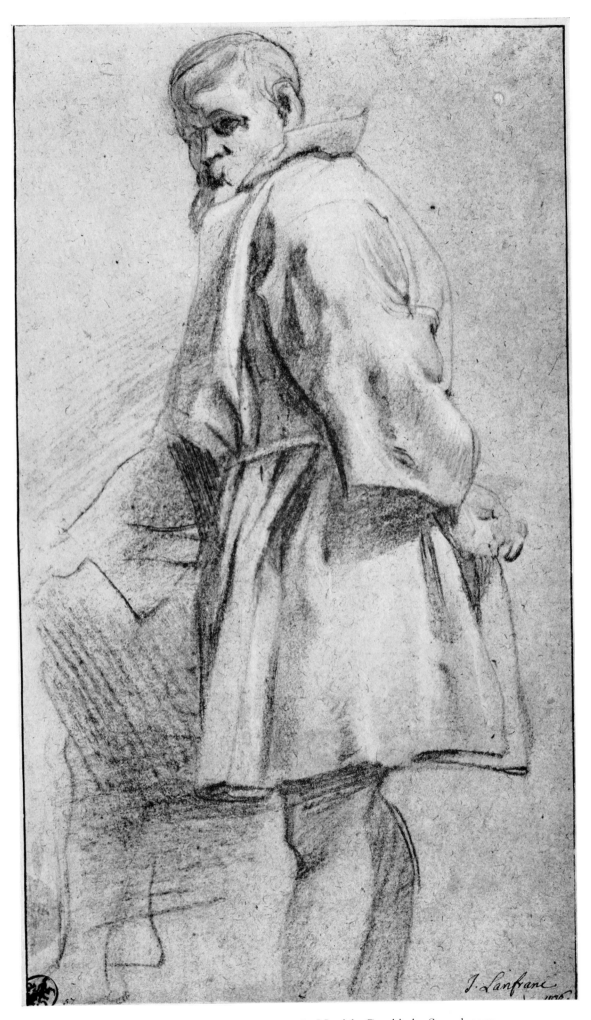

98 (Cat. No. 84) A MAN STANDING. Munich, Graphische Sammlungen

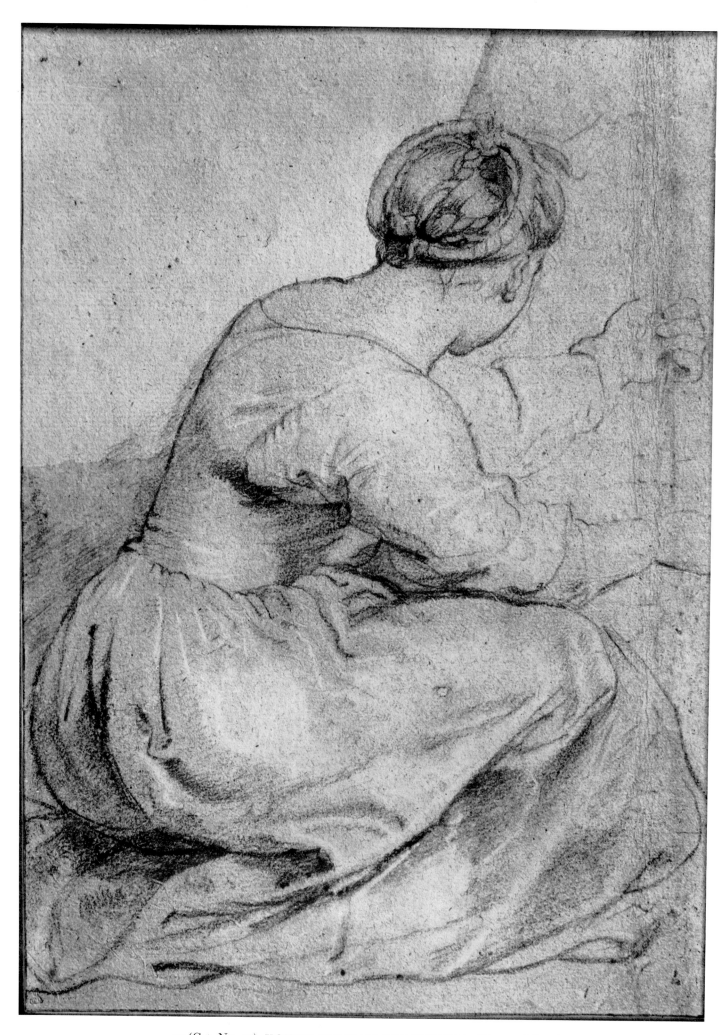

99 (Cat. No. 90) YOUNG WOMAN CROUCHING. Vienna, Albertina

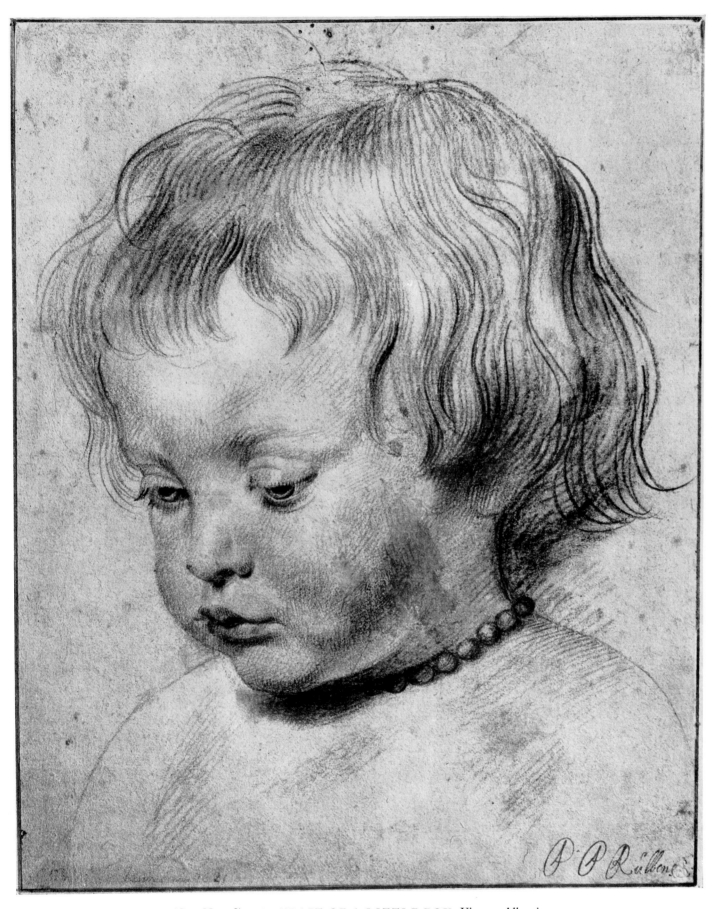

100 (Cat. No. 98) PORTRAIT OF A LITTLE BOY. Vienna, Albertina

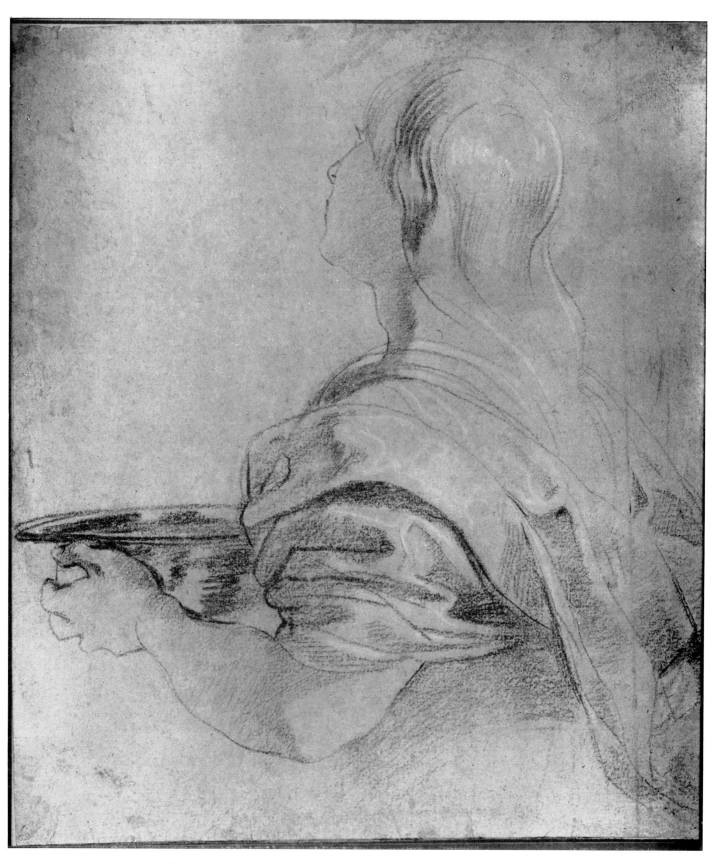

101 (Cat. No. 94) YOUNG WOMAN HOLDING A BOWL. Vienna, Albertina

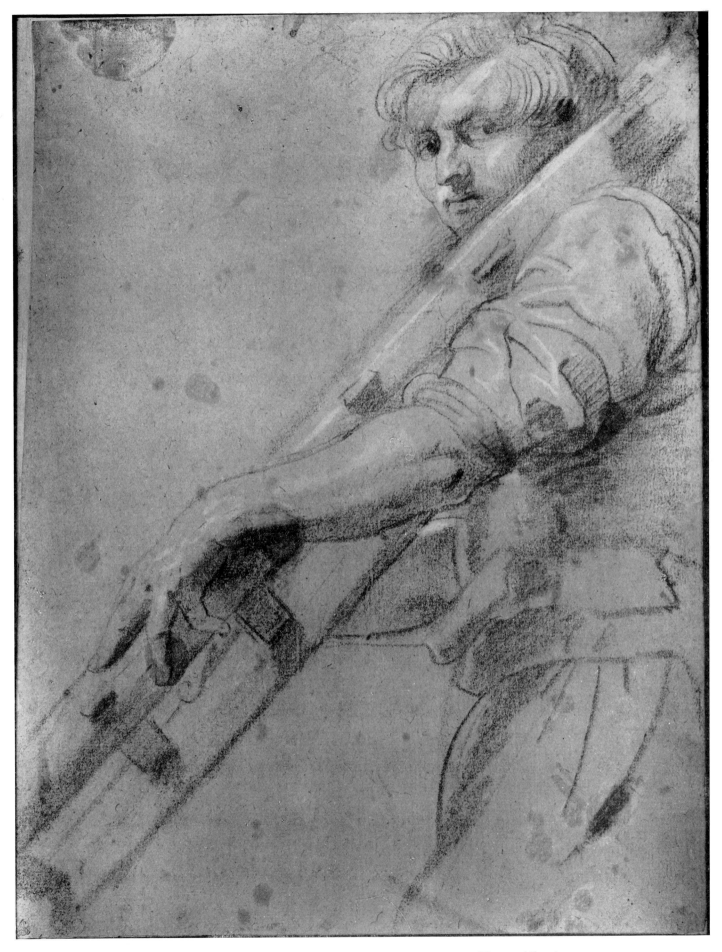

102 (Cat. No. 99) YOUNG MAN CARRYING A LADDER. Vienna, Albertina

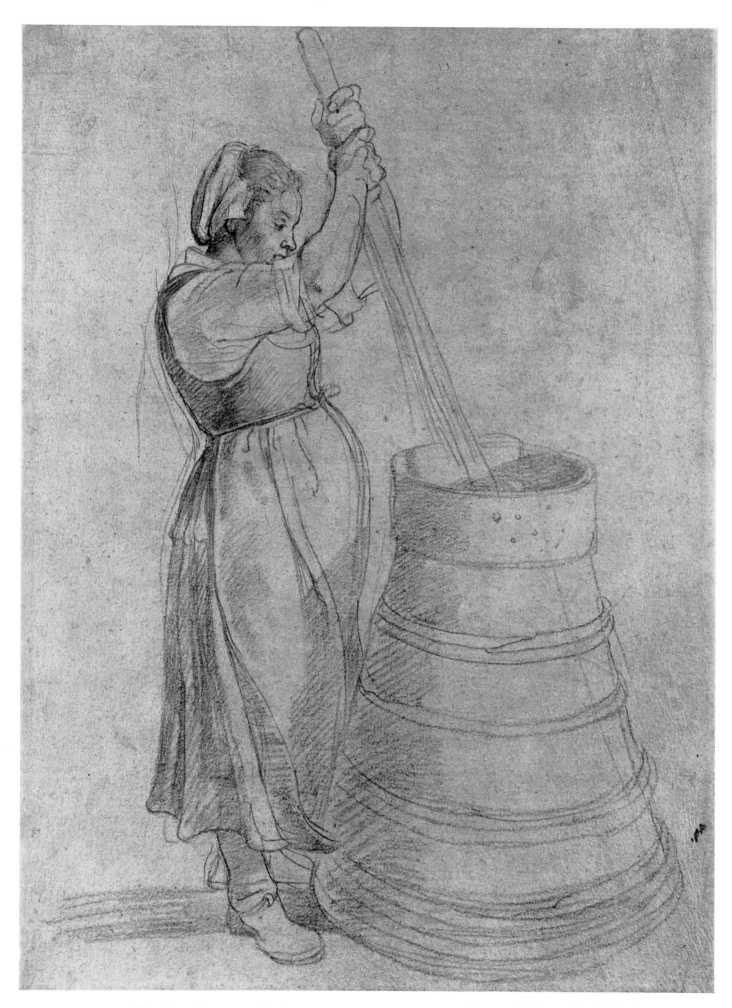

103 (Cat. No. 95) PEASANT GIRL CHURNING BUTTER. Chatsworth, Devonshire Collection

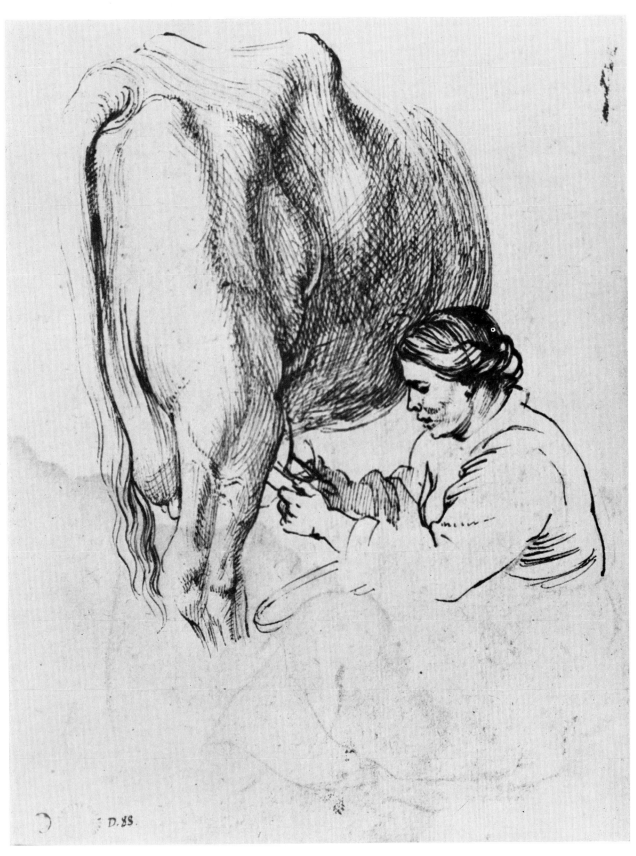

104 (Cat. No. 88) WOMAN MILKING A COW. Besançon, Musée des Beaux-Arts

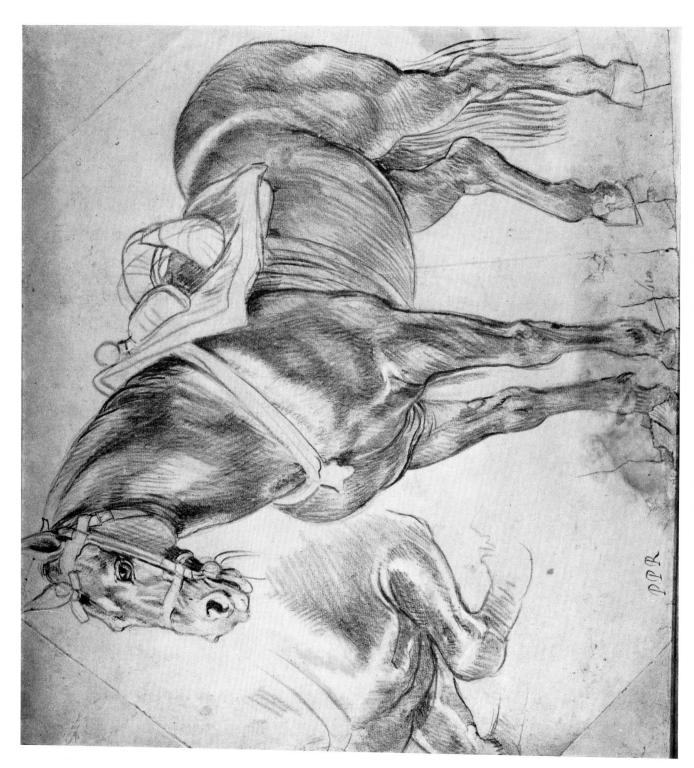

105 (Cat. No. 87) A SADDLED HORSE. Vienna, Albertina

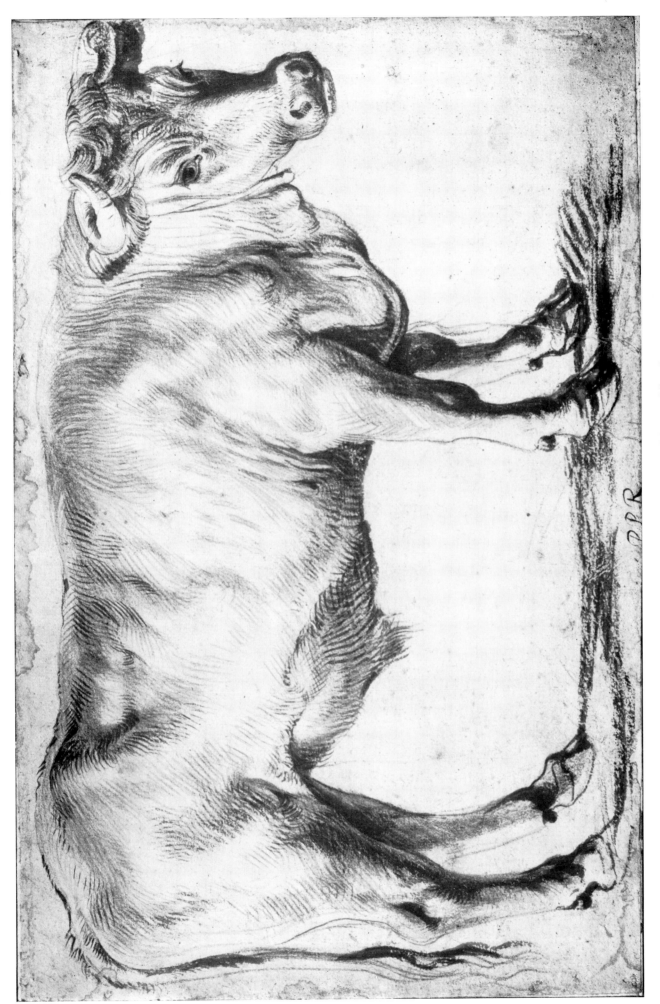

106 (Cat. No. 91) A BULLOCK. Vienna, Albertina

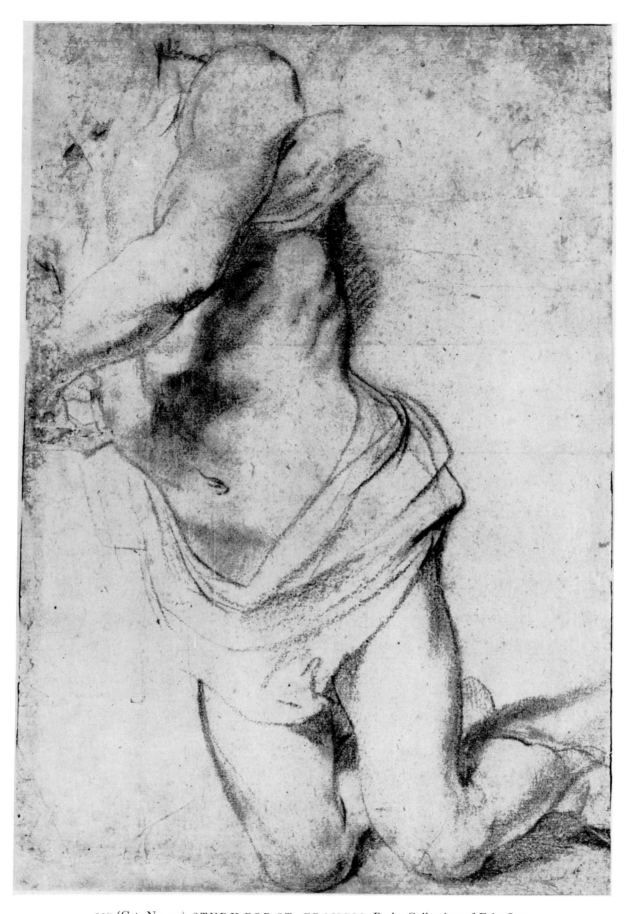

107 (Cat. No. 92) STUDY FOR ST. FRANCIS. Paris, Collection of Frits Lugt

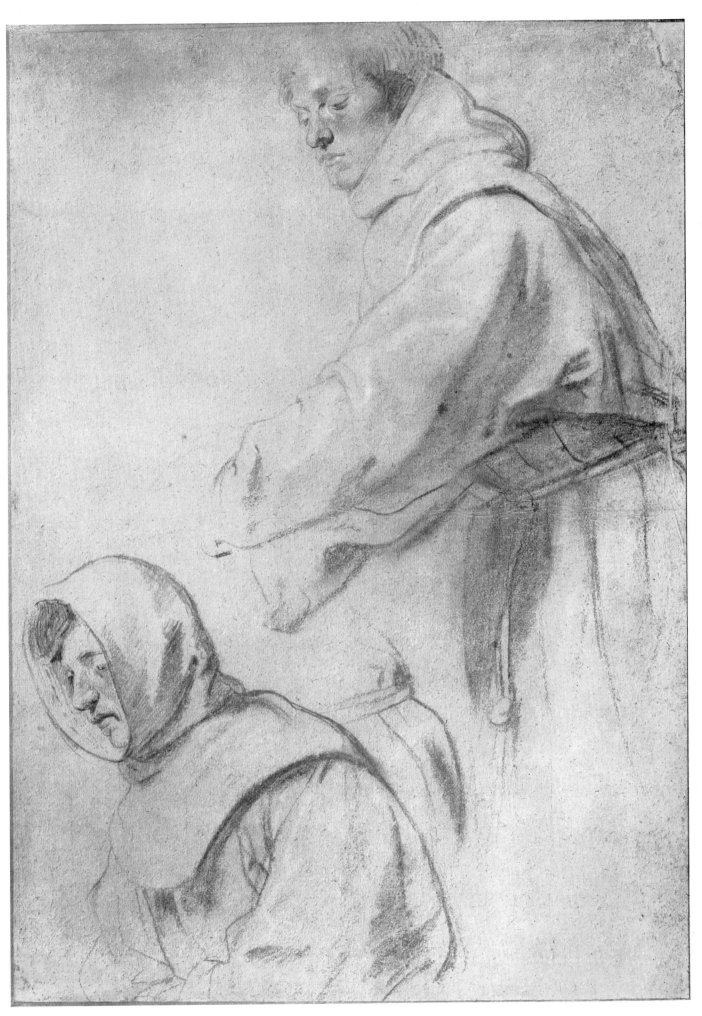

108 (Cat. No. 93) TWO FRANCISCAN MONKS. Chatsworth, Devonshire Collection

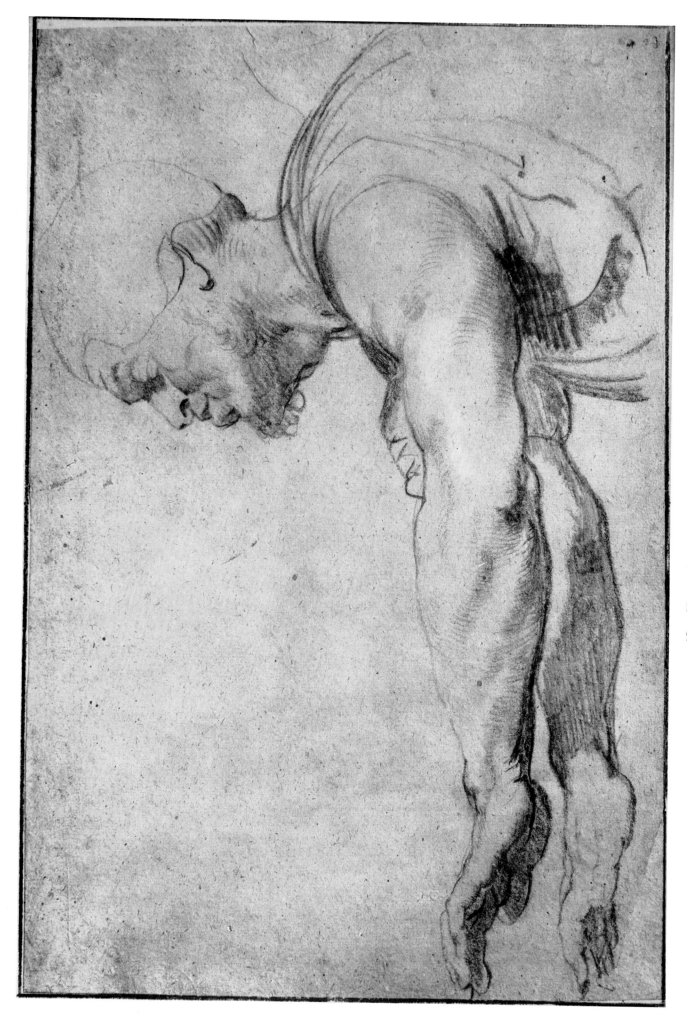

109 (Cat. No. 100) A BLIND MAN. Vienna, Albertina

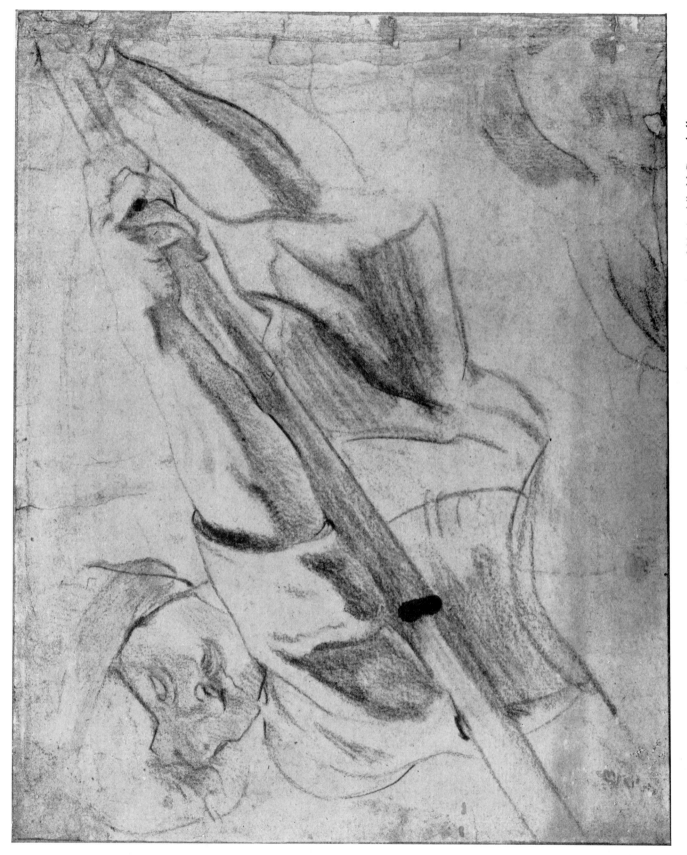

110 (Cat. No. 96) A MAN THRUSTING WITH A LANCE. Glasgow, Collection of Sir Archibald Campbell

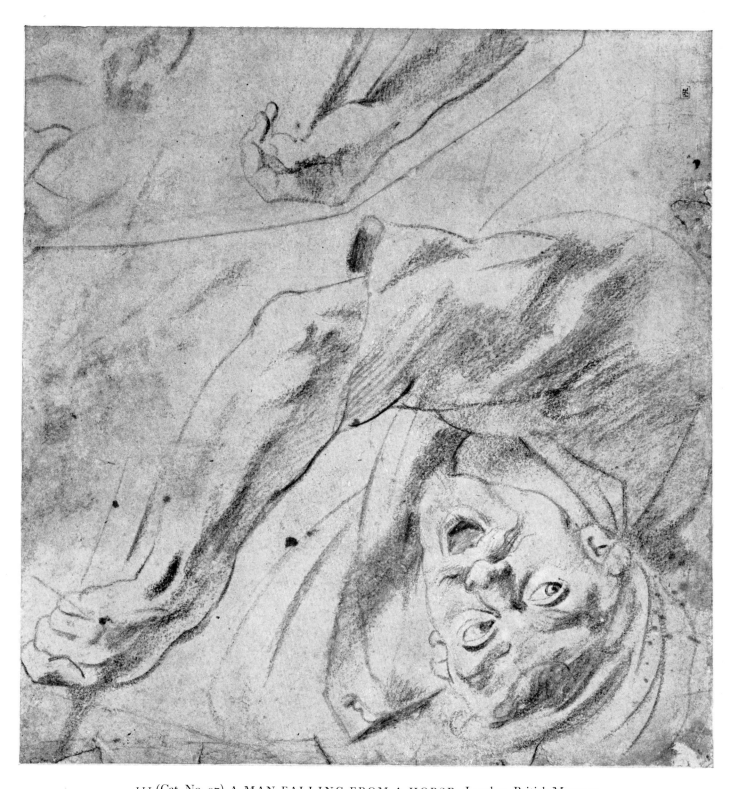

111 (Cat. No. 97) A MAN FALLING FROM A HORSE. London, British Museum

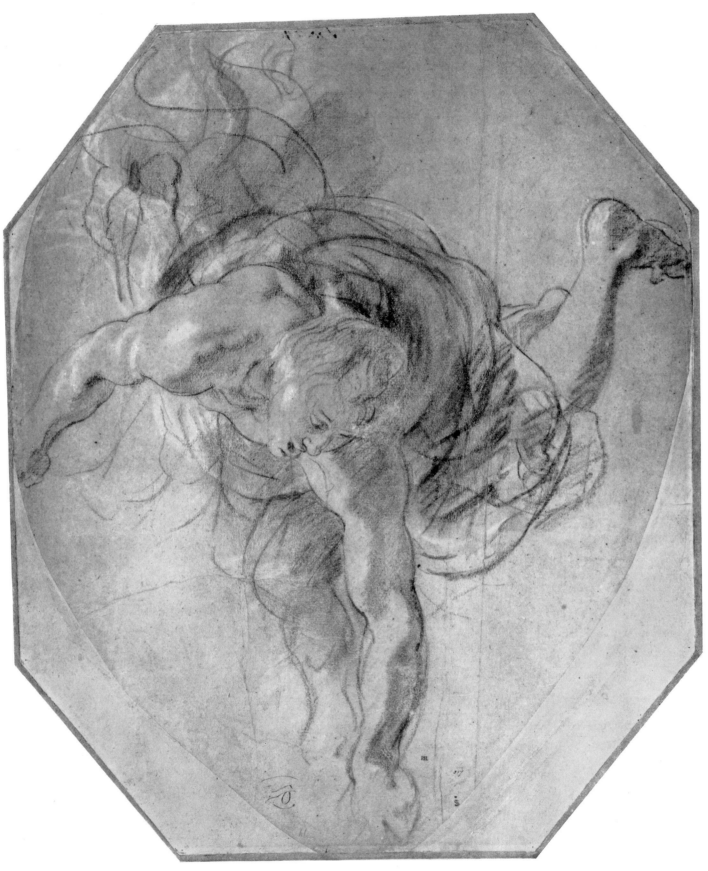

112 (Cat. No. 102) A STUDY FOR MERCURY DESCENDING. London, Victoria and Albert Museum

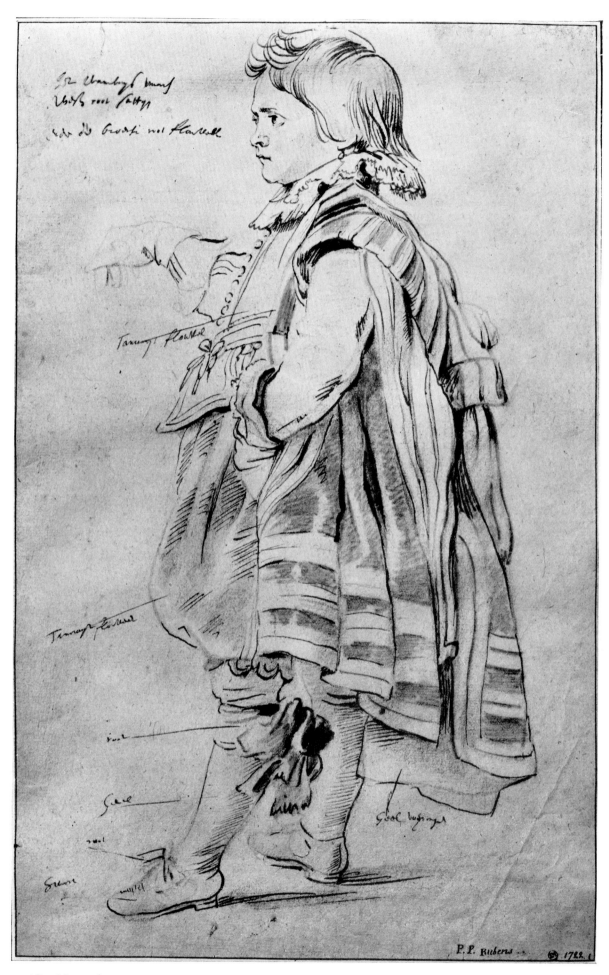

113 (Cat. No. 101) ROBIN, THE DWARF OF THE EARL OF ARUNDEL. Stockholm, Nationalmuseum

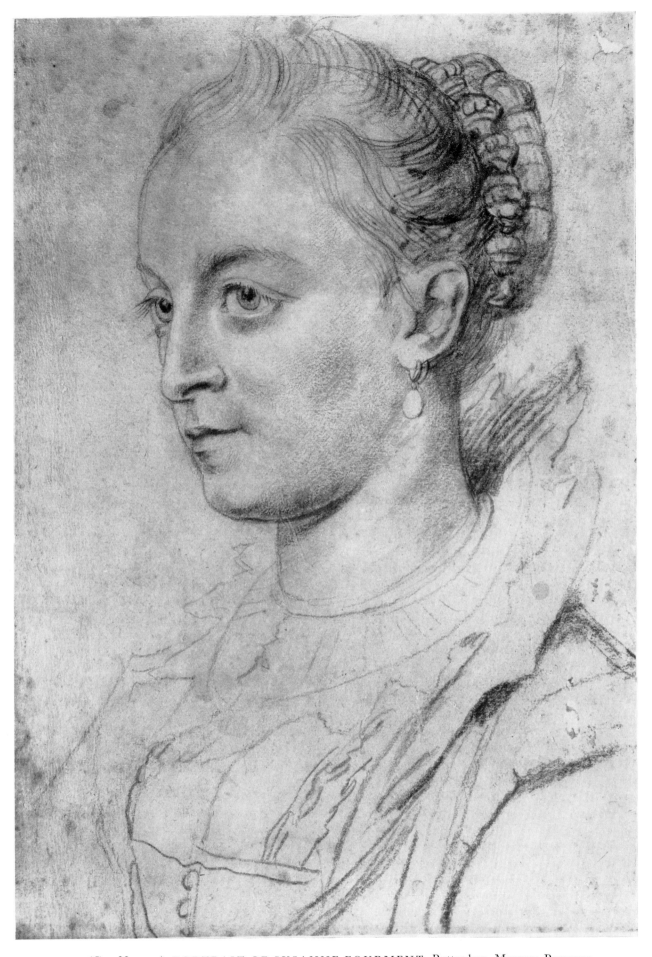

114 (Cat. No. 104) PORTRAIT OF SUSANNE FOURMENT. Rotterdam, Museum Boymans

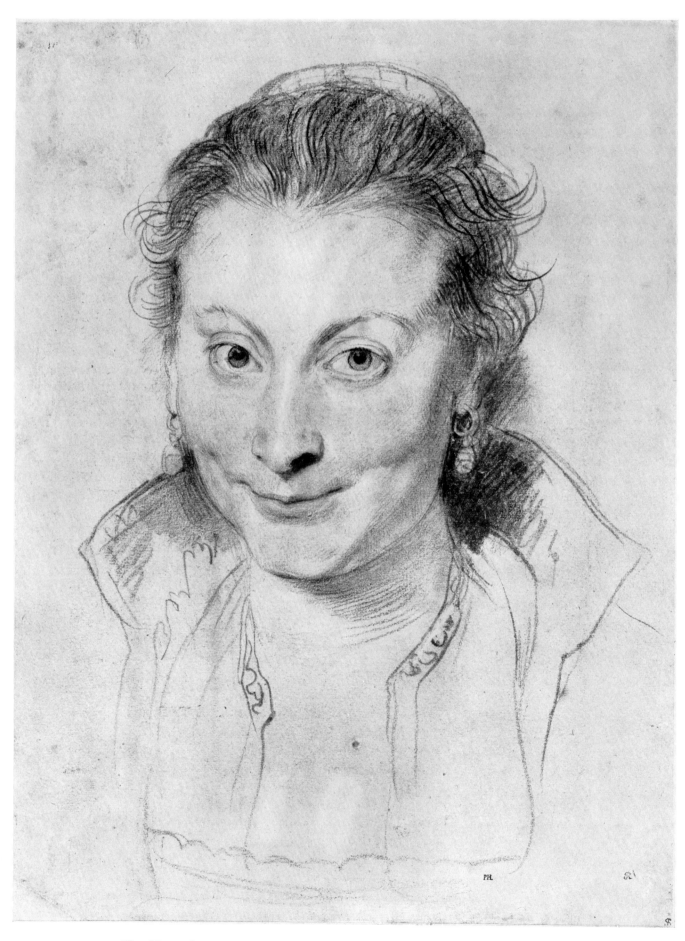

115 (Cat. No. 103) PORTRAIT OF ISABELLA BRANT. London, British Museum

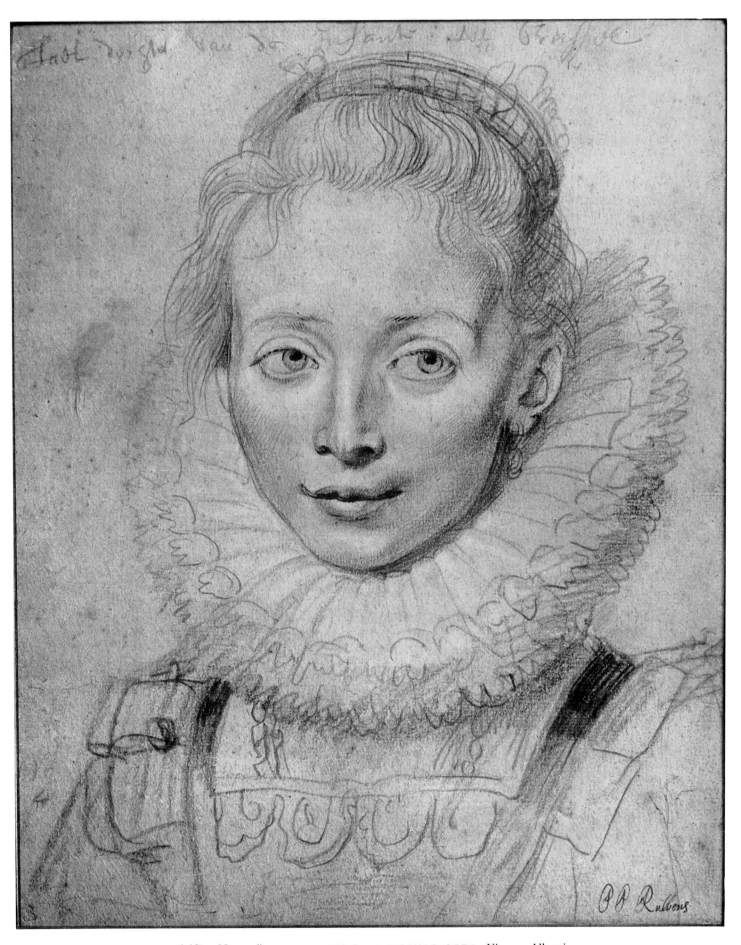

116 (Cat. No. 106) PORTRAIT OF A YOUNG GIRL. Vienna, Albertina

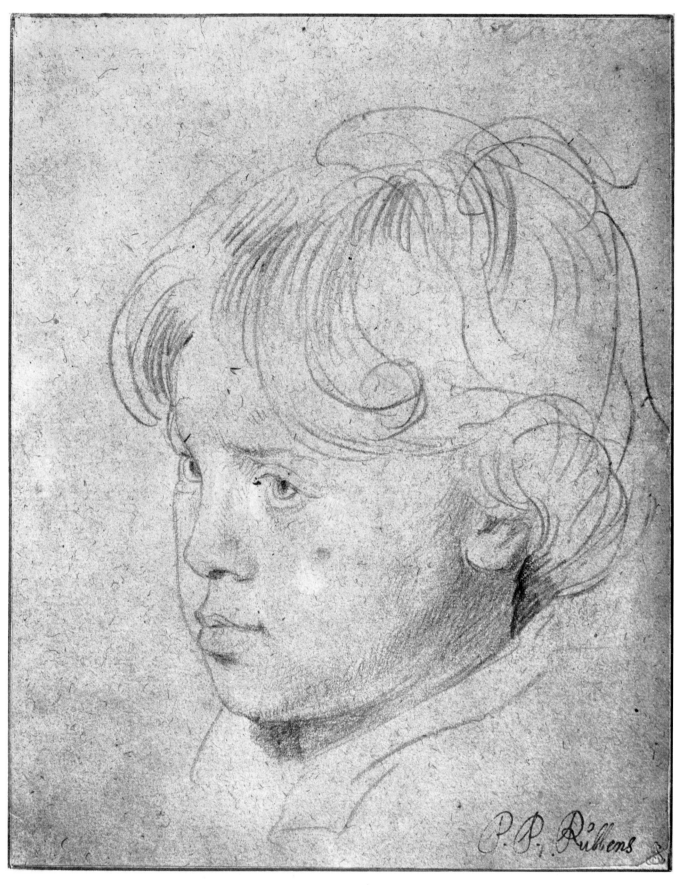

117 (Cat. No. 108) PORTRAIT OF RUBENS' SON NICOLAS. Vienna, Albertina

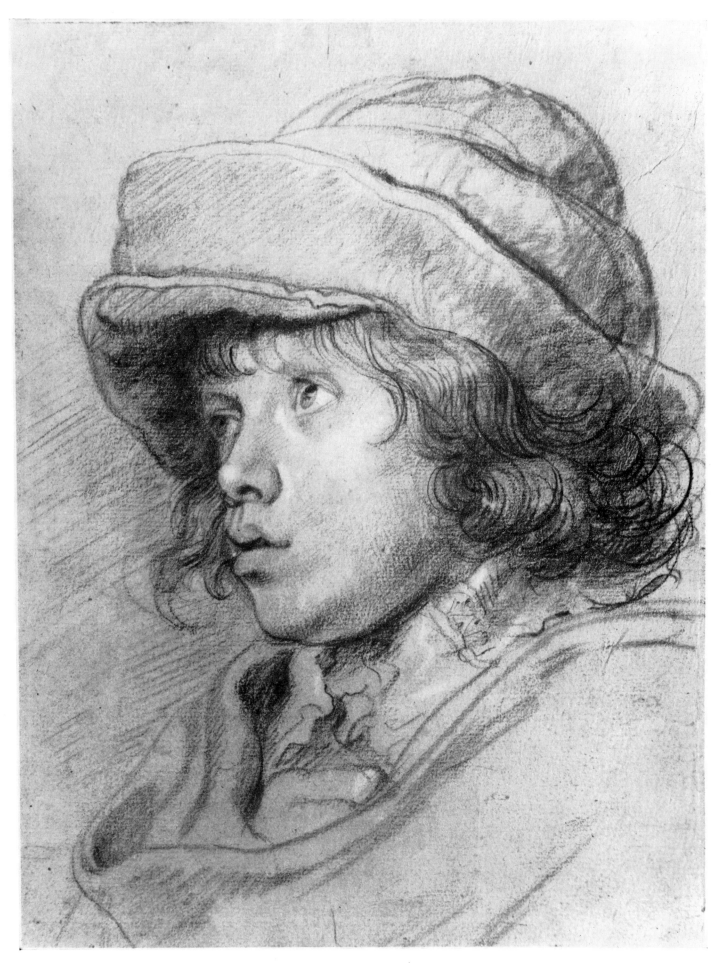

118 (Cat. No. 109) PORTRAIT OF RUBENS' SON NICOLAS. Vienna, Albertina

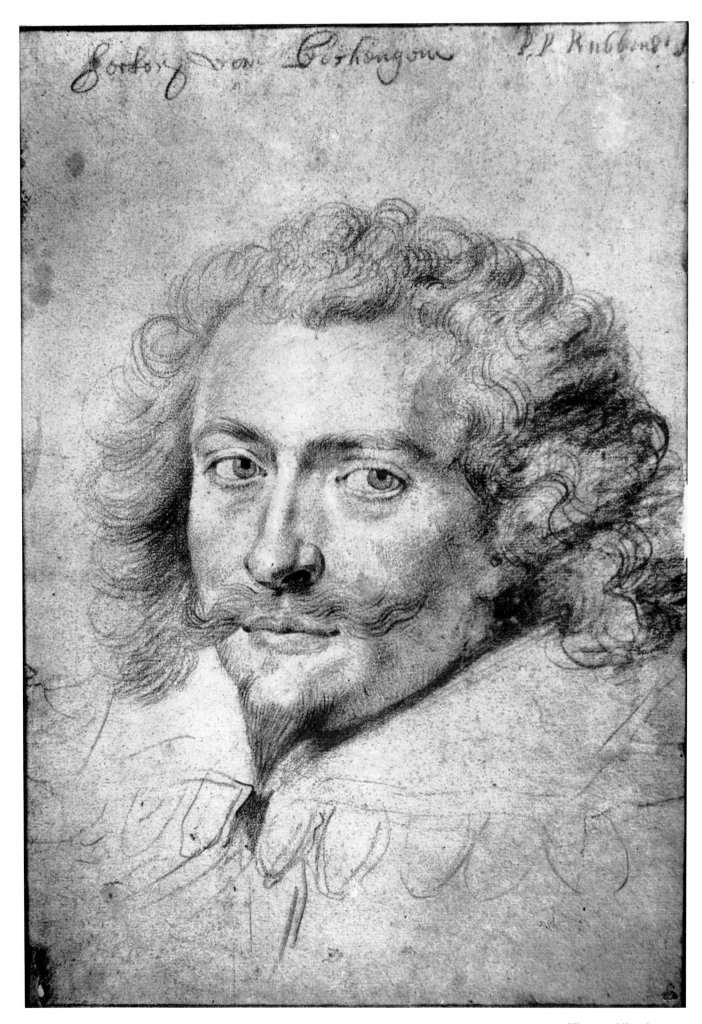

119 (Cat. No. 107) PORTRAIT OF GEORGE VILLIERS, DUKE OF BUCKINGHAM. Vienna, Albertina

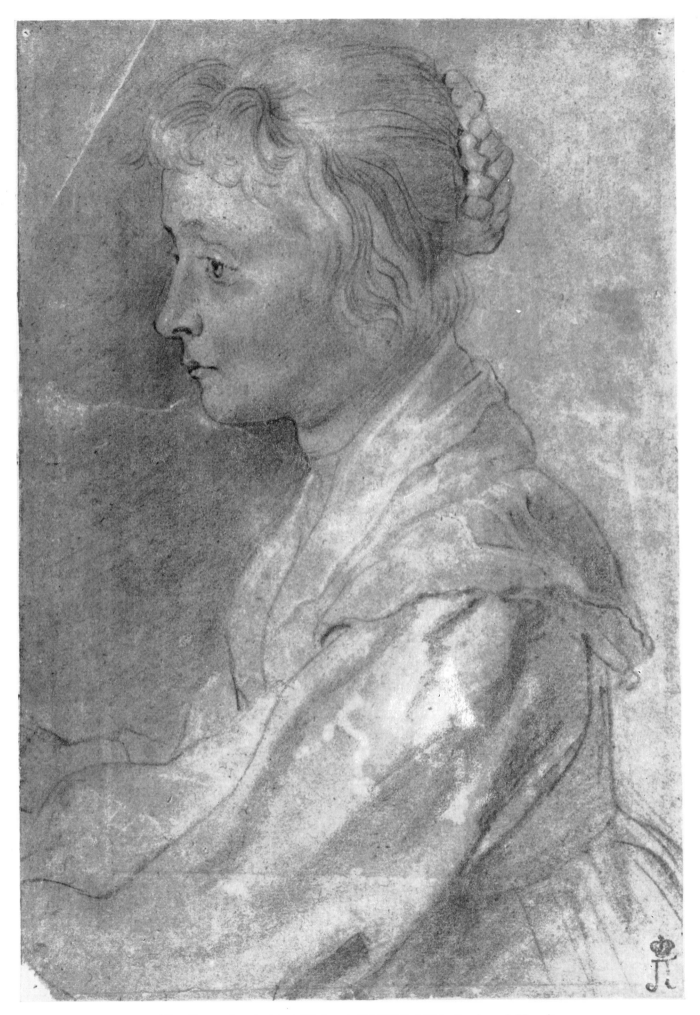

120 (Cat. No. 112) PORTRAIT OF A YOUNG GIRL. Leningrad, Hermitage

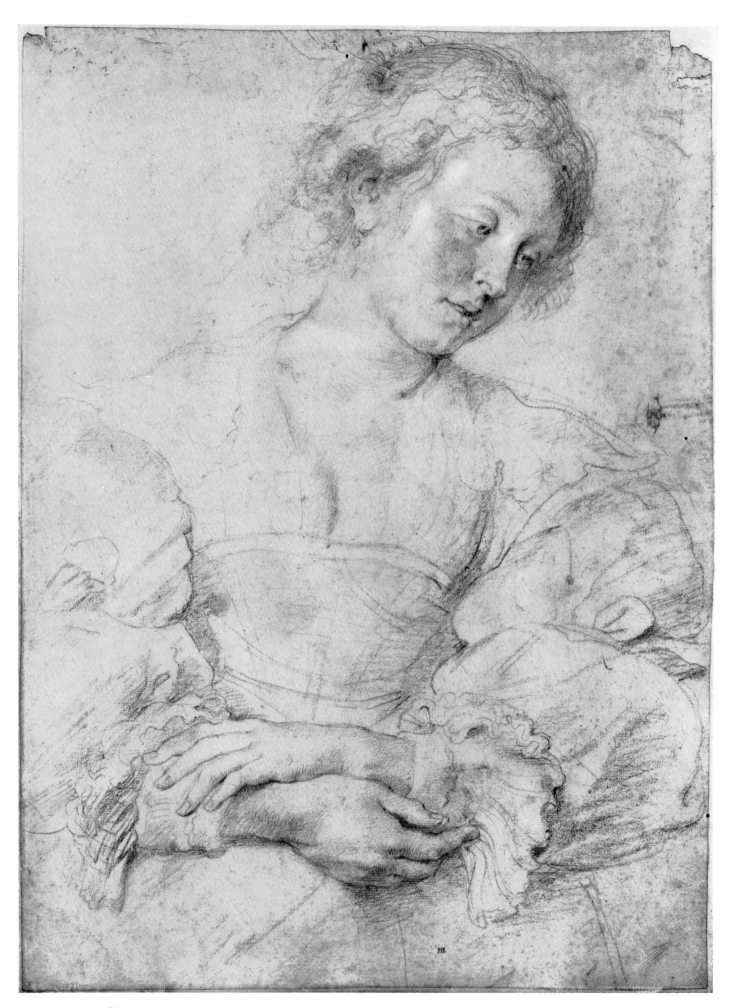

121 (Cat. No. 110) YOUNG WOMAN WITH CROSSED HANDS. Rotterdam, Museum Boymans

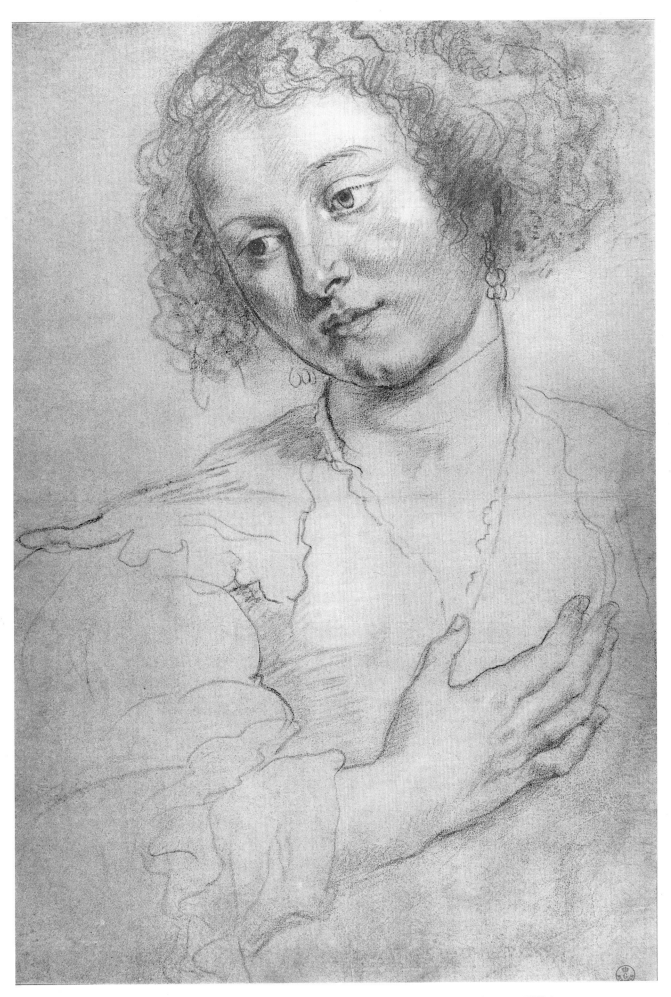

122 (Cat. No. 113) YOUNG WOMAN LOOKING DOWN. Florence, Uffizi

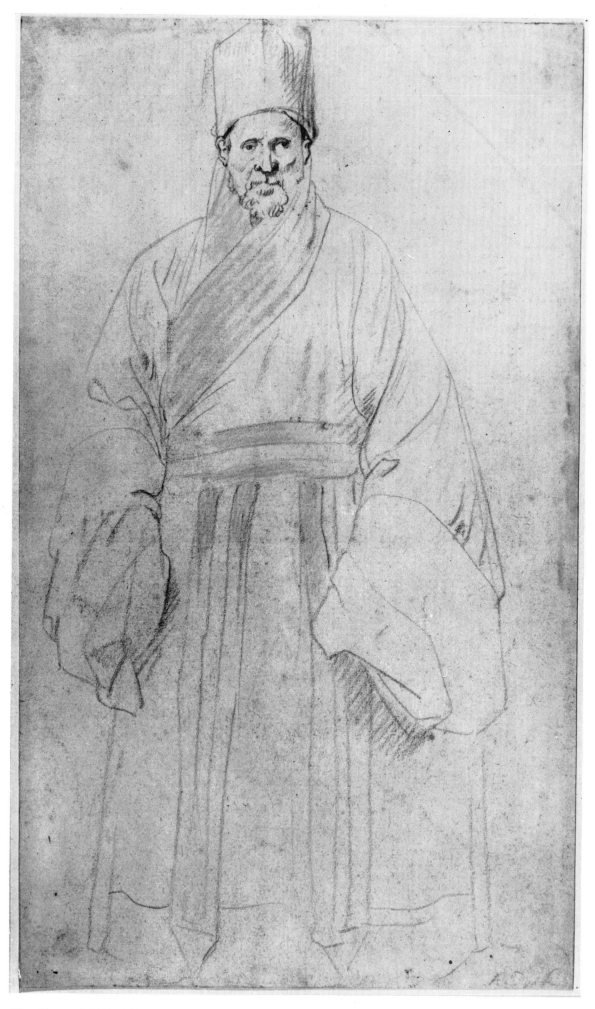

123 (Cat. No. 105) JESUIT MISSIONARY IN CHINESE COSTUME. New York, Pierpont Morgan Library

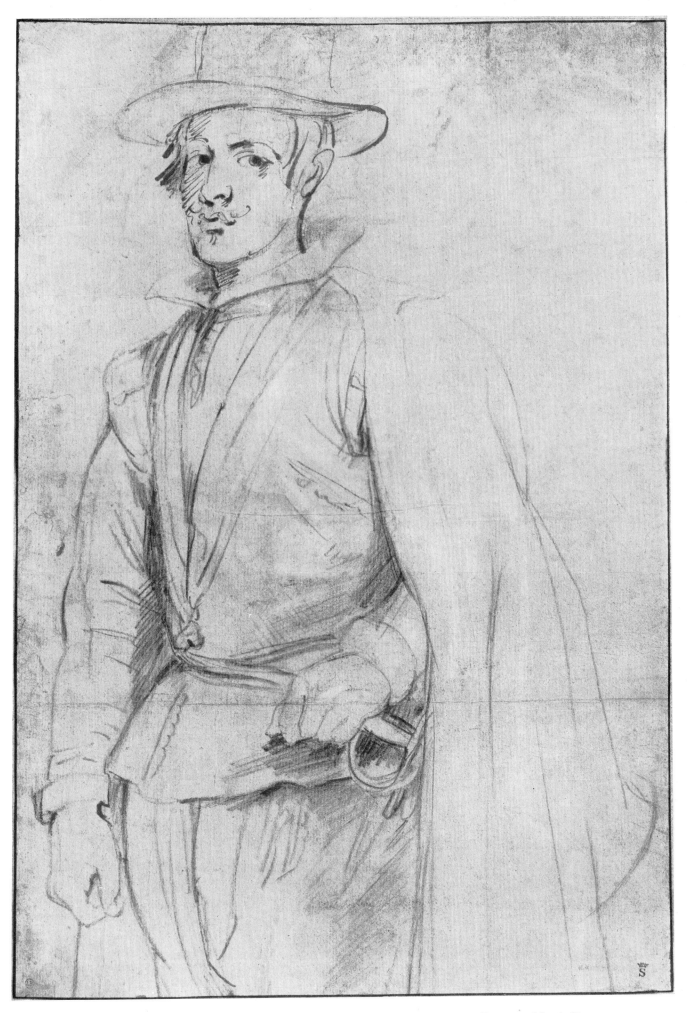

124 (Cat. No. 111) PORTRAIT OF KING PHILIP IV OF SPAIN. Bayonne, Musée Bonnat

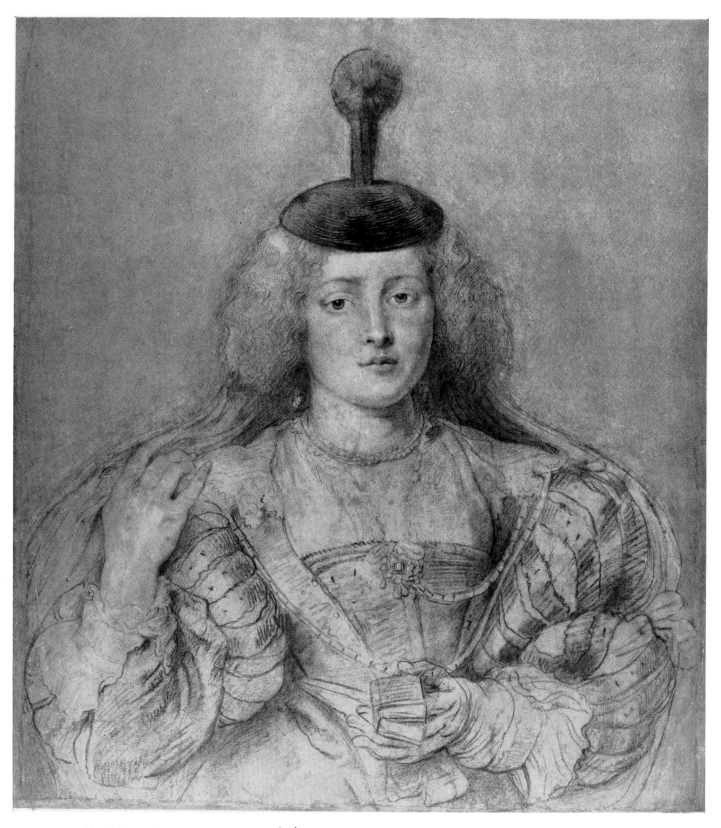

125 (Cat. No. 114) PORTRAIT OF HÉLÈNE FOURMENT. London, Collection of Count Antoine Seilern

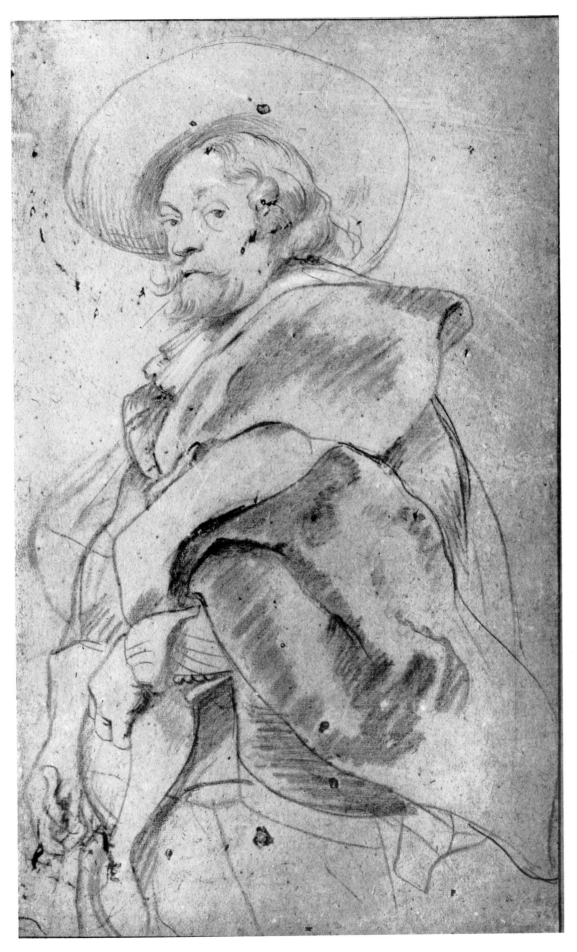

126 (Cat. No. 123) SELF-PORTRAIT. Paris, Louvre

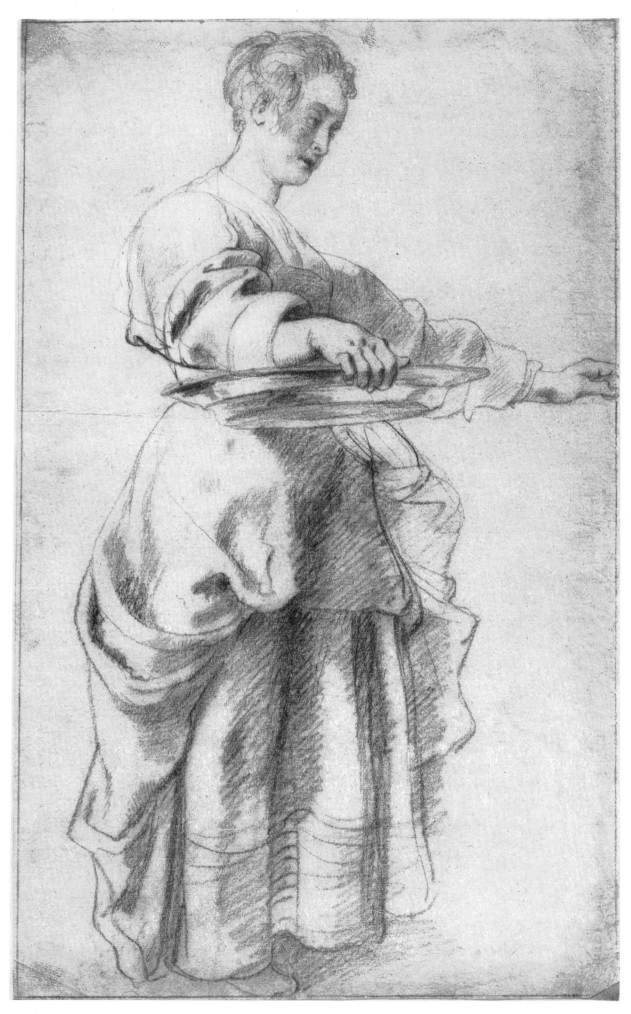

127 (Cat. No. 116) YOUNG WOMAN HOLDING A TRAY. Paris, Collection of Frits Lugt

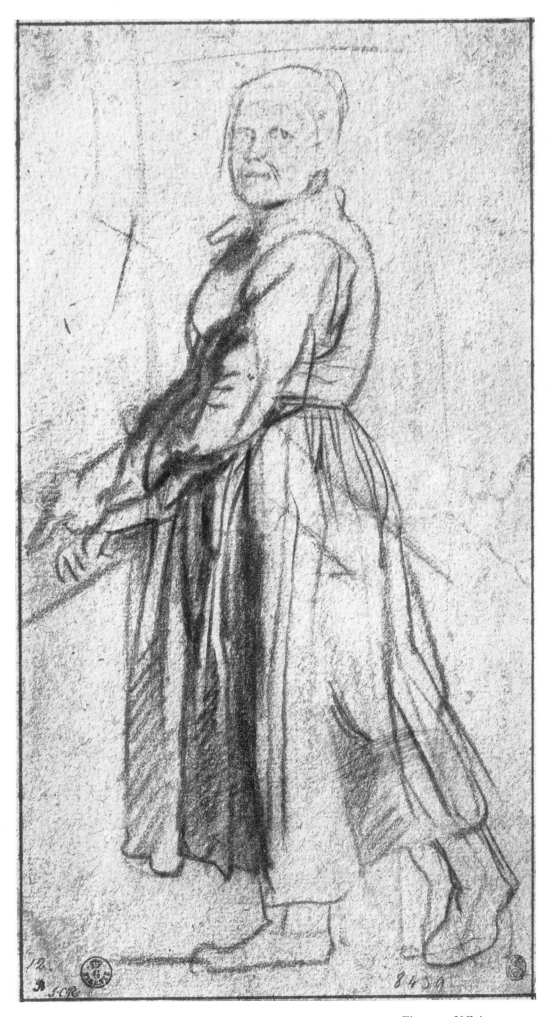

128 (Cat. No. 117) A PEASANT WOMAN, WALKING. Florence, Uffizi

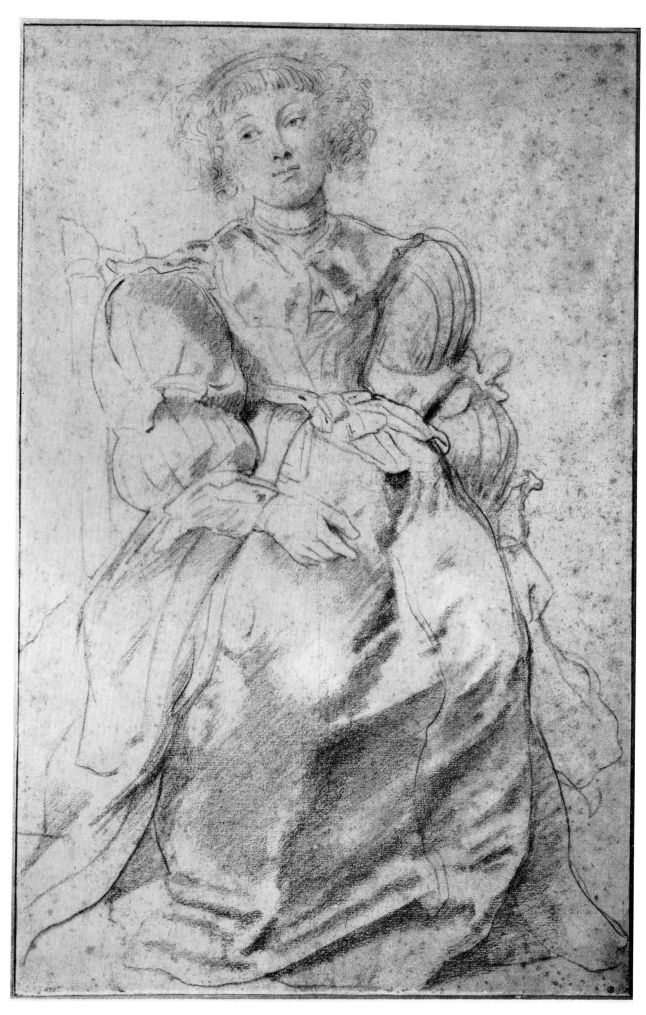

129 (Cat. No. 115) PORTRAIT OF HÉLÈNE FOURMENT. Rotterdam, Museum Boymans

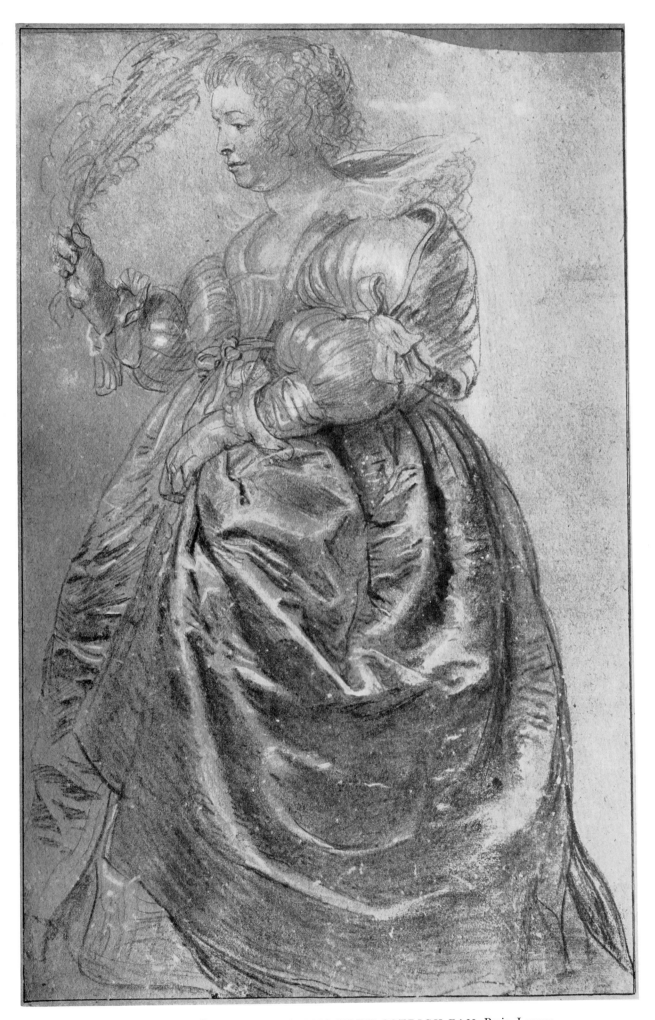

130 (Cat. No. 118) YOUNG WOMAN WITH OSTRICH FAN. Paris, Louvre

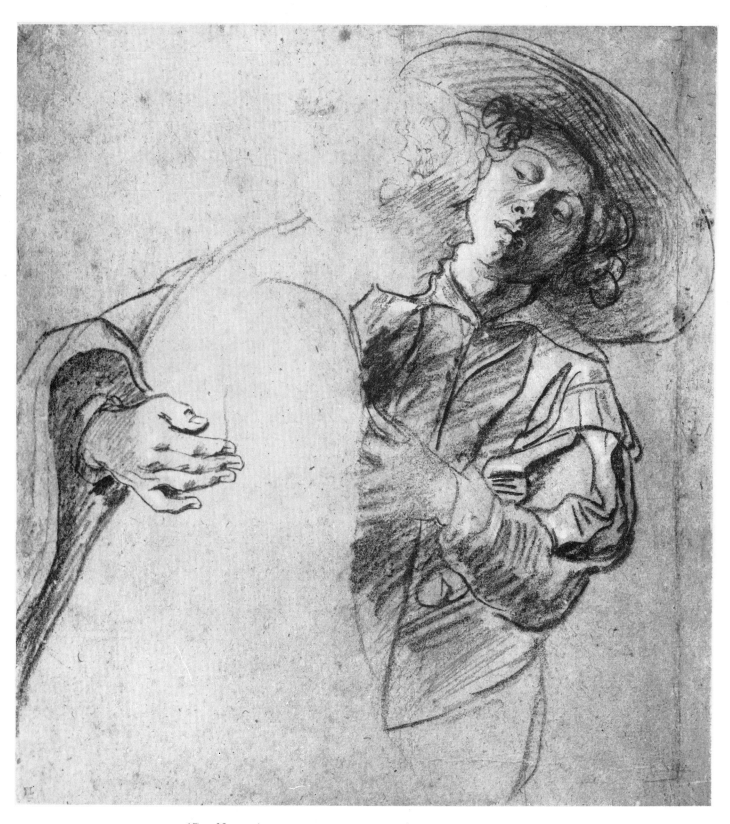

131 (Cat. No. 120) A YOUNG COUPLE. Amsterdam, Fodor Collection

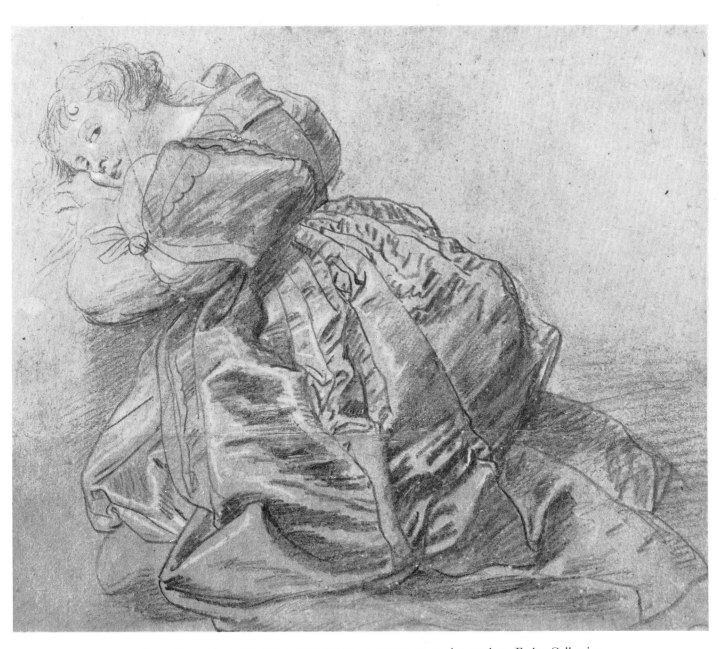

132 (Cat. No. 121) A YOUNG WOMAN, KNEELING. Amsterdam, Fodor Collection

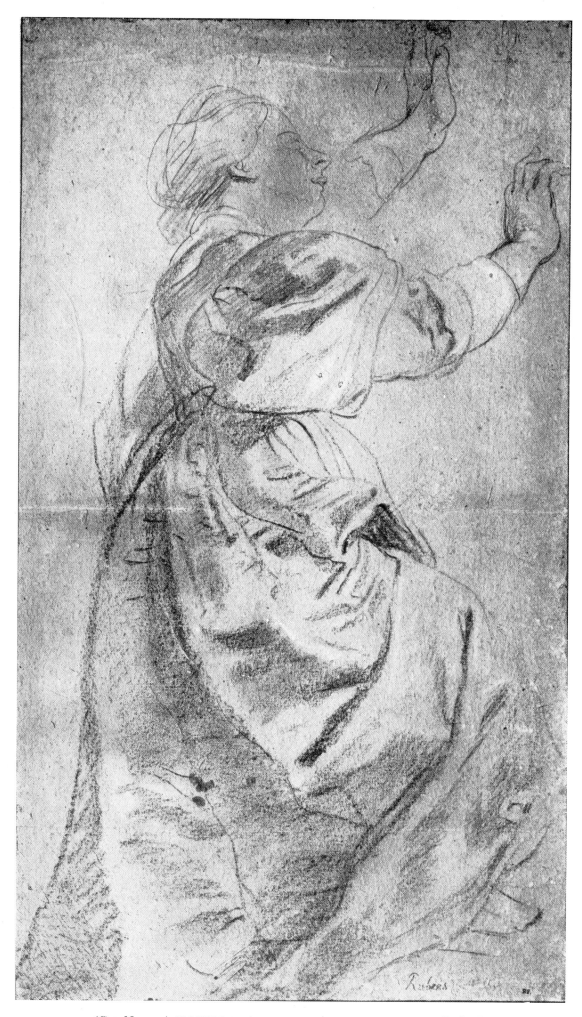

133 (Cat. No. 124) YOUNG WOMAN WITH RAISED ARMS. Paris, Louvre

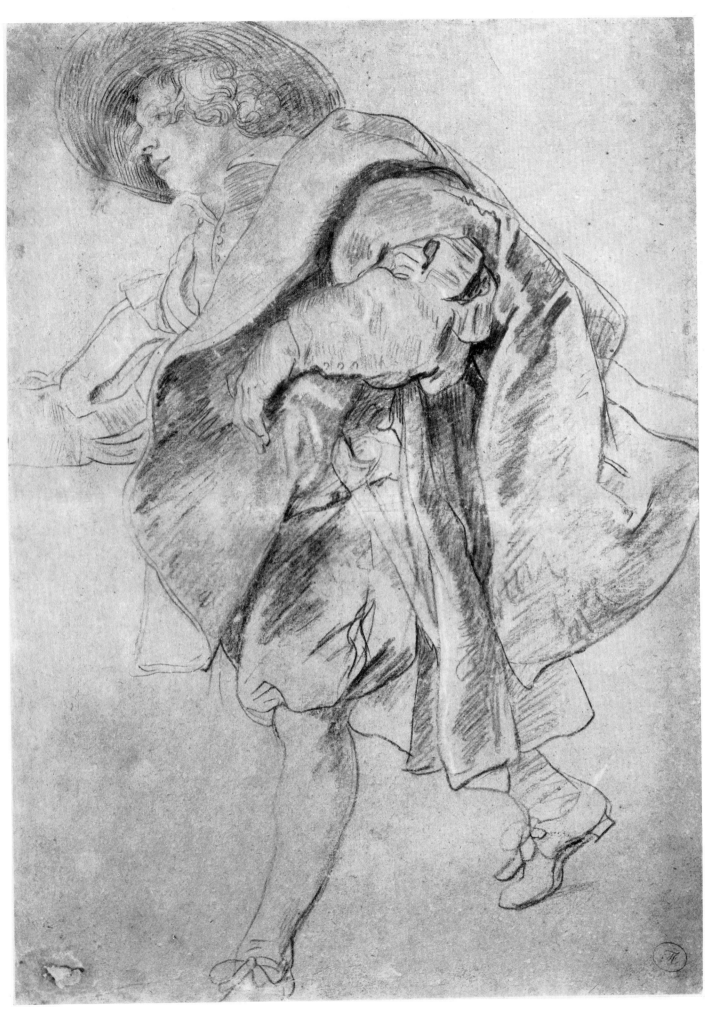

134 (Cat. No. 119) A YOUNG MAN, WALKING. Amsterdam, Fodor Collection

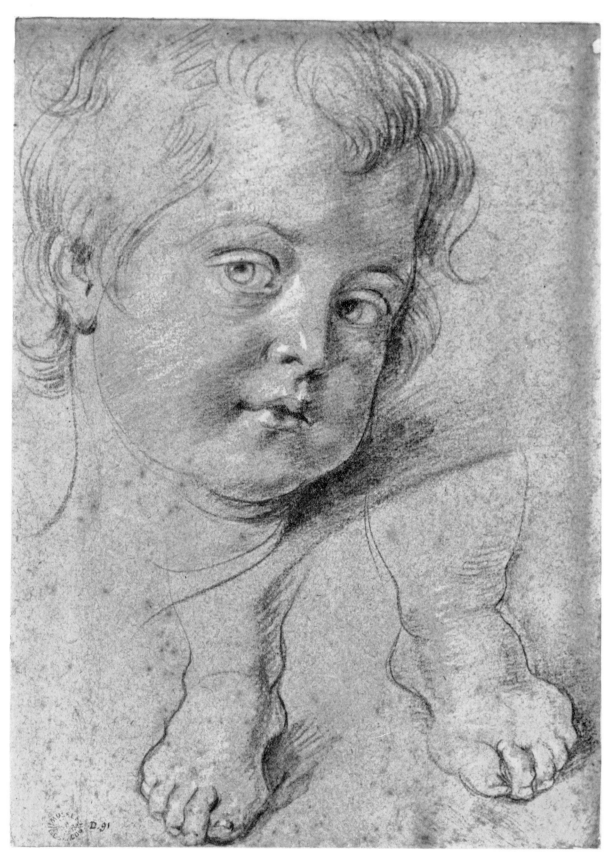

135 (Cat. No. 125) HEAD AND FEET OF A CHILD. Besançon, Musée des Beaux-Arts

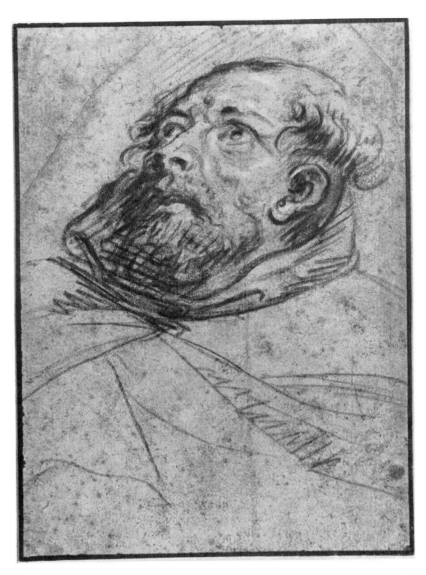

136 (Cat. No. 122) HEAD OF ST. FRANCIS.
Frankfurt, Städelsches Kunstinstitut

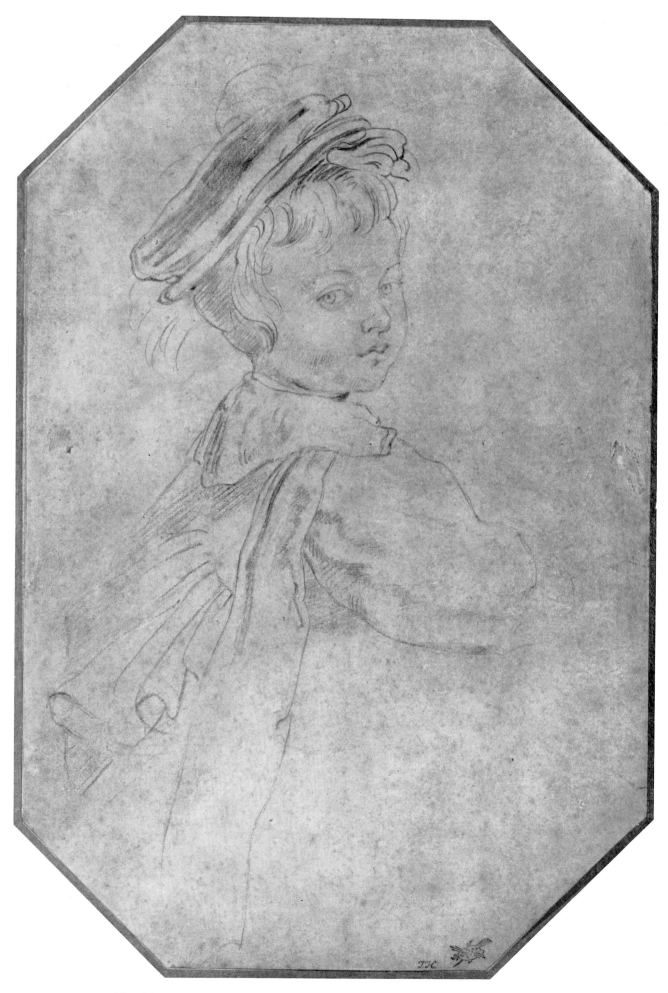

137 (Cat. No. 127) PORTRAIT OF FRANS RUBENS. Rotterdam, Museum Boymans

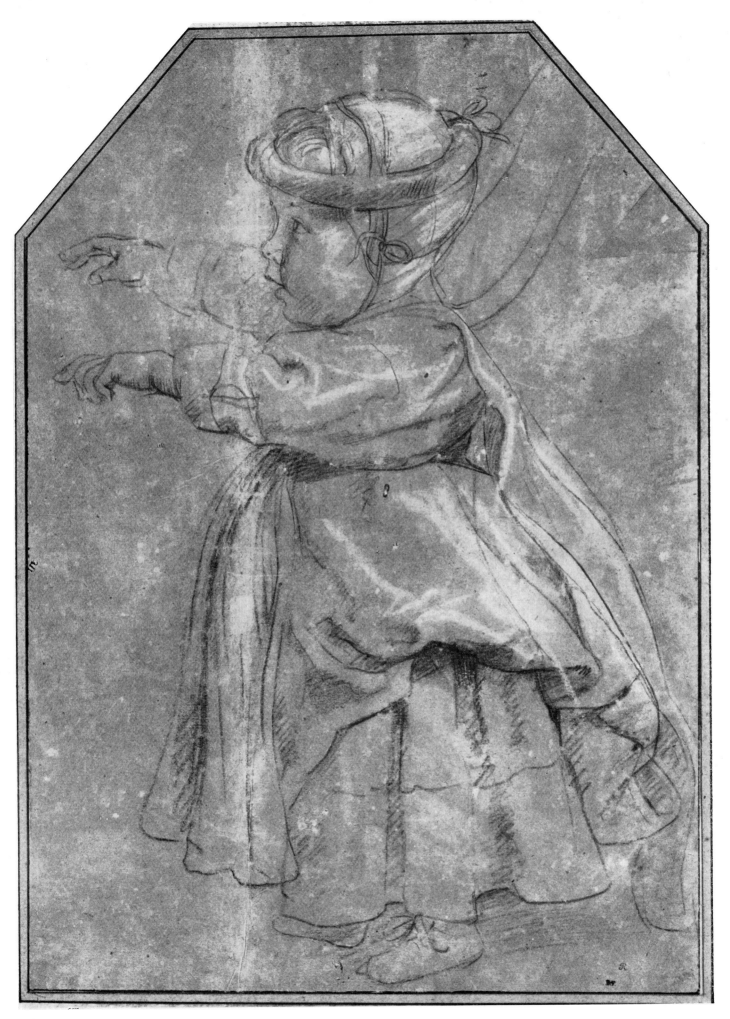

138 (Cat. No. 128) A SMALL CHILD. Paris, Louvre

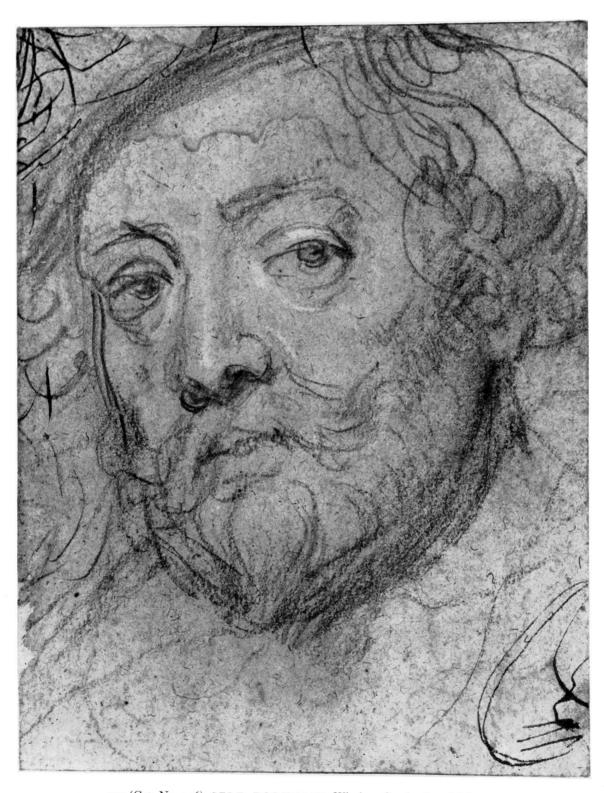

139 (Cat. No. 126) SELF-PORTRAIT. Windsor Castle, Royal Library

III
LANDSCAPES

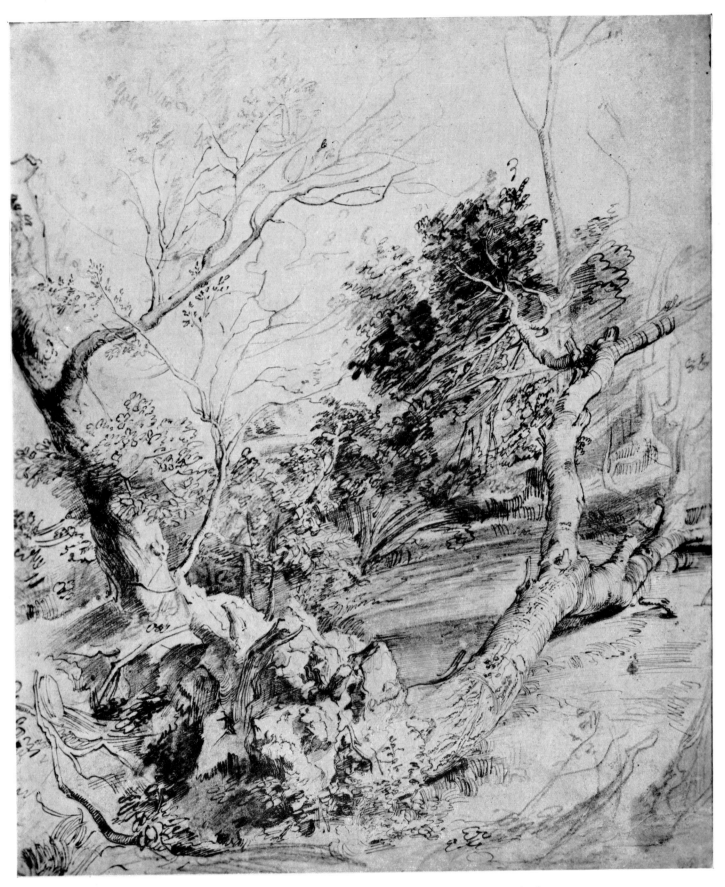

140 (Cat. No. 131) LANDSCAPE WITH FALLEN TREE. Paris, Louvre

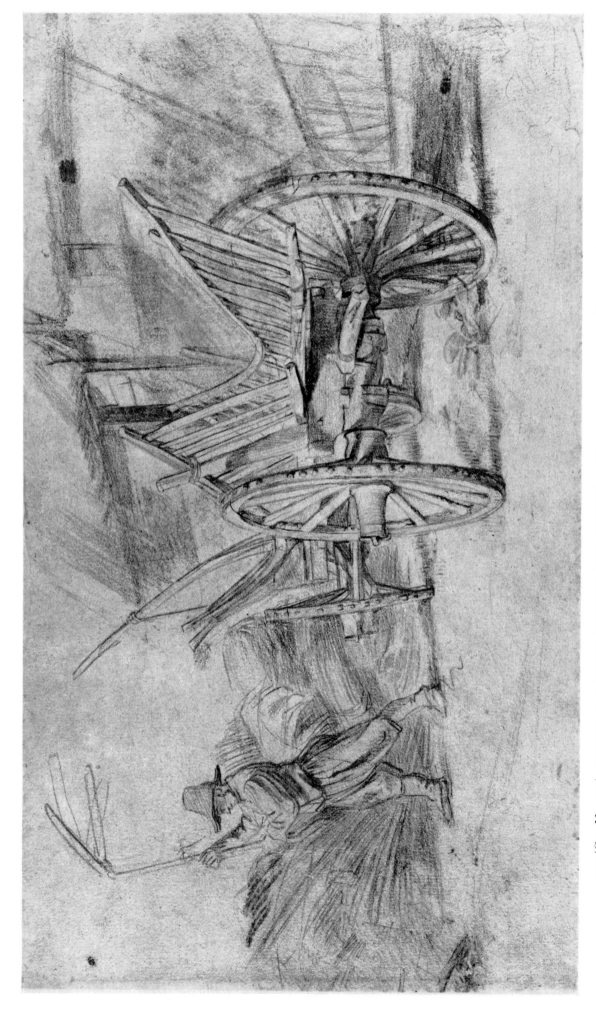

141 (Cat. No. 129) FARMYARD WITH FARMER THRESHING, AND A HAY-WAGON. Chatsworth, Devonshire Collection

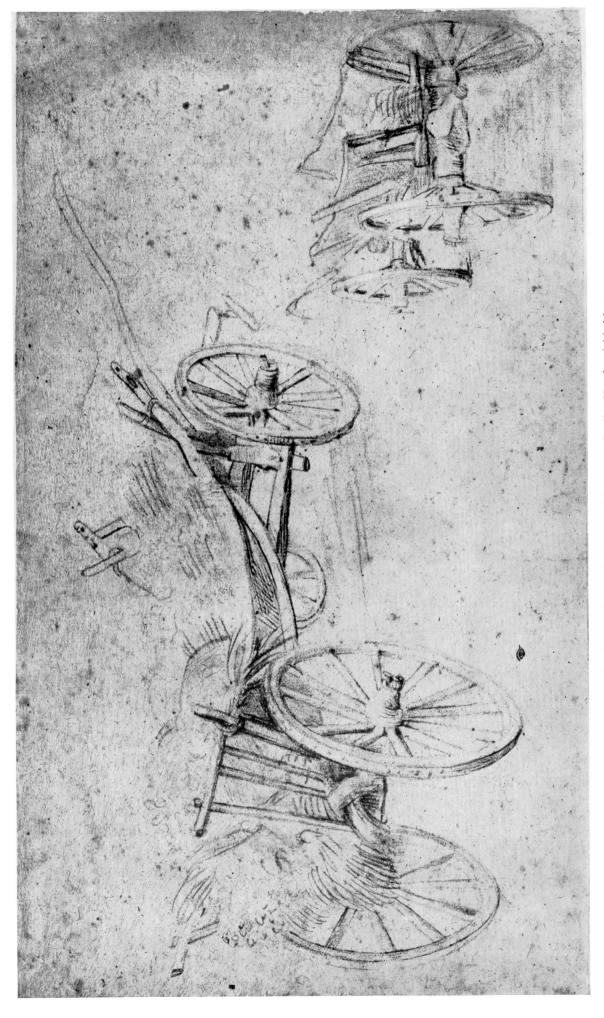

142 (Cat. No. 133) TWO FARM WAGONS. Berlin, Kupferstichkabinett

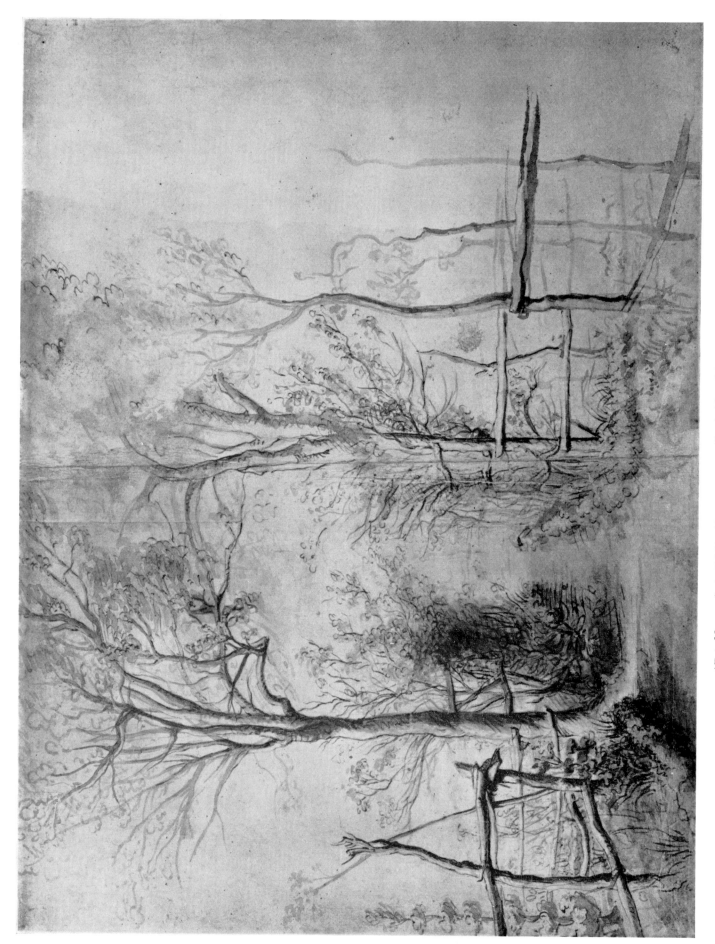

143 (Cat. No. 130) A COUNTRY LANE. Cambridge, Fitzwilliam Museum

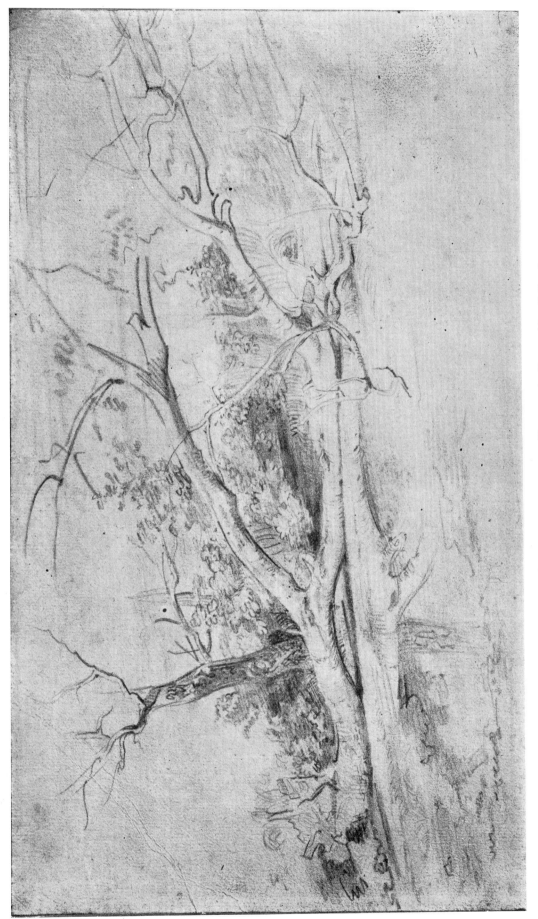

144 (Cat. No. 132) A FALLEN TREE. Chatsworth, Devonshire Collection

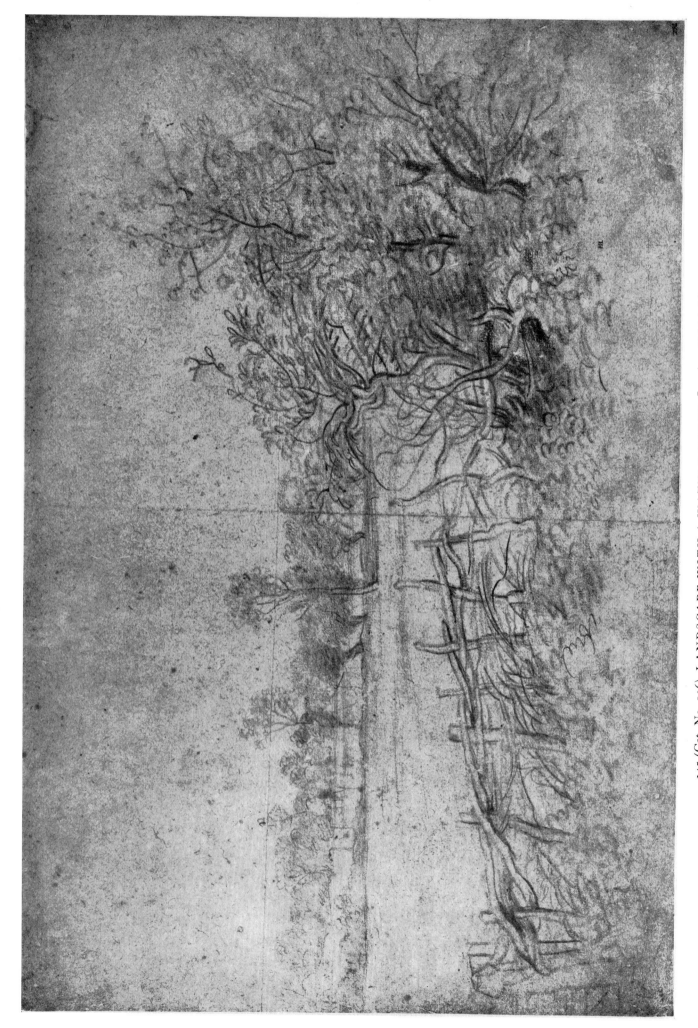

145 (Cat. No. 136) LANDSCAPE WITH A WATTLE FENCE. London, British Museum

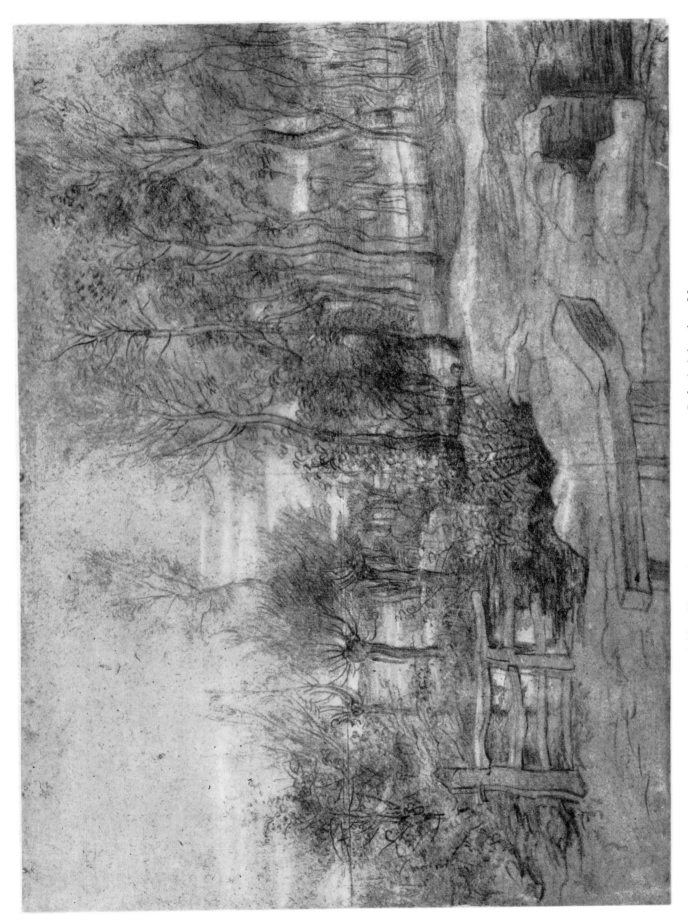

146 (Cat. No. 137) WOODLAND SCENE. Oxford, Ashmolean Museum

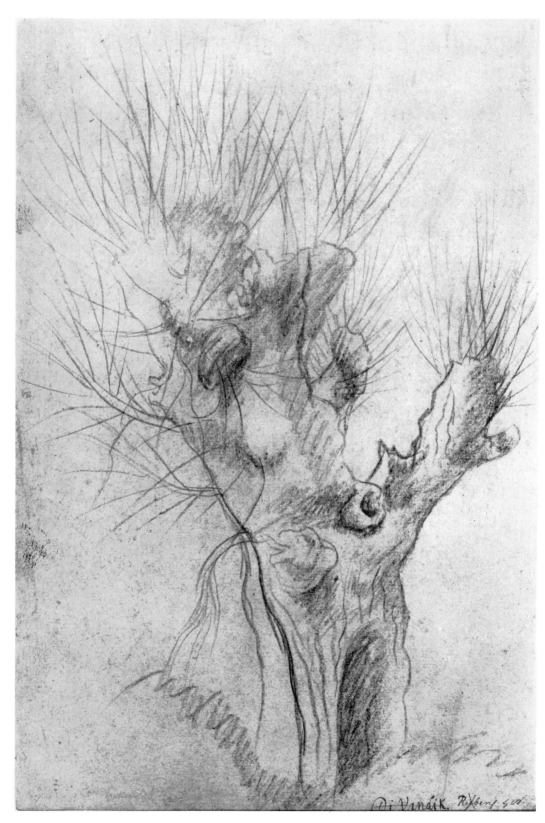

147 (Cat. No. 134) A WILLOW TREE. London, British Museum

IV
DESIGNS FOR SCULPTURES, ENGRAVINGS AND WOODCUTS

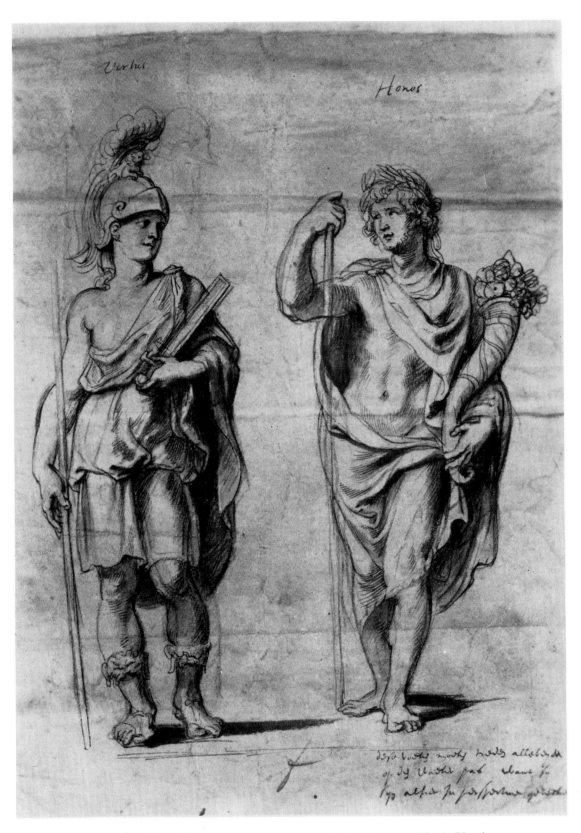

148 (Cat. No. 138) VIRTUE AND HONOUR. Antwerp, Musée Plantin

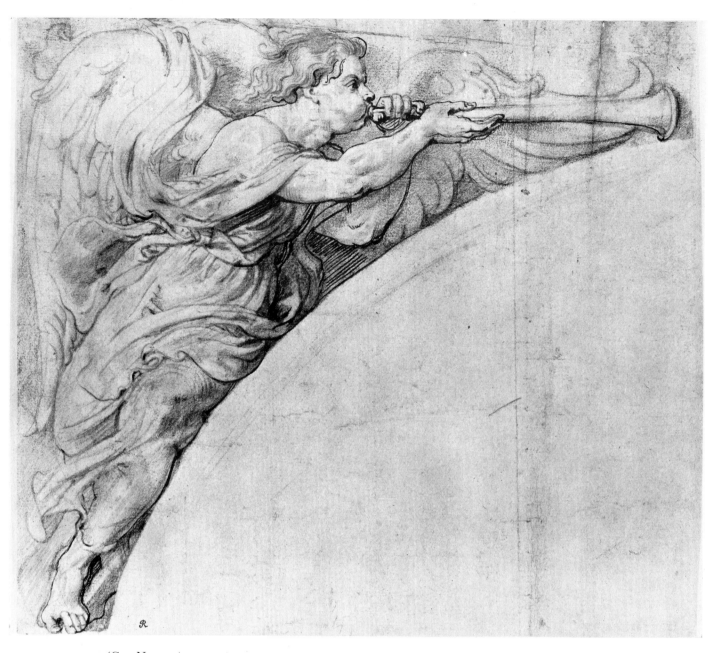

149 (Cat. No. 144) AN ANGEL BLOWING A TRUMPET. New York, Pierpont Morgan Library

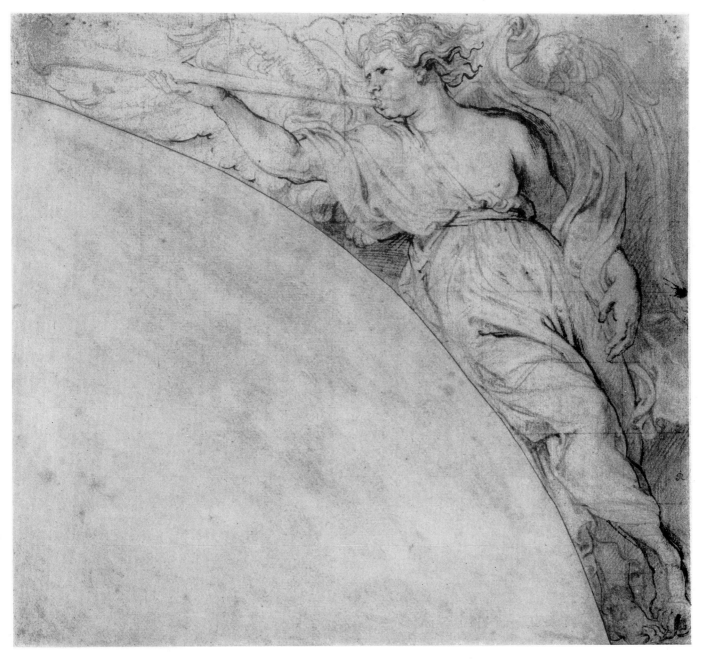

150 (Cat. No. 145) AN ANGEL BLOWING A TRUMPET. New York, Pierpont Morgan Library

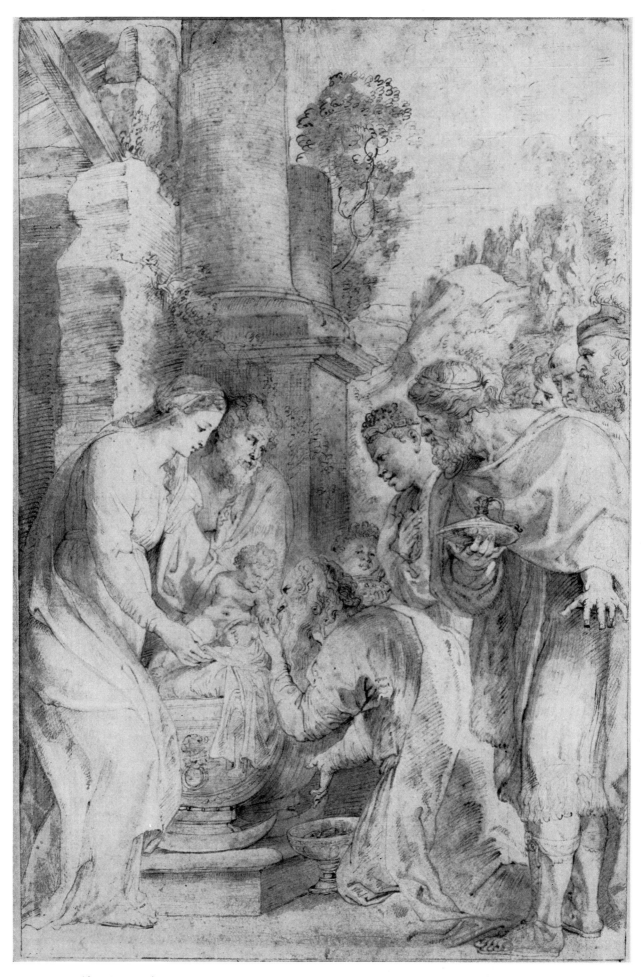

151 (Cat. No. 139) THE ADORATION OF THE MAGI. New York, Pierpont Morgan Library

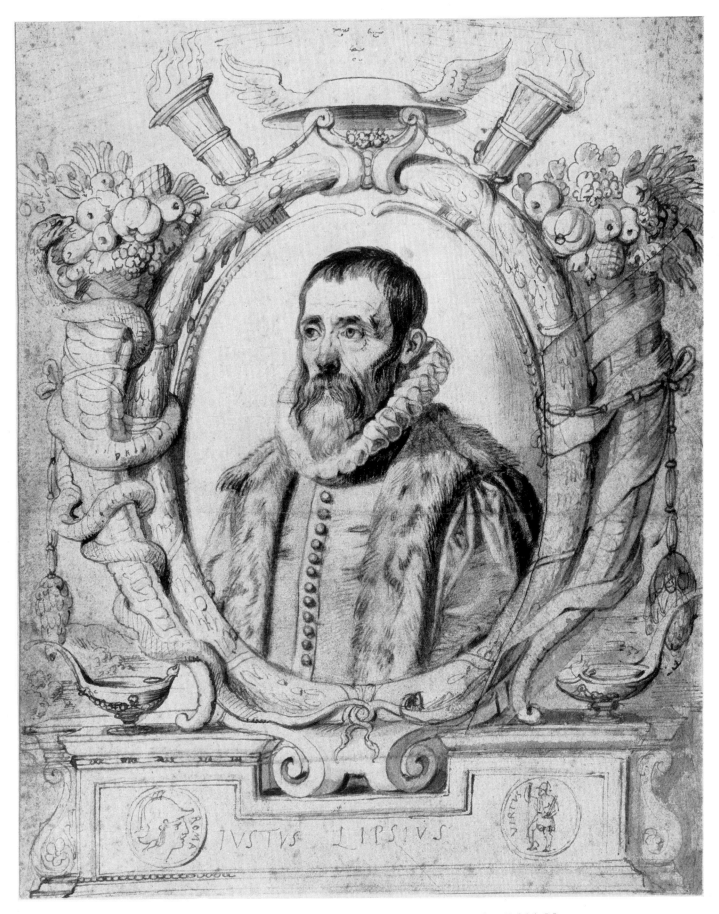

152 (Cat. No. 141) PORTRAIT OF JUSTUS LIPSIUS. London, British Museum

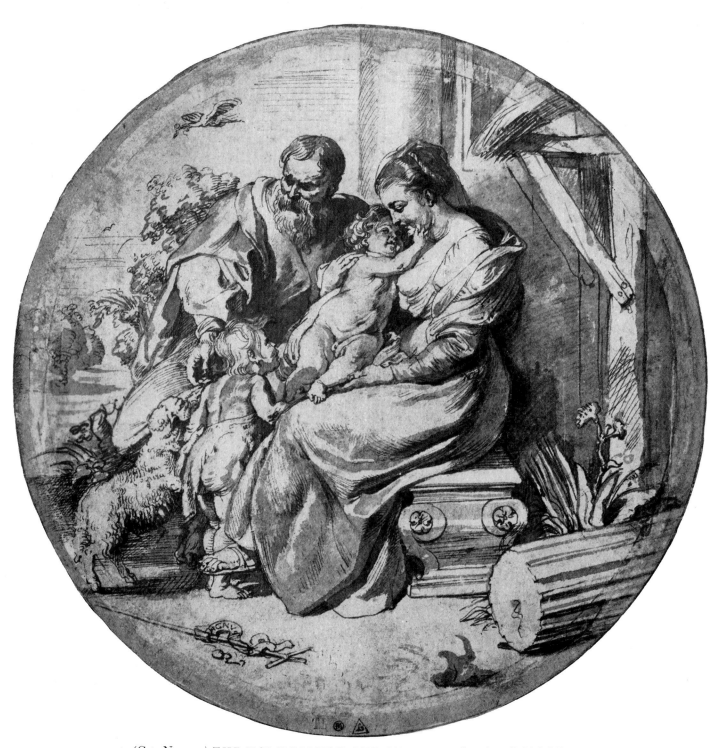

153 (Cat. No. 142) THE HOLY FAMILY AND ST. JOHN. London, British Museum

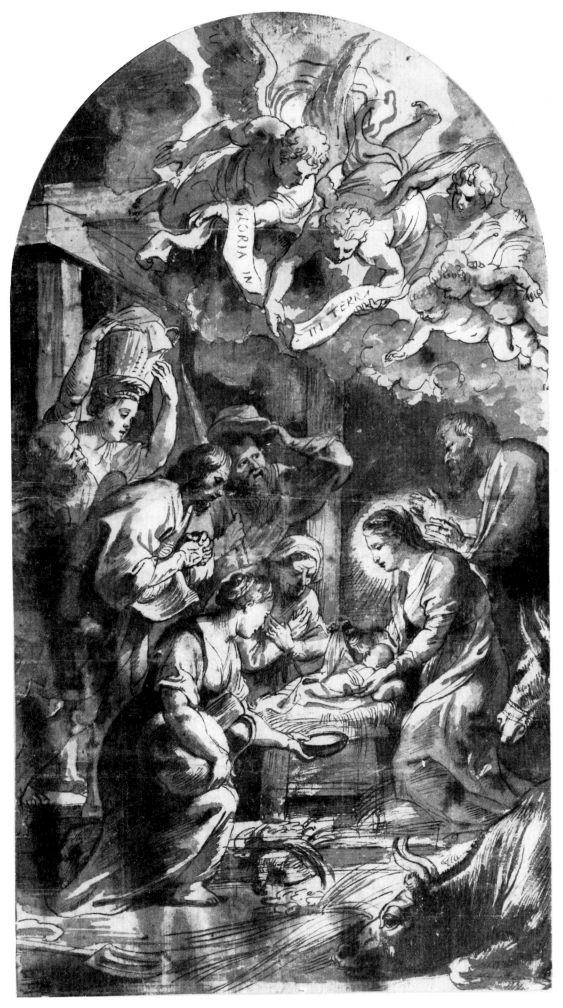

154 (Cat. No. 143) THE ADORATION OF THE SHEPHERDS. Paris, Collection of Frits Lugt

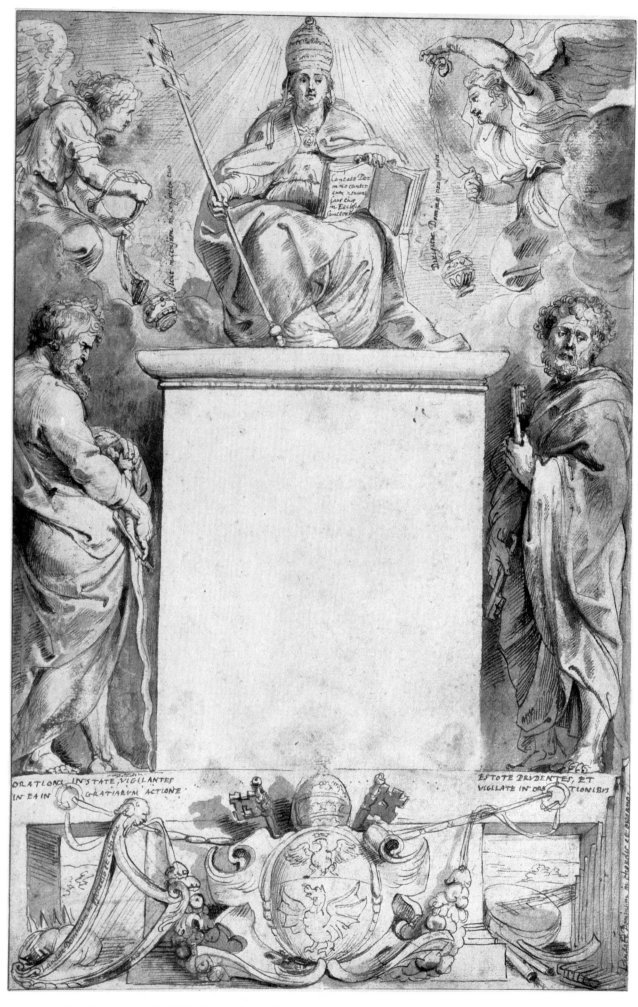

155 (Cat. No. 140) DESIGN FOR THE TITLE-PAGE OF THE BREVIARIUM ROMANUM.
London, British Museum

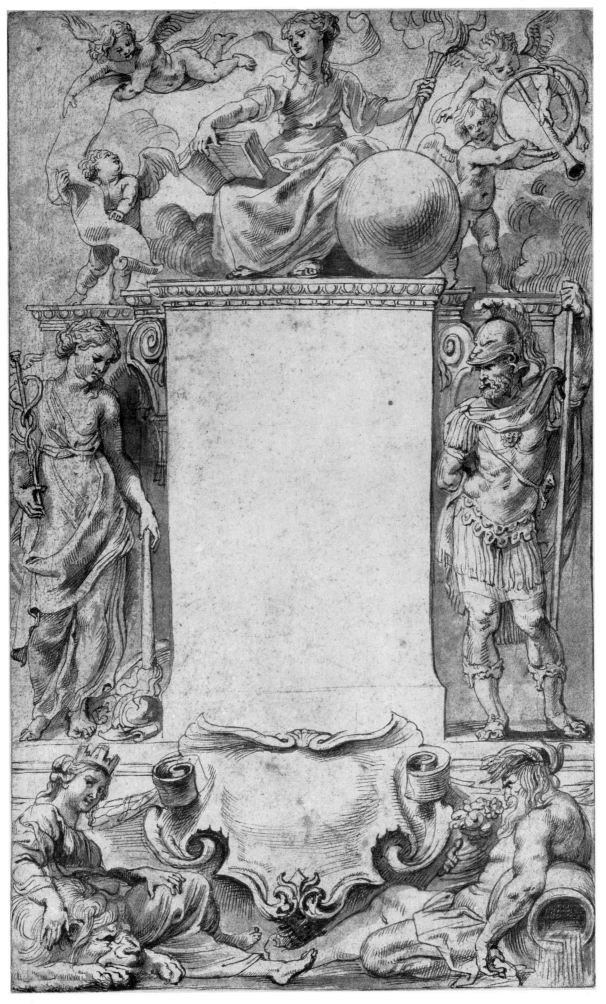

156 (Cat. No. 146) DESIGN FOR THE TITLE-PAGE OF FRANCISCUS HARAEUS' ANNALES
DUCUM BRABANTIAE. London, British Museum

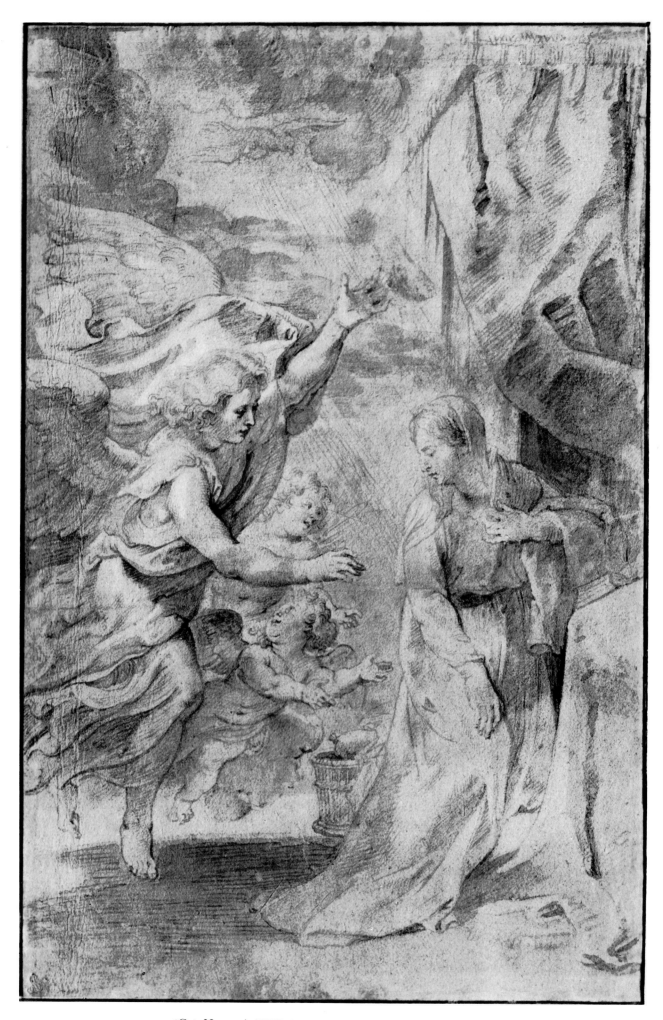

157 (Cat. No. 147) THE ANNUNCIATION. Vienna, Albertina

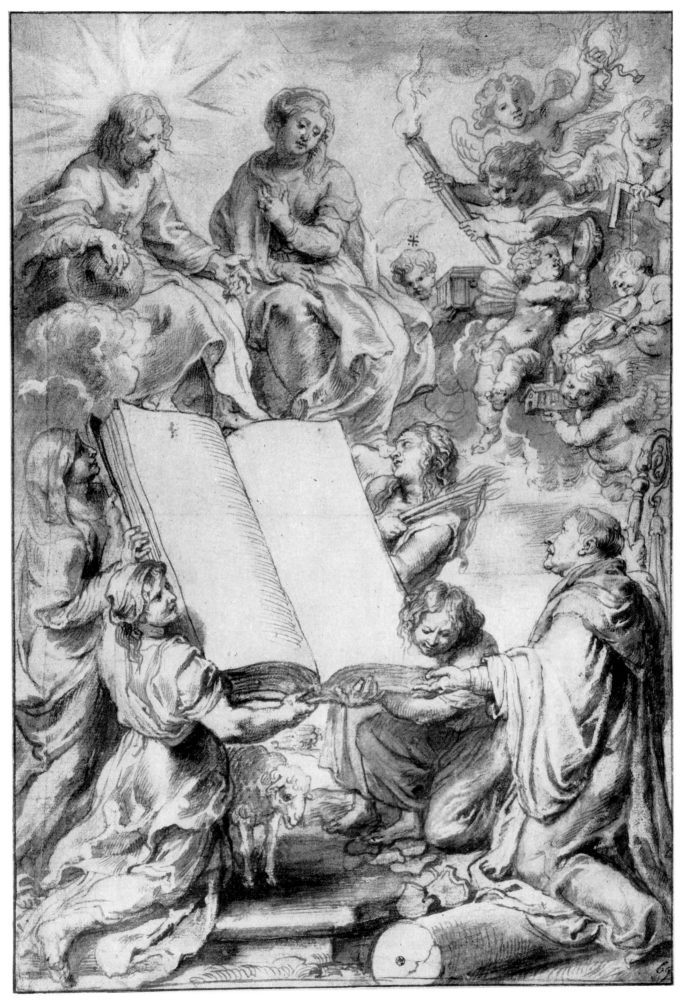

158 (Cat. No. 151) TITLE-PAGE FOR THE WORKS OF LUDOVICUS BLOSIUS. London, British Museum

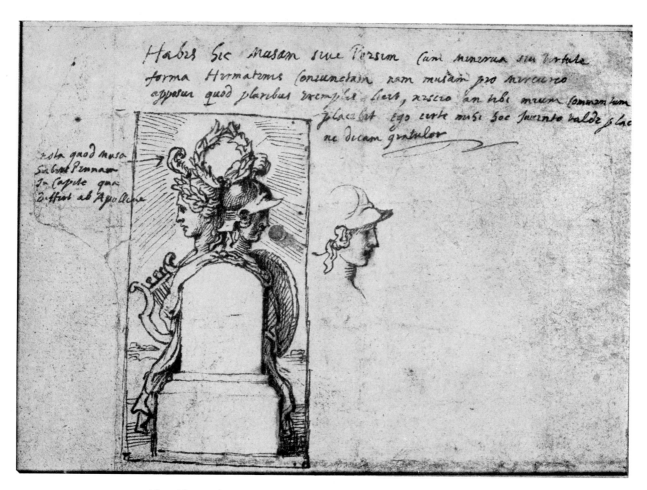

159 (Cat. No. 153) POETRY AND VIRTUE. Antwerp, Musée Plantin

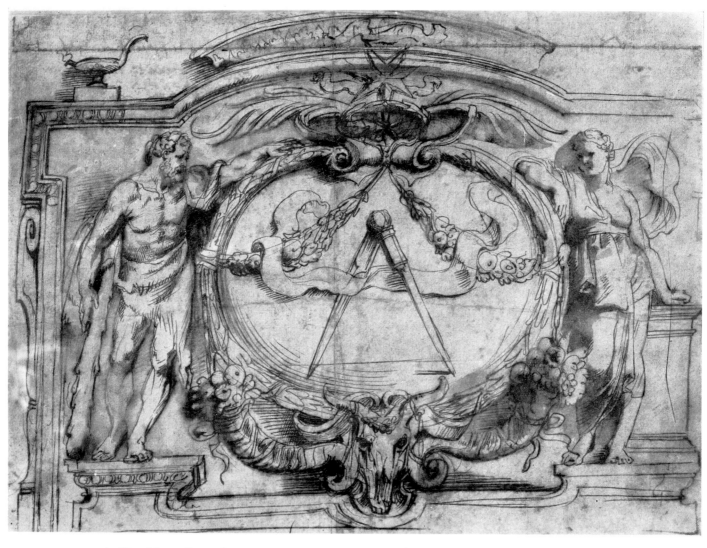

160 (Cat. No. 148) THE EMBLEM OF THE PLANTIN PRESS. Antwerp, Musée Plantin

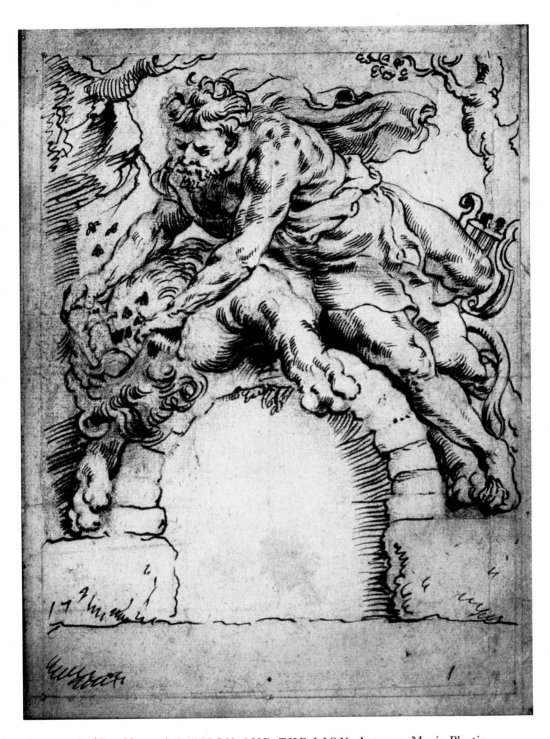

161 (Cat. No. 154) SAMSON AND THE LION. Antwerp, Musée Plantin

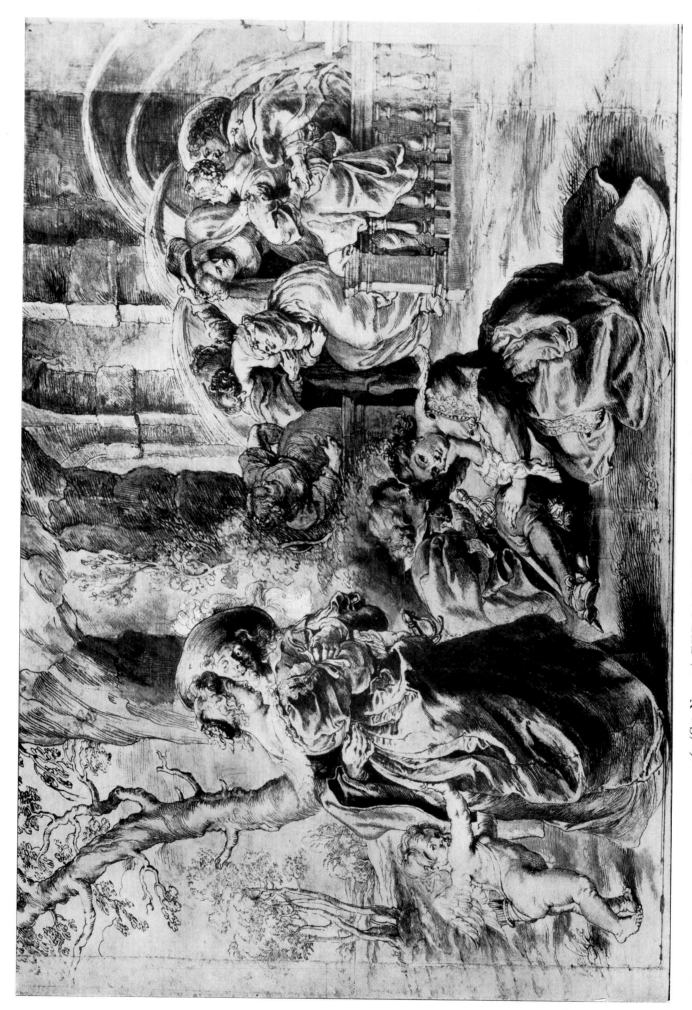

162 (Cat. No. 152) THE GARDEN OF LOVE. New York, Metropolitan Museum of Art

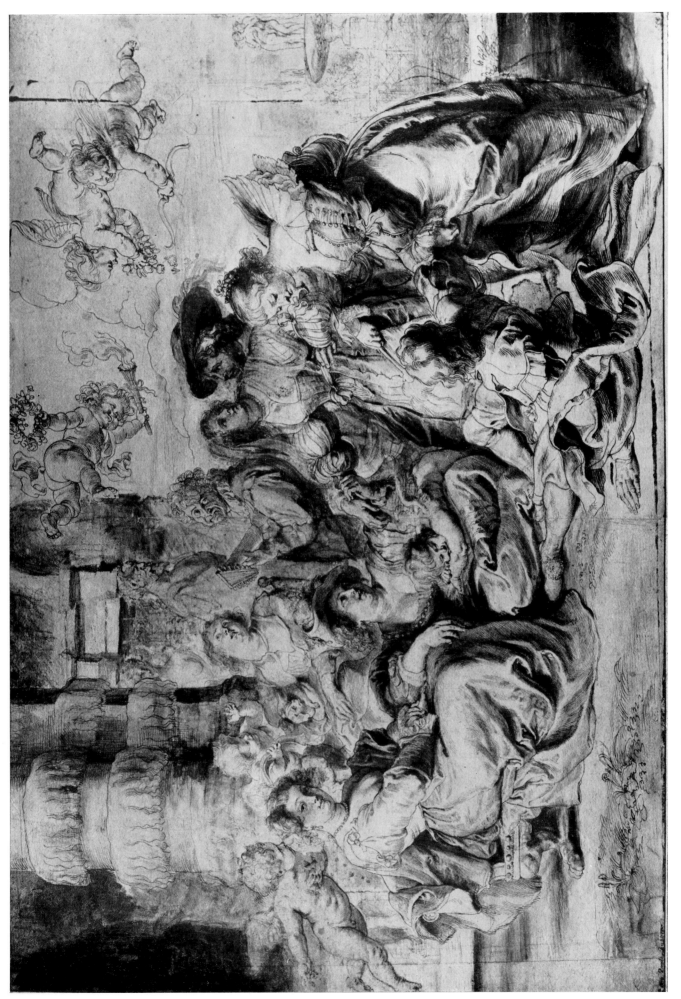

163 (Cat. No. 152) THE GARDEN OF LOVE. New York, Metropolitan Museum of Art

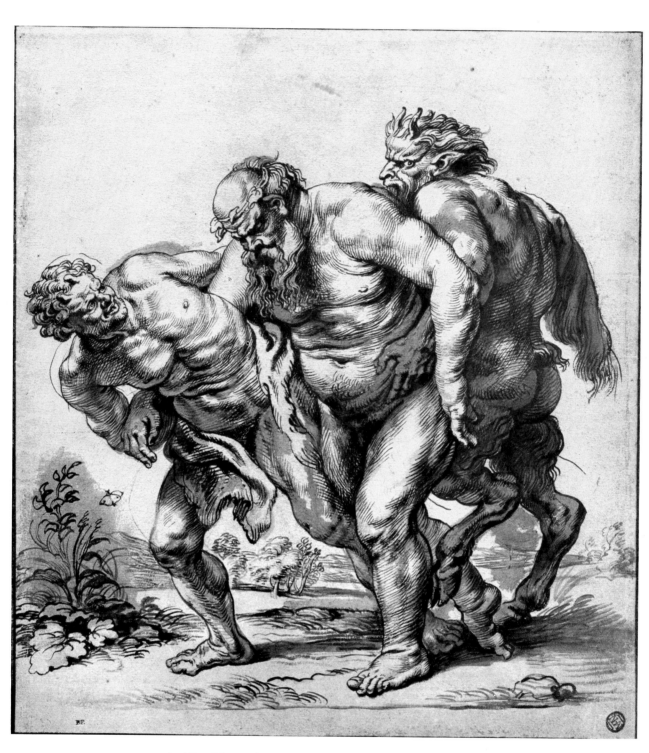

164 (Cat. No. 155) MARCH OF SILENUS. Paris, Louvre

V

COPIES BY RUBENS AFTER OTHER MASTERS AND DRAWINGS RETOUCHED BY RUBENS

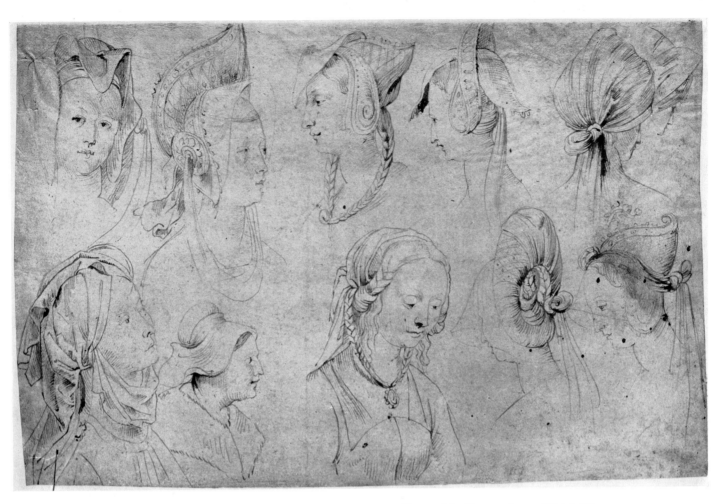

165 (Cat. No. 162) ELEVEN HEADS OF WOMEN. Brunswick, Herzog Anton Ulrich-Museum

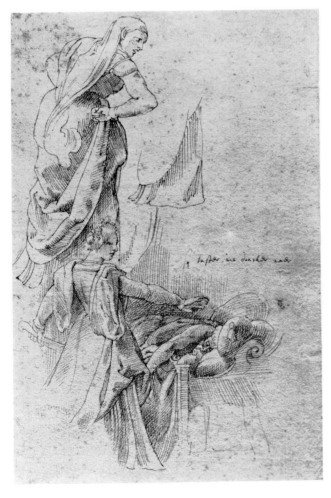

166 (Cat. No. 156) TWO COPIES AFTER TOBIAS
STIMMER. London, Private Collection

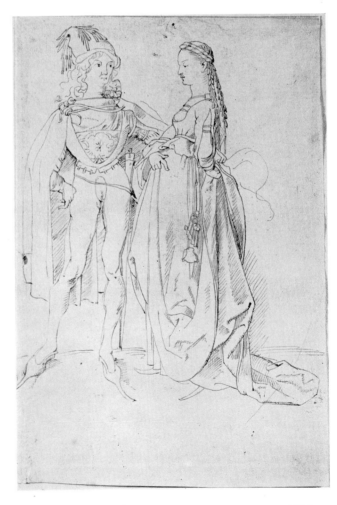

167 (Cat. No. 157) A YOUNG COUPLE, AFTER
VAN MECKENEM. Berlin, Kupferstichkabinett

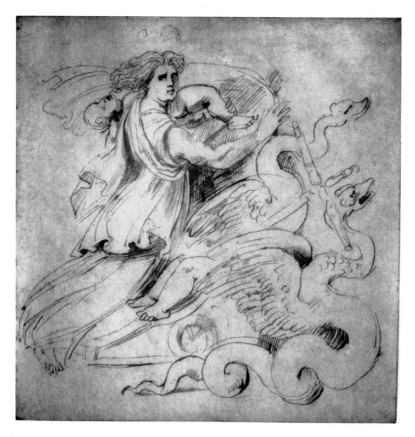

168 (Cat. No. 159) *THE FLIGHT OF MEDEA*. Rotterdam, Museum Boymans

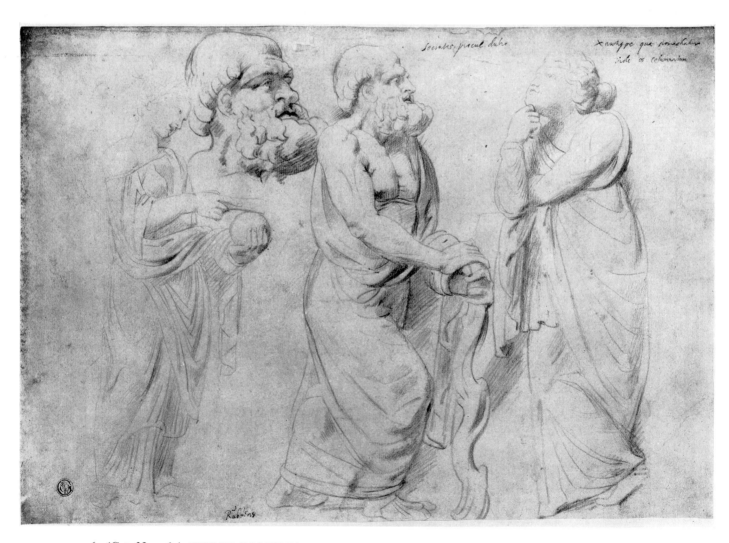

169 (Cat. No. 160) *THREE FIGURES FROM A ROMAN SARCOPHAGUS*. Chicago, Art Institute

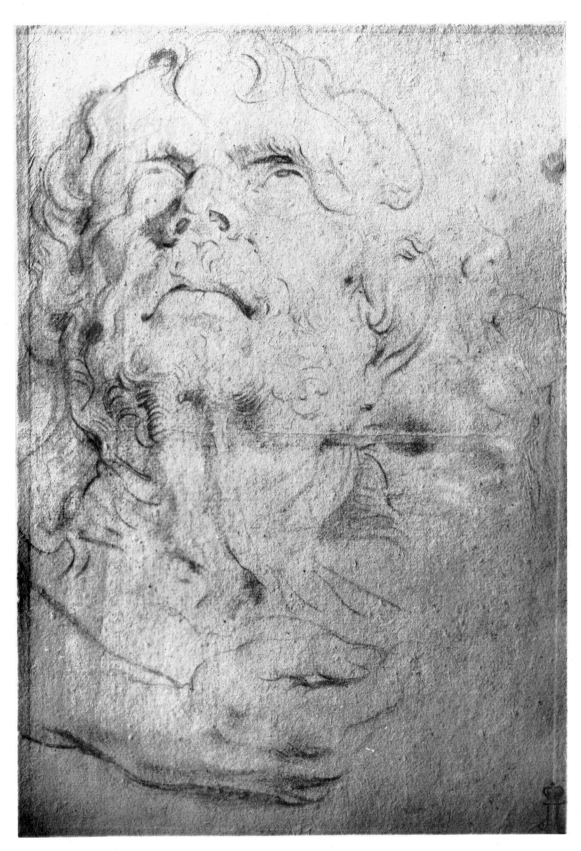

170 (Cat. No. 165) THE HEAD OF SENECA. Leningrad, Hermitage

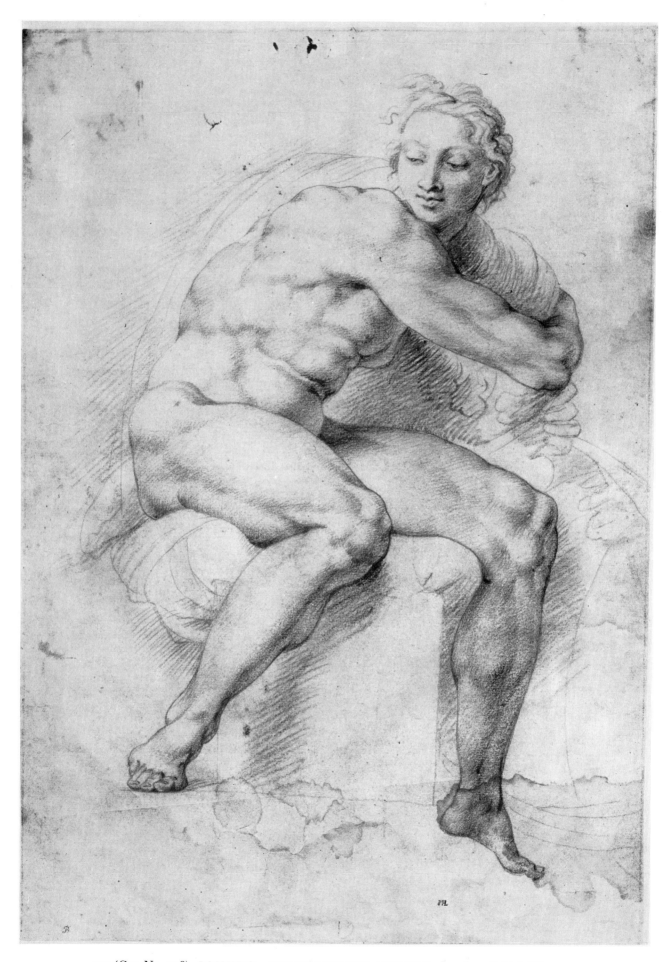

171 (Cat. No. 158) IGNUDO, AFTER MICHELANGELO. London, British Museum

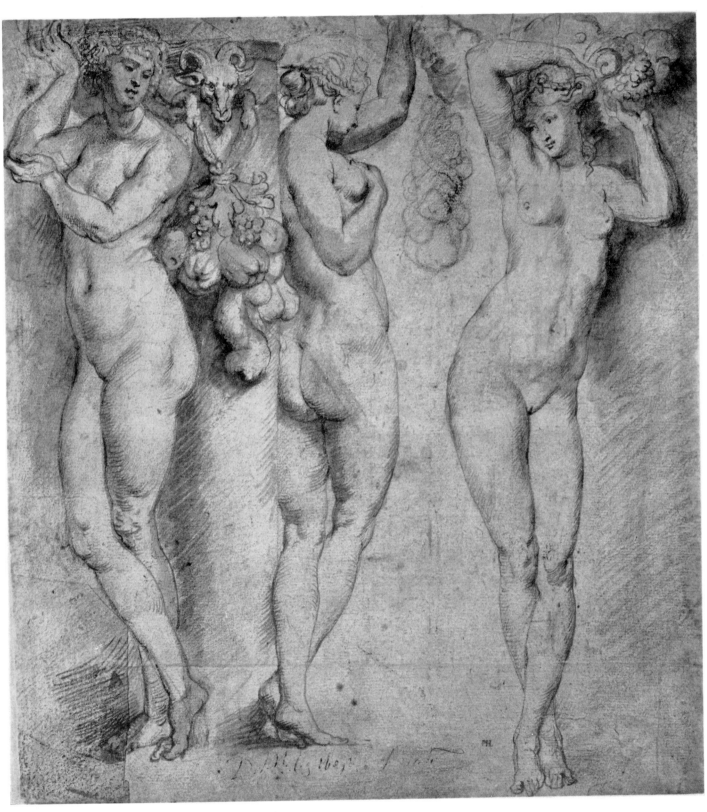

172 (Cat. No. 166) THREE CARYATIDS, AFTER PRIMATICCIO. Rotterdam, Museum Boymans

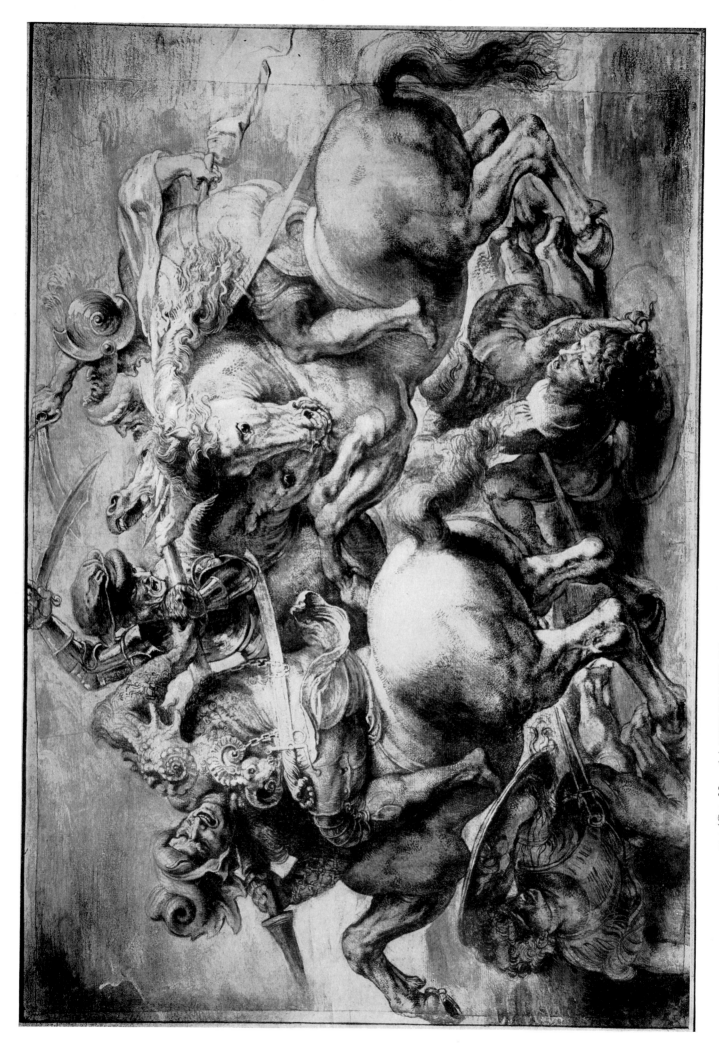

173 (Cat. No. 161) THE FIGHT FOR THE STANDARD, AFTER LEONARDO DA VINCI. Paris, Louvre

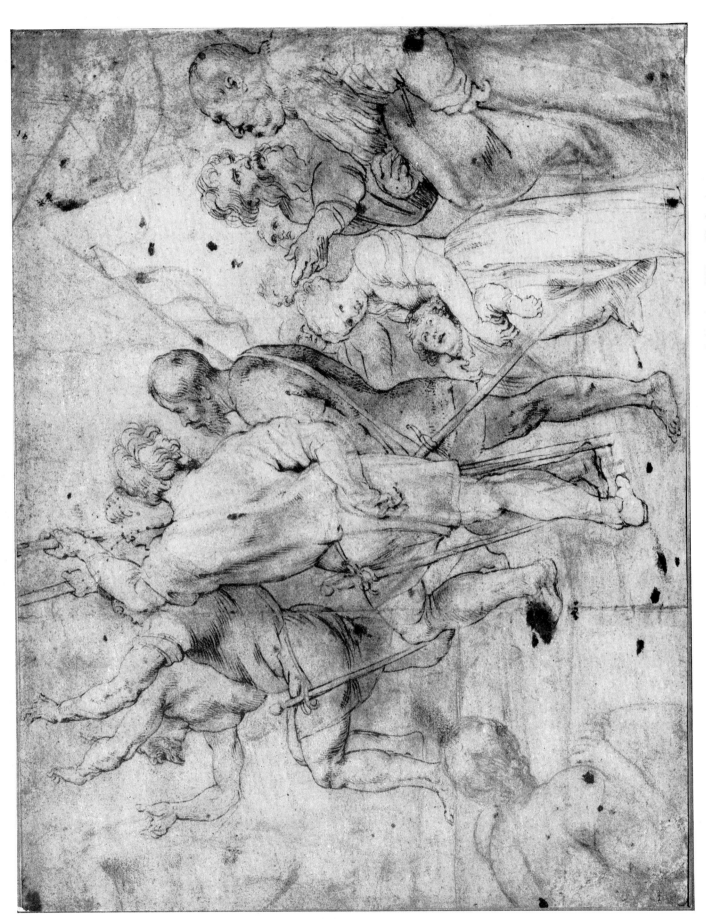

174 (Cat. No. 167) ECCE HOMO, AFTER TITIAN. London, Collection of Victor Koch

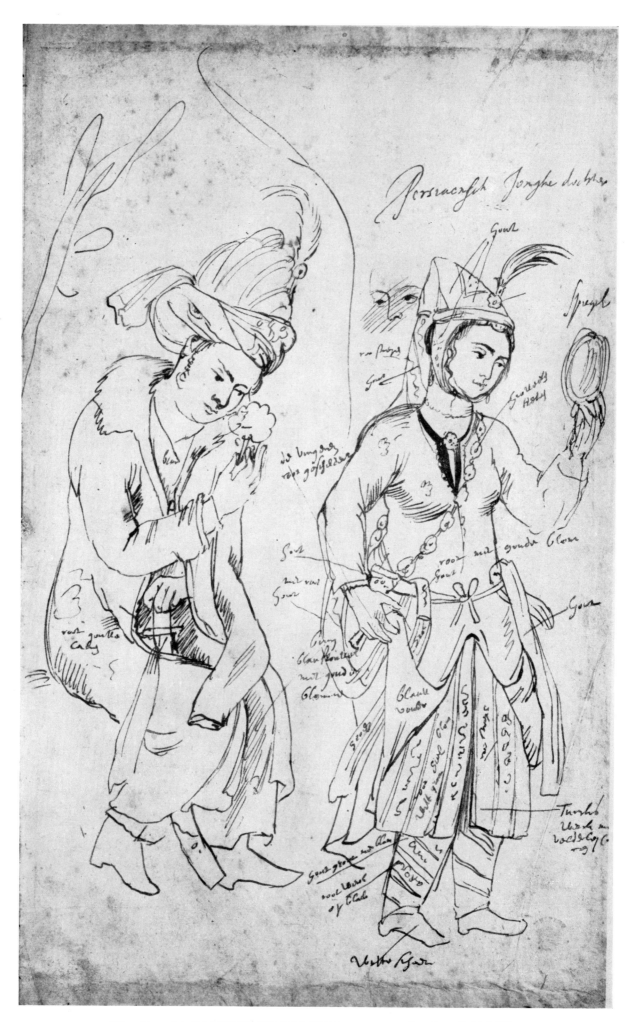

175 (Cat. No. 163) FIGURES IN ORIENTAL DRESS. London, British Museum

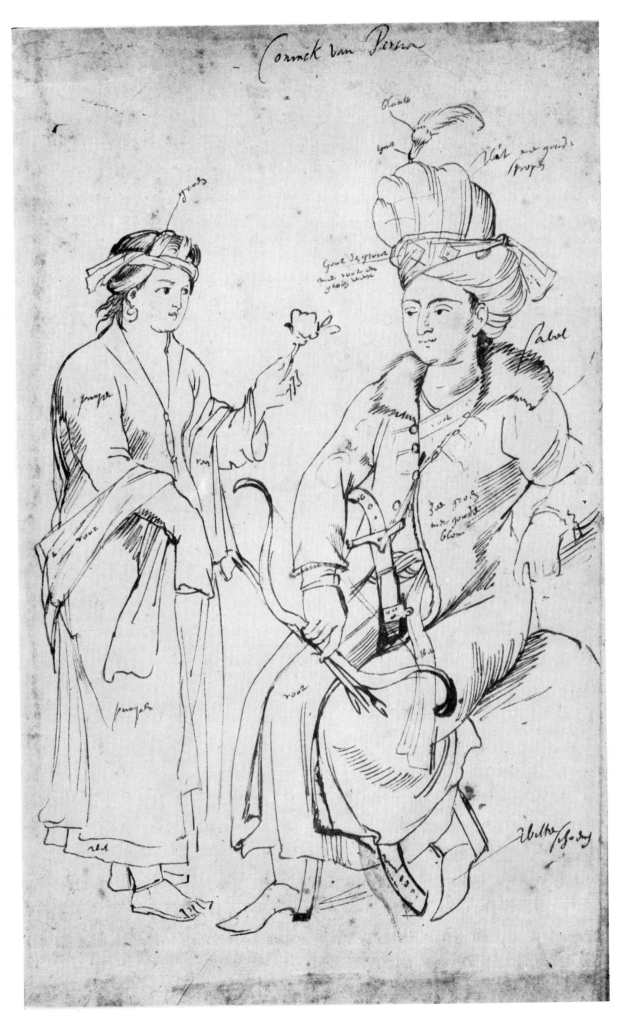

176 (Cat. No. 163) FIGURES IN ORIENTAL DRESS. London, British Museum

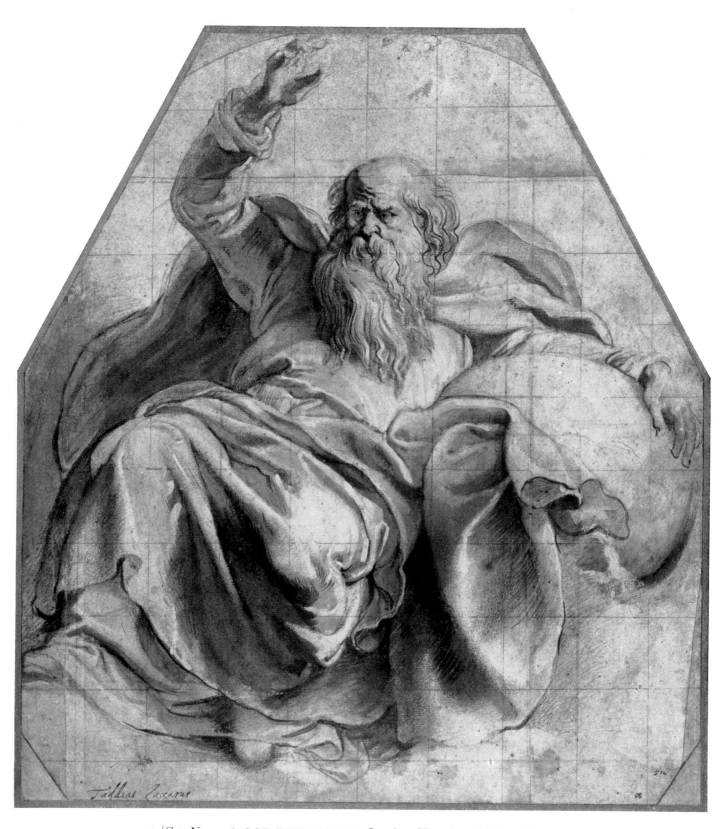

177 (Cat. No. 170) GOD THE FATHER. London, Victoria and Albert Museum

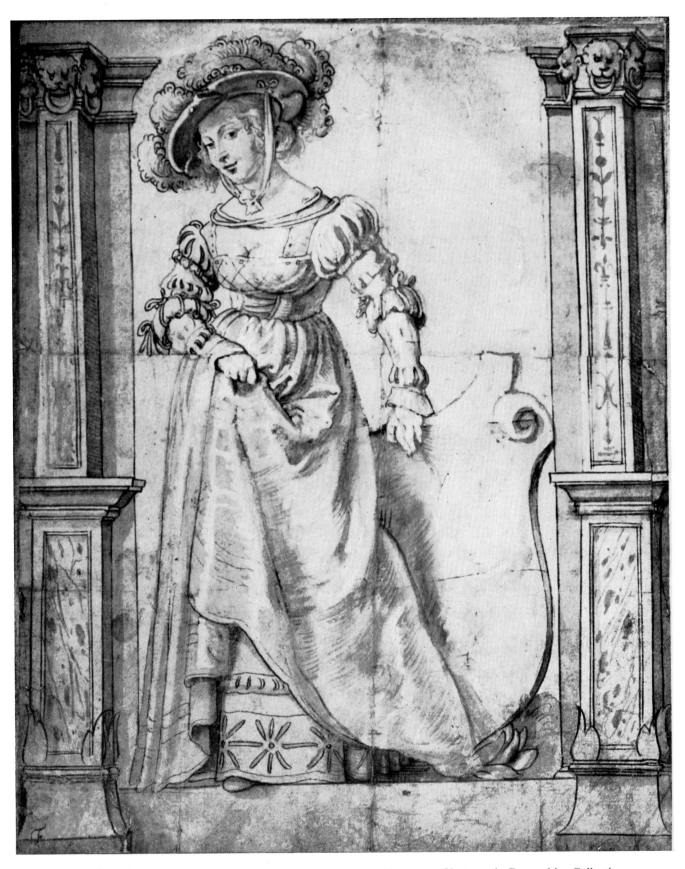

178 (Cat. No. 168) YOUNG WOMAN HOLDING A SHIELD. Chatsworth, Devonshire Collection

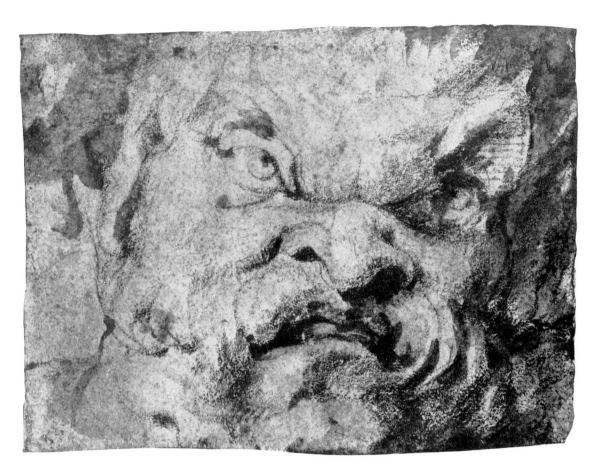

179 (Cat. No. 164) HEAD OF SILENUS. New York, Metropolitan Museum

LIST OF PLATES

LIST OF PLATES

SKETCHES FOR COMPOSITIONS

1. (Cat. No. 1). *The Discovery of Callisto*. Berlin, Kupferstichkabinett
2. (Cat. No. 2). *A Battle of Greeks and Amazons*. London, British Museum
3. (Cat. No. 5). *Christ Crowned with Thorns*. Brunswick, Herzog Anton Ulrich-Museum
4. (Cat. No. 3). *The Descent from the Cross*. Leningrad, Hermitage.
5. (Cat. No. 4). *The Entombment of Christ*. Rotterdam, Museum Boymans
6. (Cat. No. 6). *The Return of the Victorious Horatius*. New York, Metropolitan Museum of Art
7. (Cat. No. 7). *Sketches for the Last Supper*. Chatsworth, Devonshire Collection
8. (Cat. No. 7 verso). *Medea and Her Slain Children*. Reverse of Plate 7. Chatsworth, Devonshire Collection
9. (Cat. No. 8). *Studies for the Suicide of Thisbe*. Paris, Louvre
10. (Cat. No. 9). *Thisbe Committing Suicide*. Brunswick (Maine), Collection of Mrs. Stanley P. Chase
11. (Cat. No. 12). *The Birth of the Virgin*. Paris, Petit Palais
12. (Cat. No. 11). *The Baptism of Christ*. Paris, Louvre
13. (Cat. No. 13). *The Death of Creusa*. Bayonne, Musée Bonnat
14. (Cat. No. 14). *The Battle of Lapiths and Centaurs*. Amsterdam, Rijksmuseum
15. (Cat. No. 10). *Cain Slaying Abel*. Amsterdam, Fodor Collection
16. (Cat. No. 15). *Judith Killing Holofernes*. Frankfurt, Städelsches Kunstinstitut
17. (Cat. No. 20). *Susanna*. Montpellier, Bibliothèque Universitaire
18. (Cat. No. 16). *St. Gregory, St. Maurus and St. Papianus*. Chantilly, Musée Condé
19. (Cat. No. 17). *The Image of the Virgin Adored by Angels*. Vienna, Albertina
20. (Cat. No. 18). *Two Shepherds and Man with Turban*. Amsterdam, Fodor Collection
21. (Cat. No. 24). *Samson and Delila*. Amsterdam, Collection of J. Q. van Regteren Altena
22. (Cat. No. 23). *Venus Lamenting Adonis*. London, Collection of Ludwig Burchard
23. (Cat. No. 22). *Venus Lamenting Adonis*. London, British Museum
24. (Cat. No. 21). *The Death of Hippolytus*. Bayonne, Musée Bonnat
25. (Cat. No. 19). *A Bacchanal*. Antwerp, Cabinet des Estampes
26. (Cat. No. 30). *Two Studies for St. Christopher*. London, British Museum
27. (Cat. No. 25). *David and Goliath*. Rotterdam, Museum Boymans
28. (Cat. No. 26). *David and Goliath*. Montpellier, Bibliothèque Universitaire
29. (Cat. No. 31). *The Conversion of St. Paul*. London, Collection of Count Antoine Seilern
30. (Cat. No. 29). *Silenus and Aegle, and Other Figures*. Windsor Castle, Royal Library
31. (Cat. No. 32). *Bathsheba Receiving David's Letter*. Berlin, Kupferstichkabinett
32. (Cat. No. 34). *Hercules Strangling the Nemean Lion*. Antwerp, Cabinet des Estampes

33. (Cat. No. 27). *Studies for the Visitation*. Bayonne, Musée Bonnat
34. (Cat. No. 28). *Studies for the Presentation in the Temple*. New York, Metropolitan Museum of Art
35. (Cat. No. 37). *The Entombment of Christ*. Amsterdam, Rijksmuseum
36. (Cat. No. 33). *Two Studies of a River-God*. Boston, Museum of Fine Arts
37. (Cat. No. 36). *Three Robed Men*. Copenhagen, Kunstmuseet
38. (Cat. No. 35). *The Assumption of the Virgin*. Vienna, Albertina
39. (Cat. No. 42). *The Descent from the Cross*. Collection of the late Mrs. G. W. Wrangham
40. (Cat. No. 38). *The Continence of Scipio*. Berlin, Kupferstichkabinett
41. (Cat. No. 39). *The Continence of Scipio*. Bayonne, Musée Bonnat
42. (Cat. No. 41). *Studies for a Drunken Silenus*. Collection of the late Mrs. G. W. Wrangham
43. (Cat. No. 43). *The Raising of Lazarus*. Berlin, Kupferstichkabinett
44. (Cat. No. 40). *The Apostles Surrounding the Virgin's Tomb*. Oslo, Nasjionalgalleriet
45. (Cat. No. 44). *The Last Communion of St. Francis*. Antwerp, Cabinet des Estampes
46. (Cat. No. 45). *Female Nudes Reclining*. London, Collection of Count Antoine Seilern
47. (Cat. No. 46). *Studies for Venus and Cupid*. New York, Frick Collection
48. (Cat. No. 48). *Hercules Standing on Discord, Crowned by Two Genii*. London, British Museum
49. (Cat. No. 47). *St. Gregory Nazianzenus*. New York, Collection of Clarence L. Hay
50. (Cat. No. 52). *Studies for a Roman Triumph*. Berlin, Kupferstichkabinett
51. (Cat. No. 49). *Roma Triumphans*. Vienna, Albertina
52. (Cat. No. 50 recto). *The Vestal Tuccia*. Paris, Louvre
53. (Cat. No. 50 verso). *Louis XIII Comes of Age*. Paris, Louvre
54. (Cat. No. 51 recto). *Marie de Médicis Receives the Olive Branch of Peace*. Formerly Bremen, Kunsthalle
55. (Cat. No. 51 verso). *Henry IV Carried to Heaven and Other Figures*. Reverse of Plate 54. Formerly Bremen, Kunsthalle
56. (Cat. No. 55). *Female Nudes Reclining*. London, Collection of Count Antoine Seilern
57. (Cat. No. 55 verso). *Centaurs Embracing*. Reverse of Plate 56
58. (Cat. No. 53 verso). *Studies for the Virgin and Child and Studies for St. George and the Dragon*. Reverse of Plate 59
59. (Cat. No. 53 recto). *The Virgin Adored by Saints*. Stockholm, Nationalmuseum
60. (Cat. No. 53 verso). *St. George and the Dragon*. Detail of Plate 58
61. (Cat. No. 54). *Studies for St. George and the Princess*. Berlin, Kupferstichkabinett
62. (Cat. No. 58). *Venus Anadyomene and Two Nereids*. London, British Museum
63. (Cat. No. 56). *A Nymph Asleep*. Rotterdam, Museum Boymans
64. (Cat. No. 62). *The Three Graces*. London, Collection of Count Antoine Seilern

LANDSCAPES

DESIGNS FOR SCULPTURES, ENGRAVINGS AND WOODCUTS

COPIES BY RUBENS AFTER OTHER MASTERS AND DRAWINGS RETOUCHED BY RUBENS

LIST OF COLLECTIONS

ACKNOWLEDGEMENT

The Author and Publishers wish to express their gratitude to the Directors of Museums and Public Collections, as well as to all Private Collectors who kindly provided photographs and gave permission for reproduction